ESSENCE CREATIVE™

THE FACE

PAUL FEDOR • PETER LEVIUS
HONG SUCK SUH • MATT HARTLE
MARK SNOSWELL • STEVEN STAHLBERG

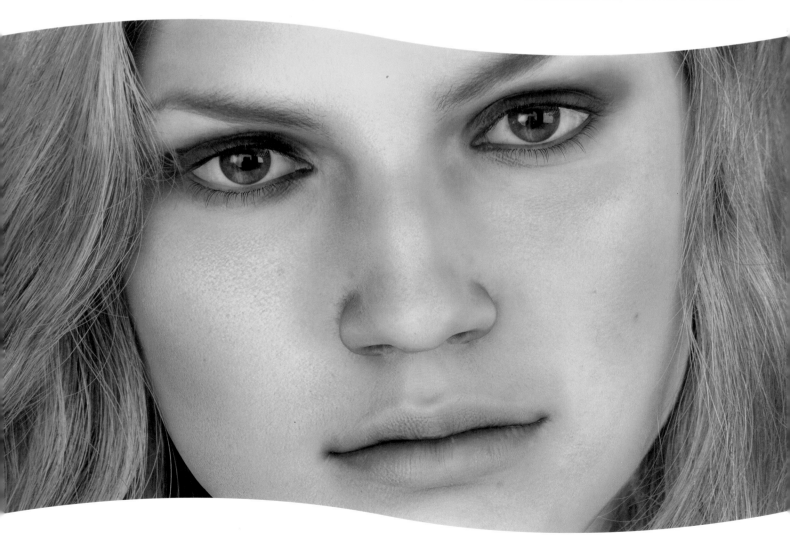

EDITED BY • DANIEL WADE

Published
by

Ballistic Publishing

Publishers of digital works for the digital world.

Aldgate Valley Rd
Mylor SA 5153
Australia

www.BallisticPublishing.com

Correspondence:
info@BallisticPublishing.com

First Edition published in Australia 2007
by Ballistic Publishing

Softcover Edition ISBN 1-921002-36-0

Managing Editor
Daniel Wade

Assistant Editor
Paul Hellard

Art Director
Mark Snoswell

Design & Image Processing
Lauren Stevens

Creative ESSENCE: The Face Artists
Paul Fedor, Peter Levius, Steven Stahlberg,
Hong Suck Suh, Mark Snoswell, Matt Hartle

Printing and binding
Everbest Printing (China)
www.everbest.com

Partners
The CG Society (Computer Graphics Society)
www.CGSociety.org

Also available from Ballistic Publishing
d'artiste Character Modeling 2 ISBN 1-921002-35-2
d'artiste Concept Art ISBN 1-921002-33-6
d'artiste Matte Painting ISBN 1-921002-16-6
d'artiste Digital Painting ISBN 0-9750965-5-9

Visit www.BallisticPublishing.com
for our complete range of titles.

Creative ESSENCE:	The Face credits
Model:	**Monika Kubickova**
3D.SK manager and co-founder:	**Richard Polak**
3D.SK founder and photo shoot supervisor:	**Peter Levius**
Photographer:	**Jiri Matula**
Models and photo shoot manager:	**Veronika Jaskova**
Project manager and photo shoot assistant:	**Tomas Babinec**
Makeup artist and hairstylist:	**Gabriela Kleinova**
Texture artist:	**Paul Fedor**
Modeler:	**Hong Suck Suh**
Eye modeler:	**Steven Stahlberg**
Texturing/Renderer:	**Mark Snoswell**
Renderer:	**Matt Hartle**

EDITORIAL

Daniel Wade
Managing Editor

Mark Snoswell
Publisher

Welcome to the first book in our new Creative ESSENCE series. This series of "how-to" books is for mid- to advanced-level artists. Creative ESSENCE is all about the essence of bringing 3D characters to life. Each book will focus on a single topic. All books in the series will also be complemented with DVDs and web releases of the valuable digital assets developed and illustrated in the books. Over time, we hope that this series will become the de-facto material for teaching methods and providing world class assets for artists to bring their characters to life.

This first ESSENCE book is all about creating photo-real human faces for games and film. It looks at the best practices for modeling and texturing a human face from photographs. In the next ESSENCE book, we will focus on rigging and animating photo-real human faces. Each ESSENCE book will bring together between six and ten of the world's most talented 3D artists in their area of expertise. They will work with a core data set that will subsequently be available to artists through the www.CGSociety.org community—the world's largest community of professional digital artists—which we have created and operate.

The team for ESSENCE: The Face includes: Paul Fedor (artist, director, and former texture guru for Sony in its PlayStation 3 cinematics department); Hong Suck Suh (3D modeler for Sony's cinematic department, with game and movie credits including 'Van Helsing' and 'The Mask 2'); Peter Levius (co-founder of 3D.SK, the CG photo reference web site for game and movie creators); Steven Stahlberg (co-author of d'artiste Character Modeling and renowned 3D artist); Matt Hartle (render guru with film credits on 'Van Helsing' and 'Scorched'); and Dr Mark Snoswell, Founder of Ballistic Media (parent company of both Ballistic Publishing and the CGSociety) and President of the CGSociety.

Future ESSENCE titles will include: The Face—Rigging and Animation; The Body—Modeling and Texturing; Detailing Characters, Digital Sculpting and Advanced Texturing; The Body—Rigging and Animation; Creatures—Wings, Fins, Scales and Talons; Effects—Fur, Hair and Clothing.

CONTRIBUTING ARTISTS

Each ESSENCE book brings together between six and ten of the world's most talented 3D artists in their area of expertise. Working as a team, the artists will work on each piece in the 3D character puzzle showing you how characters are created in a production environment for the most efficiency and best results.

PAUL FEDOR
TEXTURING

PETER LEVIUS
PHOTOGRAPHY

HONG SUCK SUH
MODELING

Paul Fedor recently worked with Sony's research and development team where he teamed up with Academy Award winning Post Supervisor Nick Brooks, and Mathew Lamb PHD as a consulting team on cinematics and pipelines. His focus was pushing the standards for next generation characters for the launch of PlayStation 3 with his work and research centered on perfecting a photo-real digital character pipeline.

Peter Levius started his creative career as a 3D character artist for a gaming company. After a series of game projects fell victim to cancellation Peter turned to another passion of his which was the collection of photo-reference. With Richard Polak, Peter created 3D.SK, a web site completely focused on photo reference for the creation and texturing of 3D characters for movies and video games.

By the time Hong was 15 he was studying programming and developing his own drawing software. He decided to study CG in the United States where he majored in Computer Art at the Academy of Art University (AAU). His first job was at WildBrain before joining ILM as a Creature Modeler. Hong's next step was Character Lead of Cinematic Group in SCEA where he currently works on PlayStation 3 cinematics.

THE ARTISTS

STEVEN STAHLBERG
EYE MODELING

Steven Stahlberg co-founded Optidigit and AndroidBlues, the virtual talent studio. He is a 2D and 3D artist, illustrator, art director, and animator. After completing his art studies in Sweden and Australia Steven worked ten years as a freelance illustrator for leading advertising agencies and publications in Europe and Asia. Steven is a co-author of d'artiste Character Modeling and an online instructor for CGWorkshops.

MARK SNOSWELL
MODELING, RENDERING, TEXTURING

Dr Mark Snoswell is President of The CGSociety and founder of Ballistic Media. His diverse range of experiences include: development of Absolute Character Tools (www.cgCharacter.com); development of The Ultimate Human Model set; film production work for Disney and Warner Brothers; production work for National Geographic; and teaching graphic design, 3ds Max and Painter. Mark's background also includes multimedia design and a career in biotechnology R&D.

MATT HARTLE
RENDERING

Matt Hartle is 3D Director at Deva Studios and prior to that was the 3D Department at BLT and Associates. He has worked on movie trailers including: 'Babel'; 'The Prestige'; 'Pirates of the Caribbean 3'; 'Charlotte's Web'; and 'X-Men 2'. He has also done visual effects in films such as: 'Van Helsing'; 'Casanova'; and 'Scorched'. Matt has taught at institutes for animation and visual effects, including: the Gnomon School of Visual Effects; The Art Institute in Santa Monica; and the Academy of Art in San Francisco.

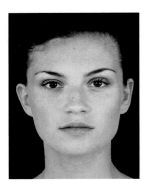

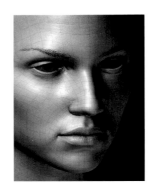

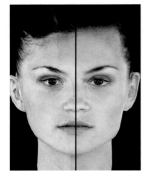
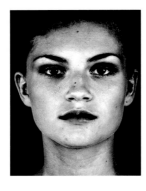

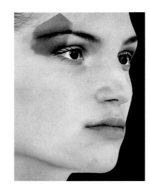
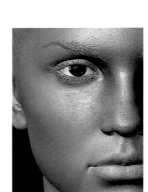

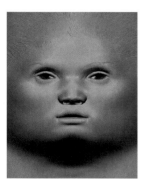
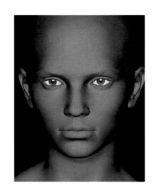
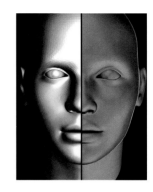
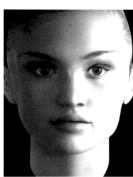
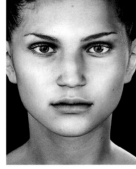
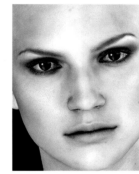
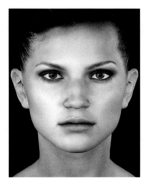
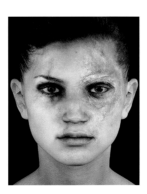
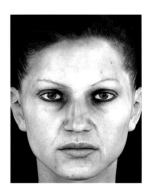

BRINGING IT ALL TOGETHER

This first Creative ESSENCE title brings together a collection of the very finest professional artists with current experience in re-creating digital humans. It represents a new format and a new series for Ballistic Publishing. A series that we plan will become a de-facto resource for professional and aspiring artists around the world. It's been a lengthy processes getting the right mix of assets, artists, and material. This is especially important as we intend to make the core assets developed in the books available on complementary ESSENCE DVDs.

One of the biggest balancing acts we had to manage was how much information we covered and at what level of detail. We chose to aim this series at the mid- to advanced-level artist. We expect that you will know the principals and will have heard of most of the techniques we cover; although you may not have had time to play with all the techniques. ESSENCE does provide a lot of detail and steps, but it's not a complete step-by-step tutorial. In addition to showing you the best of current professional approaches, we will also show you some of the upcoming techniques and tools. So without further ado let's look at what's to come in this, the very first Creative ESSENCE: The Face.

Making photo-real human faces

The most valuable thing you can do as a digital artist is to bring a totally believable digital character to life. We are going to show you some of the best techniques on photographing, modeling, UV mapping, texturing and rendering a believable digital double of our lovely model Monika. A lot of the credit for the material in this first book goes to the remarkable efforts, and talents, of Paul Fedor—artist, director, and former texture guru for Sony in its PlayStation 3 cinematics department. Paul worked closely with us and helped to coordinate a photo shoot with Peter Levius (co-founder of 3D.SK), and modeling by Hong Suck Suh (3D modeler for Sony's cinematic department). Between them they demonstrate the very best of class in preparing models to match photographs, UV mapping and creating baked texture maps. Paul then goes on to show some great tricks for faking believable skin rendering and generating awesome aging and tissue damage textures. We also have Steven Stahlberg (co-author of d'artiste Character Modeling) demonstrating his approach to making, texturing, and rendering photo-real eyes. Finally, Matt Hartle (render guru with film credits on 'Van Helsing' and 'Scorched') shows us some of the best practices for high-end rendering. This team effort results in a world-class model, UV mapping, textures and rendering techniques. The results are worthy of any next-gen game. Given the materials, time and practice, any reader will be able to re-create this work and even take it further. With more time and hand-polishing, the material and techniques will yield work suitable for the very best high-definition video and film output.

Basics, alternatives and the future

I have contributed to this book in a number of areas. I had intended to just cover some basics and a few new techniques, like sub-surface scattering for rendering realistic skin. However, in preparing material for the book I became aware of the vast potential of current and future graphics cards to revolutionize many of the processes covered in this book. What started out as development of a DirectX shader just to show two photographs on a single model, resulted in an extensive shader tool that automates much of the tedium of current map projection and blending.

Complementary assets—community of digital artists

We intend to make the digital assets and tools developed in this book available on a complementary DVD. We also plan to collect a growing pool of new tools, like the shader tools I describe, and make them available to the global community. All of this will be done in conjunction with our online division, the CGSociety. This will be the first time we bring together our publishing division, Ballistic Publishing, and our community, the CGSociety so closely. I hope to meet many of you online—to hear your comments, to see what you do with the material we provide.

Mark Snoswell

Dr Mark Snoswell
Publisher, Ballistic Publishing
President, CGSociety

Ballistic Publishing and the CGSociety are divisions of Ballistic Media.
www.BallisticPublishing.com
www.CGSociety.org

THE PROCESS

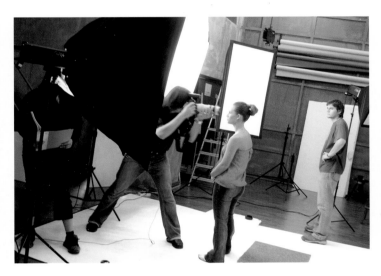

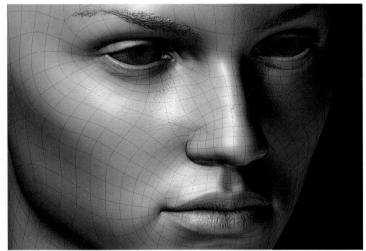

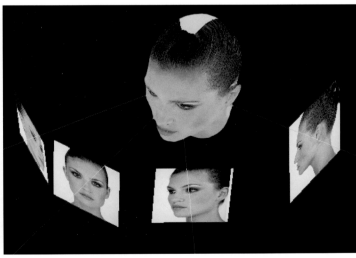

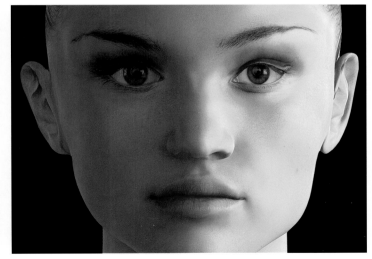

The ESSENCE journey: Starting in a photo studio in Prague in the Czech Republic, our model Monika was captured by the crew at 3D.SK from every angle in preparation for transformation into a photo-real digital character. From there, Hong Suck Suh in California created the 3D model based on Monika's features and passed the model along to Paul Fedor (also in California) who combined the photographs and 3D model to texture Monika—as a beautiful woman, as an aging woman, and finally as an injured and disfigured woman. In the meantime, Steven Stahlberg in Malaysia created the eyes for Monika. The next step was where things got hairy. Creating realistic, shoulder-length, hair is one of the most difficult CG challenges.

There are many variables that affect whether hair looks real, from the styling, to thickness, and the way light behaves when reflecting through hair. It would be no exaggeration to say that our attempts at hair took as long as the rest of the process of creating digital Monika. Due to its complexity, we will cover how to create hair in ESSENCE: Effects—Fur, Hair, and Clothing. For the hair you see on the cover, we have gone with the compositing of Monika's hair from the original photo shoot. While this was happening, Mark Snoswell in Adelaide began perfecting his DirectX shaders to generate and place textures automatically on the model geometry. Finally, Matt Hartle in California brought together the everyone's assets for the final renders.

PETER LEVIUS

PRETTY IN PIXELS
PHOTOGRAPHING FOR CG REFERENCE

Lights, makeup, lights, camera, action

Our most popular reference website in the 3D.SK family of sites is Female Anatomy for Artists. It's fairly easy to guess why as human anatomy is the foundation for most types of fantasy illustration or 3D artworks. The website is focused on figure drawing, anatomy study and posing/rigging of 3D models. For our regular photo shoots, we typically shoot full-body shots of models in various poses from classical figure drawing poses, action fighting poses, moving poses, and requested poses. We prefer to shoot the models with hard shadows.

The Monika photo shoot was for 3D.SK, so the brief was a little different. The assignment was to create reference shots for a glamour-style magazine cover. Adding makeup to the mix provided a big challenge to the shoot so we brought in a professional makeup artist, Gabriela Kleinova, who was able to do some great work.

A photo shoot is a team effort and we had the full 3D.SK team involved including Veronika Jaskova AKA Kristin

(project manager for the anatomy websites and manager of models and photo shoots); Tomas Babinec (project manager for Environment Textures and 3D.SK); and Jiri Matula (photographer).

Diffuse Lighting: Main key light (1000W) is positioned straight in front of the model. We use a soft box (150cm) to diffuse the light. There are also lights on the sides of the model. One additional light is used to lighten up the background as this helps with post-production. For details such as the head, eyes and ears, we also use reflector boards. Contrast Lighting: Main key light (1000W) is positioned on the side of the model and there is another fill light in front of the model. This creates very good shape definition, which is very useful for sculptors, painters and, figure drawing students.

3D.SK has expanded in many directions with several specialty sites including: Female Anatomy (female-anatomy-for-artist.com); Human Anatomy (human-anatomy-for-artist.com); Environment Textures (environment-textures.com); and 3D Tutorials (3dtutorials.sk).

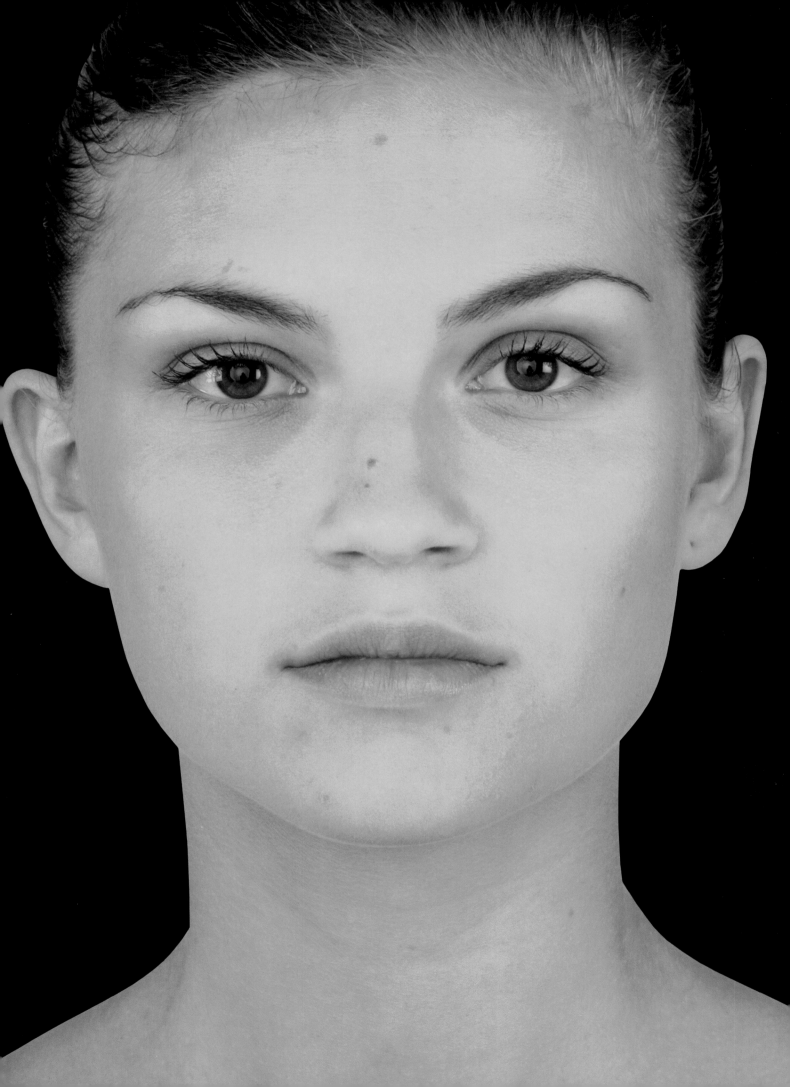

🔻 Step 1: Setting up

I met Monika for the first time a few years ago—she was one of our first models. I chose her back then because of her symmetric and very feminine face. This photo shoot was different to most. We were taking photos only of the head and hair so we expected it to be much shorter than usual. The opposite was true—it took almost seven hours. Because we usually don't hire a makeup artist and hair stylers (we prefer to shoot our models without makeup), we underestimated how much time it would take to create the right makeup. It was also crucial to check everything out under different lights and from different distances.

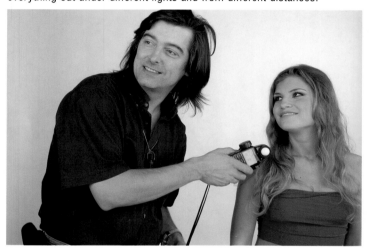

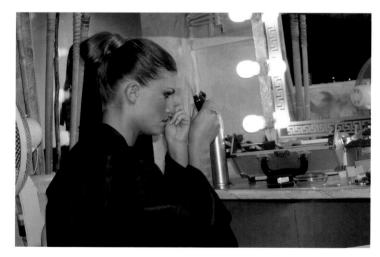

🔻 Step 2: Lighting

After playing with the lighting setup for half-an-hour trying to get perfectly flat lighting, we realized that the problem was not in light but that one side of the face was a few percent in scale darker. This wouldn't be noticeable under normal conditions, but with extreme details and completely diffused light it was different. We were lucky to have a good makeup artist with enough patience and skill to work on the makeup until it was perfect. I think even Monika was surprised how good she looked with professional makeup and good lighting in place.

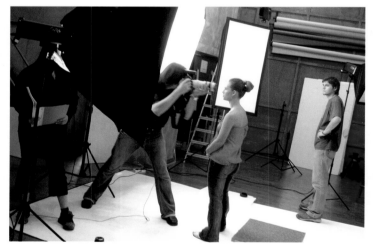

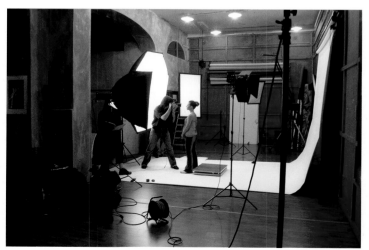

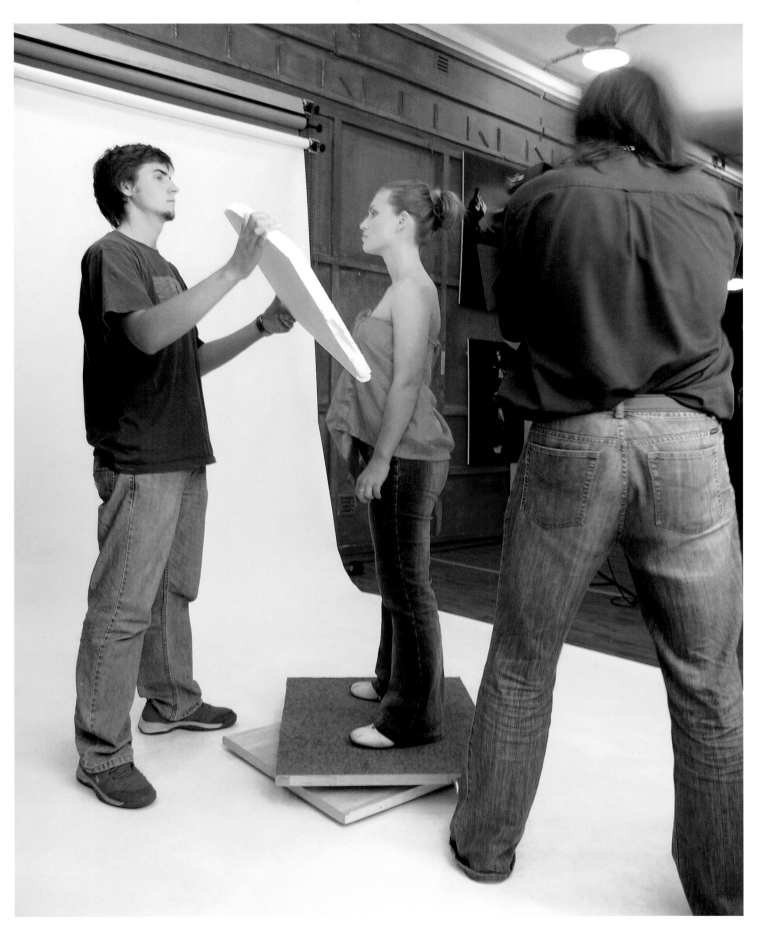

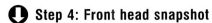

Step 3: Setting up for first shot

This is the very first shot, and it took almost an hour to get this one right. To fine-tune the light intensities, soft-box positions, and makeup require a lot of patience. We took several shots and made small adjustments after each of them. The idea is to get perfect diffuse and even light on both sides of the face which sounds much easier than it is. In the end, we realized there was a slight difference in right cheek makeup intensity, and the lights were set up properly.

Step 4: Front head snapshot

The front head snapshot is the most important photo for head modeling and texturing. We took several shots from the same angle just to be sure we ended up with a pretty good photo. Models are not perfectly symmetrical, and a small movement of the head can result in a different outline of the head and facial features. More shots provide better information of the actual 3D object for the modeler.

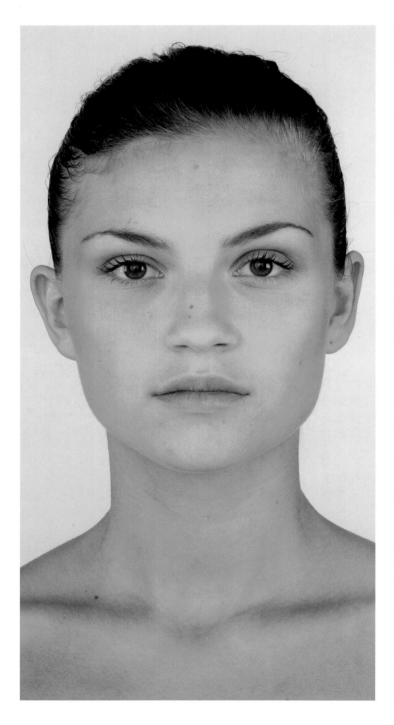

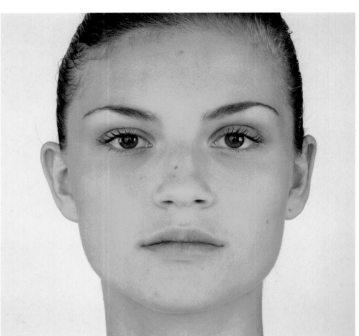

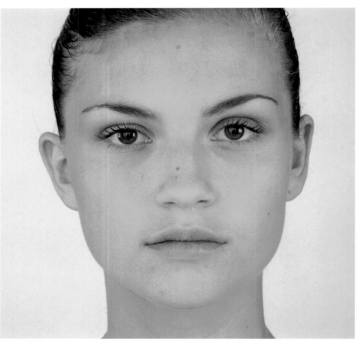

Step 5: Skin structure

This photo is intended to bring more of the skin structure detail in case it is required. It is a pretty sharp photo and at 16-megapixel resolution, there is more than enough detail to use.

Step 6: Photographing the lips

Taking a good photo of lips can be tricky. Lips are naturally glossy, and we don't really want any glossiness in our textures. Glossiness and highlights are always created in the final render according to lighting in the scene, so it looks unnatural to have more sources of highlights. As you can see there is still a little glossiness present in the first photo. Otherwise, it's very sharp and has good detail. As usual, we play with the light intensity and reflection board positions to get different results. Texture artists can then use the best parts of each photo to compose the final texture.

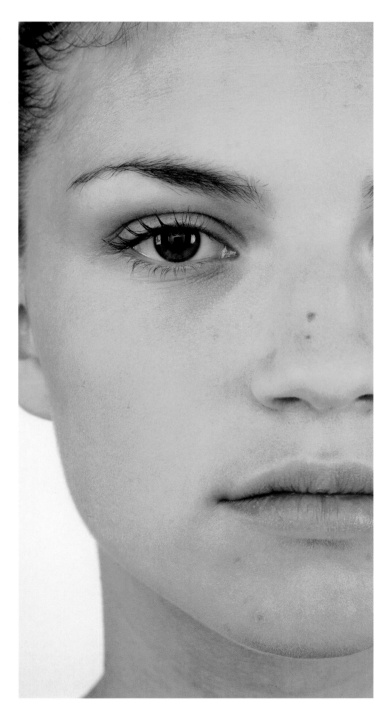

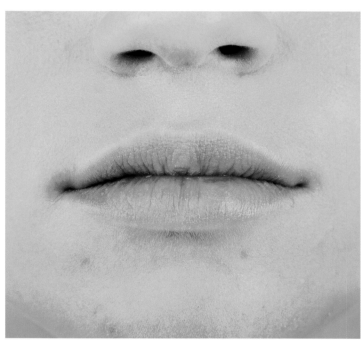

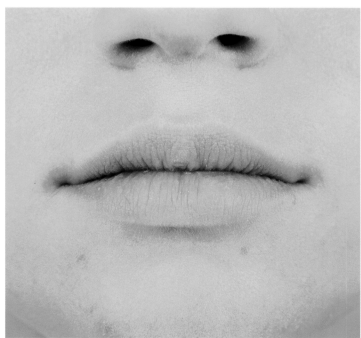

Step 7: Eyelids

Another example of multiple shots of the same object. Eyelids are tricky as there are many facial features like the nose interfering with the light. Notice that the right side of the eyelid on the first photo is darker than on the second photo and vice versa with the left side.

Step 8: Eye socket snapshot

This is the view from below the eye socket. We took up to six of these shots with different light setups as this area is extremely curved, and it is really hard to get rid of the shadows and highlights.

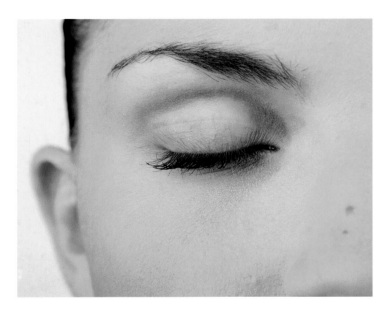

Step 9: Flat texture

Again it's good to compose both photos to create a perfectly flat texture without shadows or highlights. In this case, it will probably require a little bit of hand adjustment in Photoshop to get rid of the small highlights and shadows.

Step 10: Eye detail

This is for detail modeling and can also be used to create a pupil texture. Shooting the eye requires using several different photos and composing it as it is highly reflective, and you can see everything in the studio reflected in it. Have you ever wondered how lights are setup for fashion photography? Just study the eye—the whole light setup should be there. We use lens extension rings to get maximum detail which can be uncomfortable for the model as the lens is only few centimeters from her eye. It also makes the lighting much harder so it's essential to have a big softbox behind the photographer as you'll see it in the reflection in the eye.

Step 11: Different eye positions

These shots are useful to get more details of eyeball, pupil, and lacrimal caruncle as well as for creating the blend shapes for animation. As you can see it is very important to always be aware of the purpose of each snapshot. It certainly helps that I have a lot of experience as 3D character artist and am able to see the results from the artist's point of view.

Step 12: Nose detail

It's necessary to focus on the nose surface instead of the eyes or face. This is a common problem as professional cameras have quite a strong depth of field. I've seen so many bad and blurred photos of this area. It helps if the model is slightly angled forward so the plane of the nose is perpendicular to the camera. Take more shots just in case and check them out after each snapshot. In our studio, we have the big screen which allows us to control each snapshot right after it is taken. Sometimes we spend more time looking at the screen than actually taking photos.

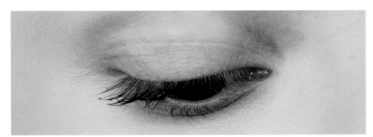

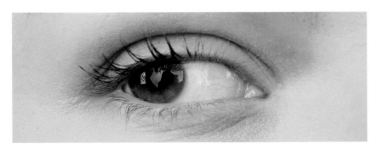

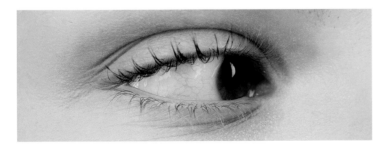

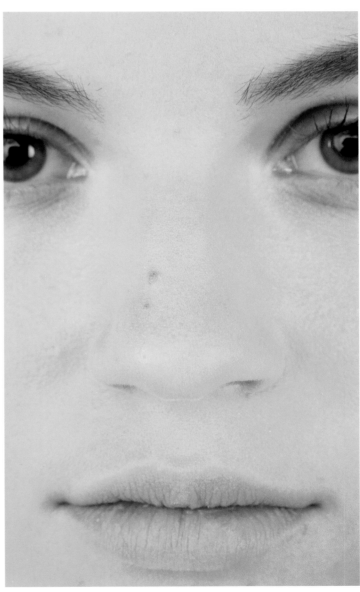

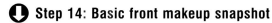

⬇ Step 13: View from below

These shots are useful for getting more information about the shape of the head and facial features such as the nose, chin, and cheekbones. This could also be used for neck texturing, but we take special photos for that purpose with the head angled back even more. As you'll notice there are two versions: with; and without makeup. Even the shot without makeup has some very fine "natural look" makeup. After we finished the photo shoot without makeup we took all the photos that contained lips or eyes again so Paul would have a good selection of photos for both of the textures.

⬇ Step 14: Basic front makeup snapshot

It's interesting how different Monika can look with and without makeup—beautiful innocent girl or dangerous vamp? It's going to be really hard to choose one to use. She is a really good model and looks great in both versions. I could spend hours looking at these pictures trying to decide.

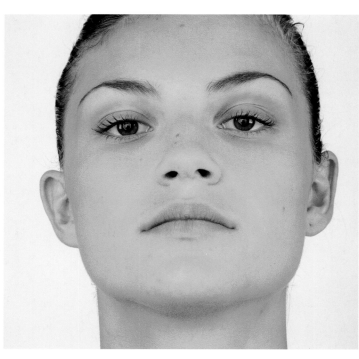

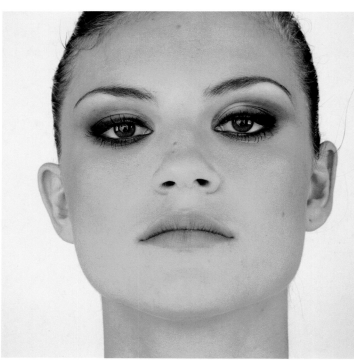

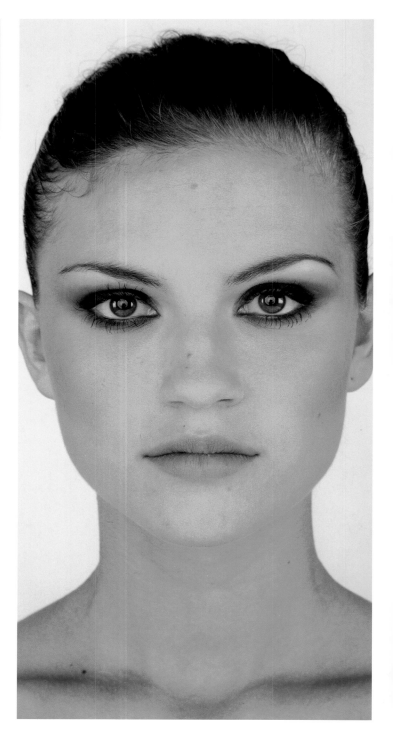

Step 15: Head angled forward

This is one of the basic snapshots we take of the head. It starts with the head straight photo, then head angled forward and backward, 3/4 photo and finally side photo.

Step 16: 3/4 snapshot

This is a very useful photo as most 3D modelers work in front and side viewports with front and side references in the background and have a hard time adjusting the curvature of the cheek bones, chin, lips, and forehead. With this photo they can just rotate the side viewport a little, set up the model in the same position and adjust all the fine shapes. The rule of thumb for taking this photo is that both eyes should be visible. In this case, we took more photos at different angles. These provide a better idea of the 3D shape of the subject. The most important angle would be rotated more to the right so it reveals more of the outline of the face.

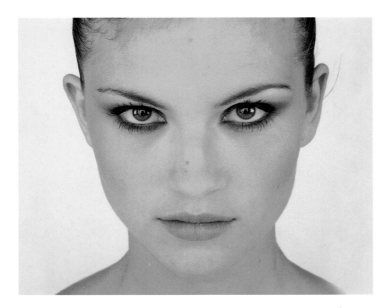

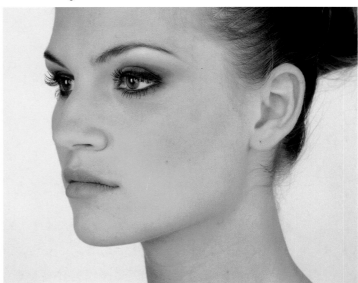

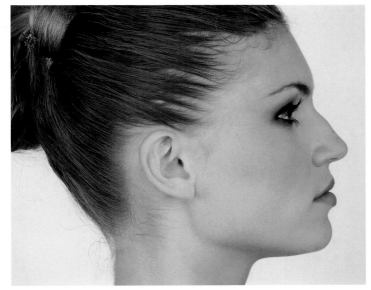

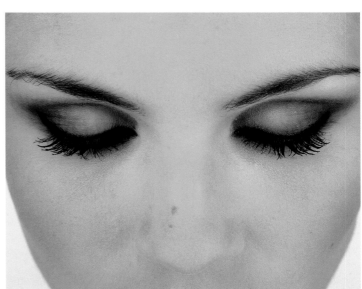

Step 17: Side snapshot

This is the second most important snapshot of the whole photo shoot. Notice that the hair is in a bun so it doesn't interfere with the shape of the head—we will take several snapshots with the unfastened hair later. This snapshot is particularly delicate as it is used for modeling of the basic shape of the head, and even the slightest horizontal or vertical angle of the head could completely change the perceived shape. We take several photos making sure the head is perfectly straight.

Step 18: Eyelids with makeup snapshot

Here is a detail of the eyelids. As you can see our makeup artist Gabina did a great job.

Step 19: Just out of bed hairstyle

As the assignment was to create references for a glamour-styled magazine cover we took some photos with a fluffy, just out of the bed hairstyle and look. It was after long hours of an exhausting photo shoot, but we were still able to have a lot of fun. Our photographer Jiri Matula as well as Monika obviously enjoyed the change of subject, even if they were both tiring at this point after several hours of shooting.

Step 20: Vogue-ready photo

You can see that these photos have great potential. Considering that they are the raw un-retouched photos the results are fantastic. Because of the extreme light conditions the forehead wrinkles are pronounced, but this would take only a few minutes for an experienced Photoshop artist to retouch the small details, and adjust colors and contrast. From there, the photo could go straight on a Vogue cover.

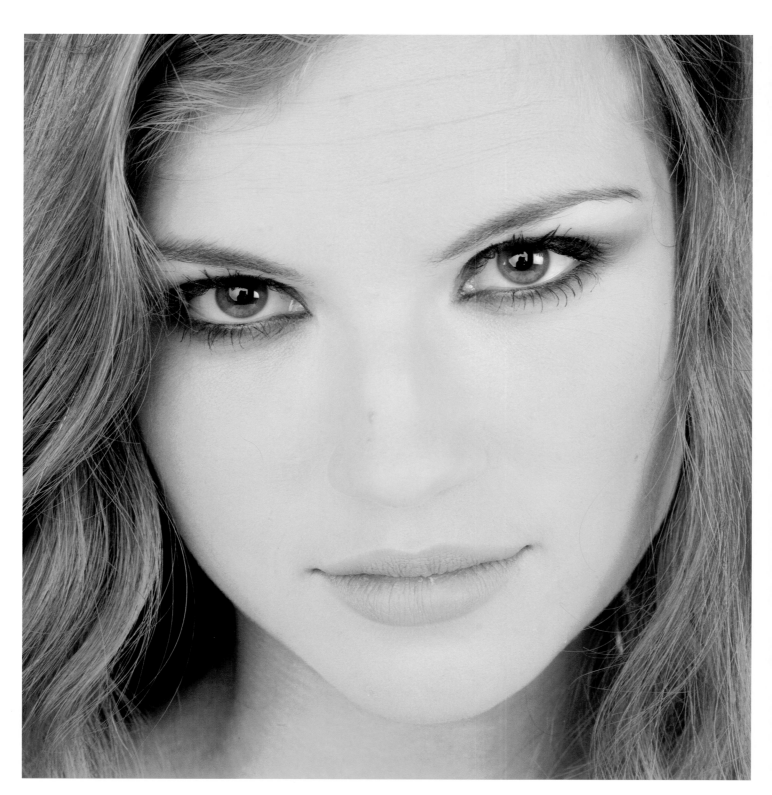

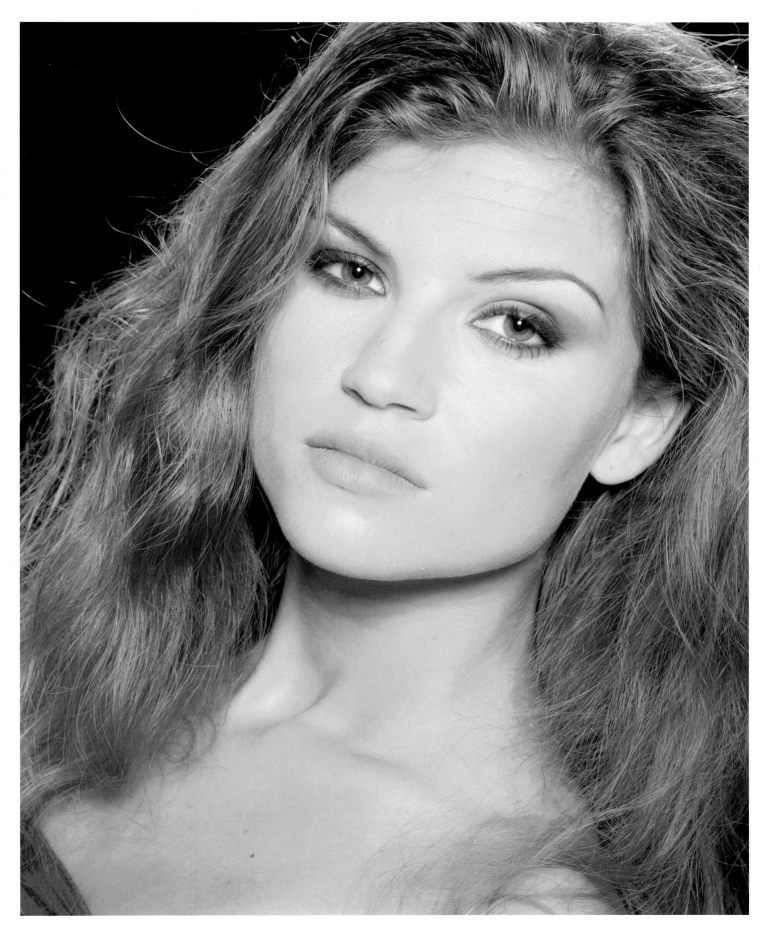

HONG
SUCK SUH

ABOUT FACE
MODELING THE HUMAN HEAD

Modeling from photo reference

The first thing to know about modeling the human head is what makes a face look different whether it's age, gender or race. It's then a matter of concentrating on catching all of the unique features of the reference or what you want the model to look like. It's also important to remember that no model will look right without some knowledge of human anatomy.

Creating a human head is pretty simple, but the hardest part is matching and adding characteristics to the model. Small changes can make the model look completely different, and sometimes it's hard to define what makes the model look odd or right.

When I do my personal work, it takes an endless amount of time to finish a single head model. It will always look different from day to day, and I'll constantly see things that need to be fixed. This is because the creative process is dependant on my mood and environment. Usually, I'll watch a movie or listen to music which is related to the character while I'm modeling. This keeps my mood even and that helps me to pull out characteristics from the model. It usually takes me less than five hours to complete the head modeling.

Another way to simplify the modeling process for me was to create my own tools. A couple of years ago, I created a tool which helps me generate human characters in order to speed up my modeling process. The tool generates UVs, multiple levels of geometries, and adds fine details to the model automatically. Each level of detail also contains around one hundred facial blend shapes. This helps me build basic features of the human head with a couple of clicks and lets me concentrate more on giving life to the model. The tool is not only for modeling, so it can cut down production time on texturing and animation work as well. This allows the texture artists and animators to concentrate more on the creative side of their craft. .

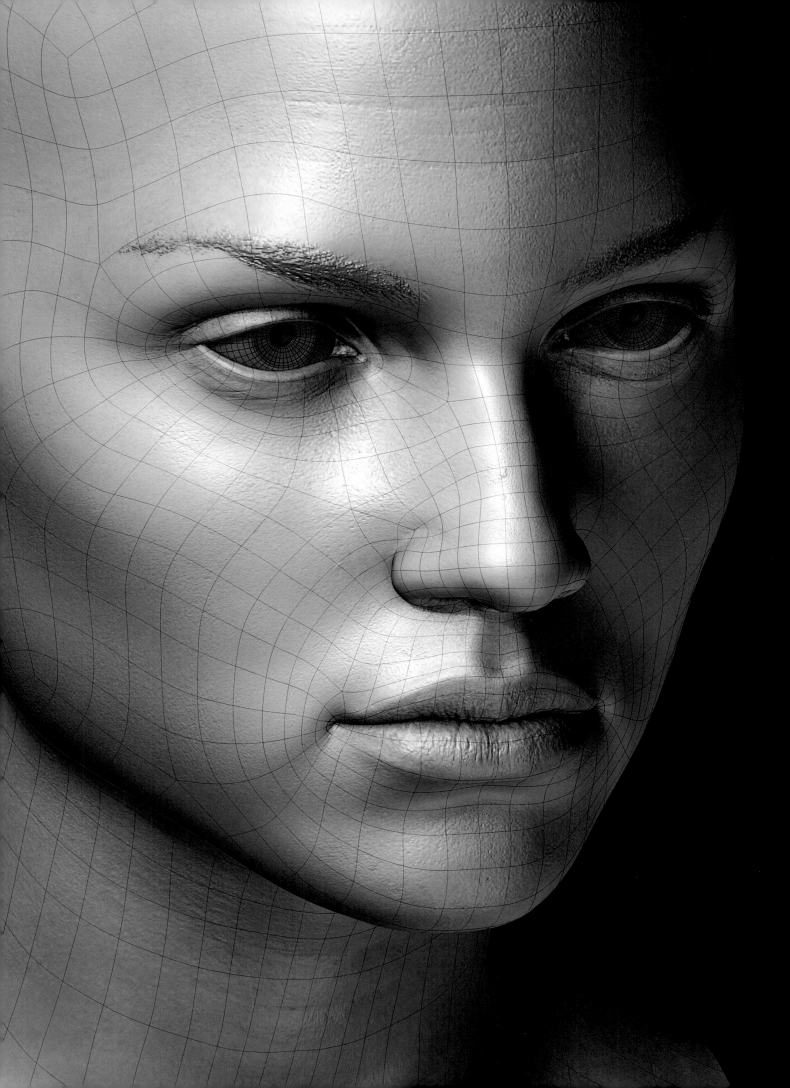

Step 1: Wrinkle lines

When planning the structure of the model, the first thing that comes to mind is the direction of the muscles. It is best to consult several different facial expressions of the subject and catch the direction of the wrinkle lines before designing the appropriate structure. Usually, there are no huge differences between the direction of the muscles and wrinkle lines, but when designing an aged character, they do not match in many circumstances.

Step 2: Designing the line structure (Face)

Optimizing lines clears the unnecessary lines and makes it possible to build the model with less geometry. It also makes the animation of the facial expression look more natural. This structure was designed considering the chin line, and direction of the muscles based on the direction of the wrinkle lines. All the lines are square structures and follow the basic structure of the Nurbs Patch Modeling.

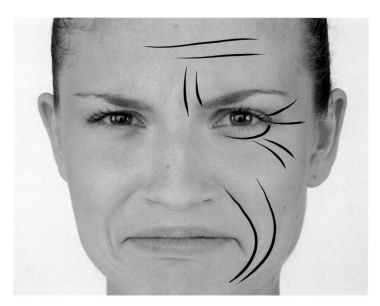

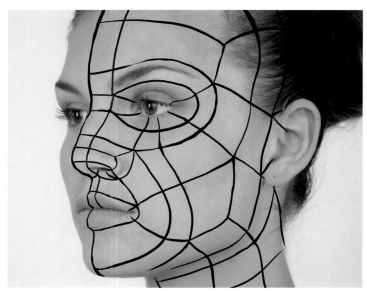

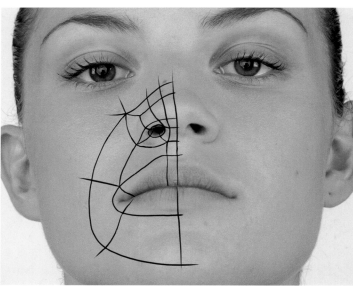

Step 3: Designing the line structure (Nose & Mouth)

Squeezing the lines on the corner of the mouth gives enough lines to create open mouth shapes for facial blend shapes. On the nose area make sure the line follows the wrinkle which starts from the side of the nose and ends at the chin.

Step 4: Designing the line structure (Ear)

The structure of the ear is very complicated. There are many different approaches to modeling the ear, but with this model it was drawn to simplify the lines.

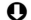

Step 5: Do I look fat in this model?

This half model was built by connecting the faces based on the structure that had already been designed. For reference, when matching the model and photo (usually in the Orthographic front view), the length between the cheek and the ears is better to be measured a little bit wider than the actual photo. This is due to the photographic distortion based on the visual angle. It is normal for the model to be slightly fatter than the actual photo.

Step 6: 3/4 view

Generally, it is better to choose the size of each face and build them in square form. Try to avoid making any sudden changes such as the rectangular form shown on the neck area.

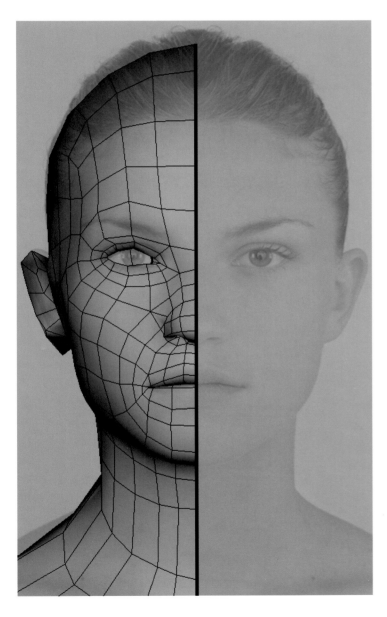

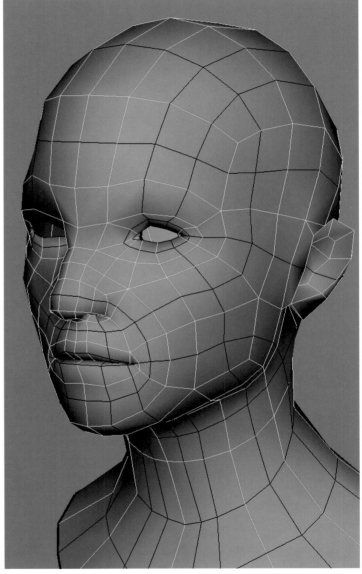

⬇ Step 7: UVs

When the low-level model is complete, the next step is the UV. It is more effective when the UV work is done at the lowest level. This enhances the speed of the working process and compatibility when the UV is modified at a higher level of detail.

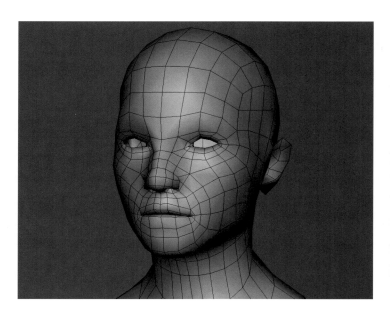

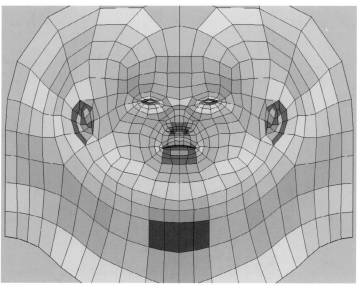

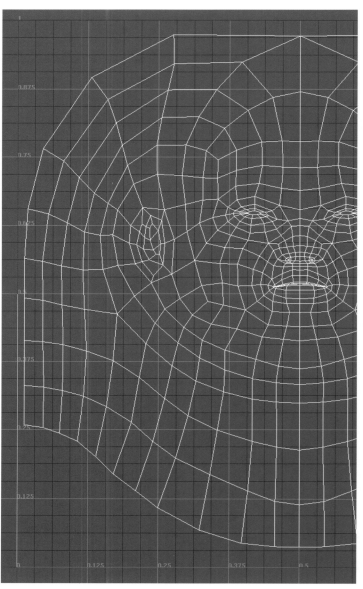

⬆ Step 8: UV distortion

This is the picture of a model that has been imported into a tool called UVLayout (www.uvlayout.com). UVLayout unwraps the UV by minimizing the distortion and makes the adjustment easier by showing each UV's distortion level in colors.

⬆ Step 9: Completed UVs

Lastly, we bring the model back to Maya to readjust the Seam part, and the parts which UVLayout did not cover. The UV process is then complete.

🔴 Step 10: 1st level poly model

This is the base-level cage model. I get to the more detailed models through subdivision and adding details. The model at this stage has 1,116 triangles.

🔴 Step 11: 2nd level poly model

More details have been added at the second level. Most of the facial blend shapes are built using this model. The model at this stage has 4,464 triangles.

🔴 Step 12: 3rd level poly model

This level of detail is used mostly in the final rendering process. If there is a facial blend shape that needs more detail, I use this model to build additional blend shapes. The model at this stage has 17,856 triangles.

🔴 Step 13: 4th level poly model

The 4th level poly model is created for specific scenes requiring more detail. For whole modeling work up to this stage I use Maya's Soft Modification Tool and my self-developed tools. Typically, it takes me approximately five hours to complete the whole modeling work in Maya. The model at this stage has 71,424 triangles.

⬇ Step 14: Detailing in ZBrush

After the color texture map is completed it is used in ZBrush for the detail work. Usually, the color map is converted into a grayscale map, and then imported as a Masking map in ZBrush. Retouching is then done to the model. This process takes only several minutes, but makes it possible to achieve fine wrinkle lines and even the expression of the skin pores.

⬇ Step 15: The ears

The ears are the most complex shapes on our face. Fortunately, most ears have much the same structure. Once you understand about the basic structure of the human ear, it can then be done quite easily every time.

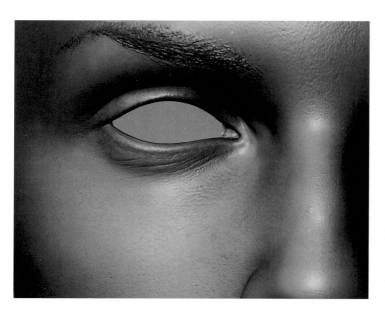

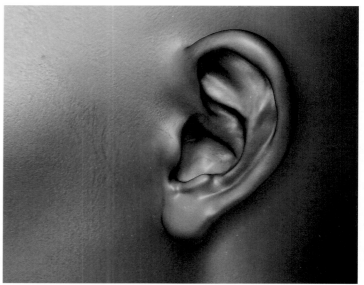

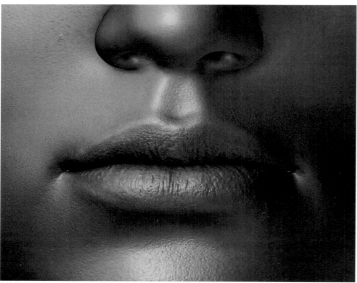

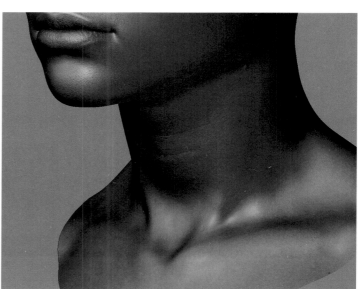

⬆ Step 16: The mouth

The side of the mouth area is a little hard to make a clean shape because a lot of lines are squashing into that area. It's better to spend some time on cleaning up at this stage in order to avoid hard work on making facial blend shapes later. Also, don't forget to check the thickness on the inside of the lips.

⬆ Step 17: The neck

The neck muscle doesn't show up too much in a neutral pose. A little bit of exaggeration of the muscle helps the model look more real.

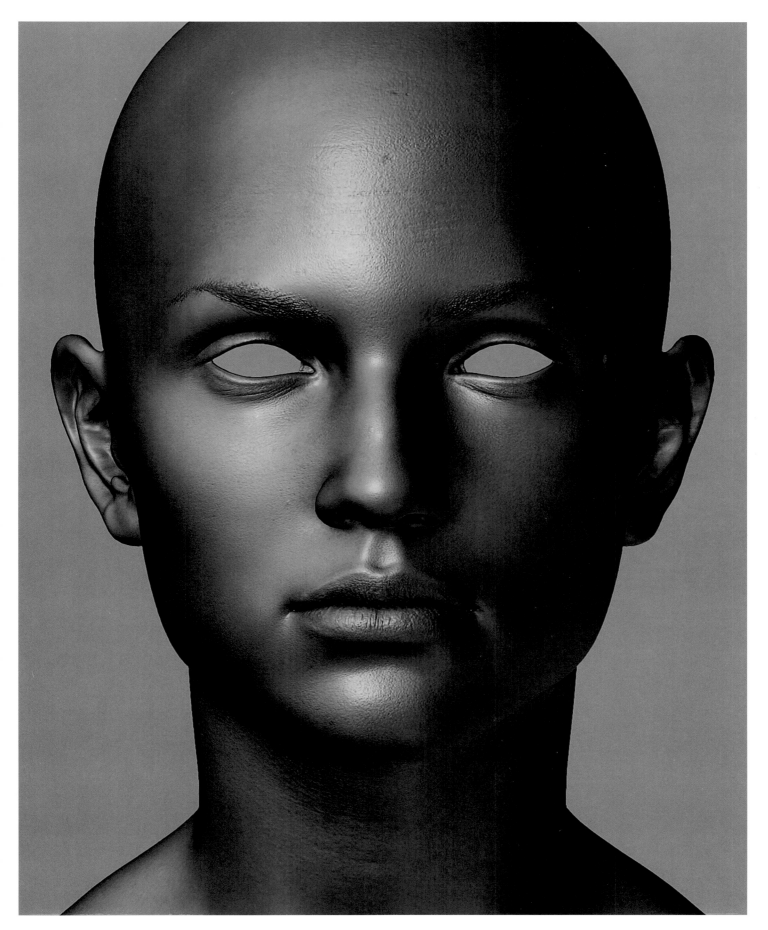

⬇ Step 18: Normal map

This is the Normal map that has been generated using the detail information from ZBrush. This detail information can be used in various methods, such as Normal, Displacement, Bump, and Cavity maps. For this example I will show the process using only the Normal map and Cavity map.

⬇ Step 19: Cavity map

This is a Cavity map which is generated using the detail information from ZBrush. The Cavity map will be used for the Diffuse map in Maya.

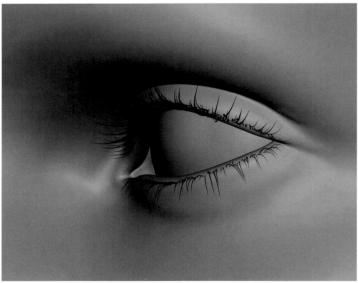

⬆ Step 20: Eyelashes

There are several ways to create eyelashes but for this process each strand of lash was drawn and implanted using Nurbs tubes.

⬆ Step 21: Eye wetness layer

A wetness layer along the lower part of the eye is a detail that is so small it is difficult to see, but numerous small details can be combined to create a character that looks more realistic.

Step 22: Final model

This is the final render in Maya using the 4th Level of Model with Normal map and Diffuse map. It's now time to hand the model over for texturing.

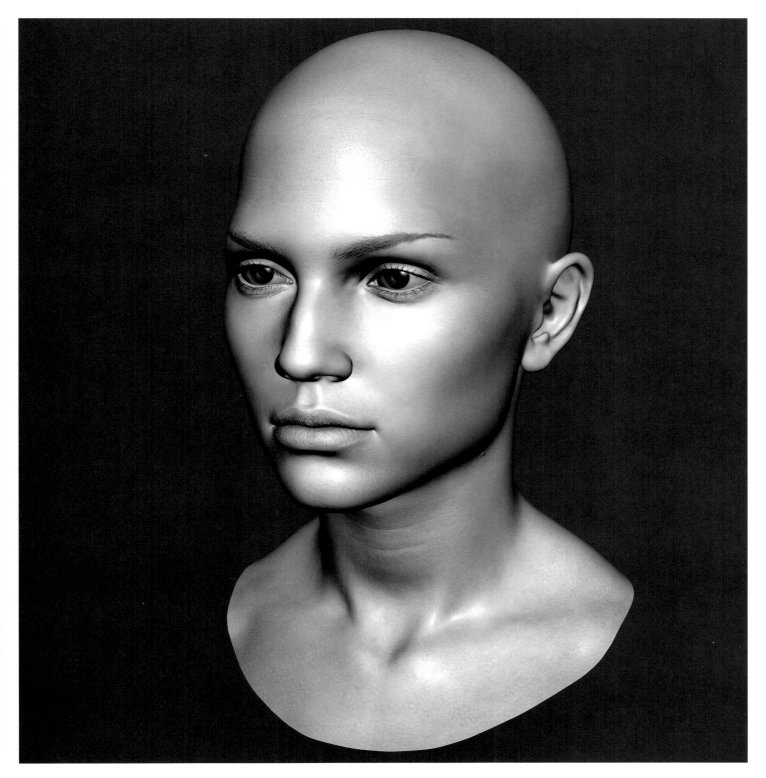

MARK SNOSWELL

PERFECT HEADS
UV MAPPING

Perfect generic models and UV mapping

There are five main stages I recommend for creating a photo-real, textured 3D model. They are: generic modeling; photography; UV mapping; detailed model fitting; and texture generation. You can group the four steps into two stages: generic modeling/UV mapping and detailed photography/texture baking/model refinement. The first two steps, generic modeling and UV mapping, are basic characteristics of a head model and are independent of any actual textures or detailed face morphology. This is what we will cover in this chapter. We will look at combining the photography, model refinement, and texture baking in the next chapter.

Generic modeling and UV mapping share many of the same goals: use quads for optimal subdivision; have smooth edge lines that follow the contours of the face; have even shaped and sized quads (maximum relaxation within the surface shape); and have detail where it is needed around the eyes and mouth. Ideally, your head shape and mapping are based on the average human mean shape so you can later plug it into a parametric head program to change its shape to any human head.

UV mapping involves generating mapping coordinates for each 3D vertex. As the 3D vertices have XYZ coordinates, the texture's coordinates are named UVW. While it is possible to paint totally in 3D and ignore all details of UV mapping, this is very inefficient. We need to pay the same attention to the quality of the UVW mapping as we did to the XYZ modeling.

All 3D models are broken down into triangles at render time. This is because a triangle is a minimum definition of a plane area. A triangle in 3D space can always be viewed flat-on for the purpose of placing a 2D texture on it. It's possible to convert any 3D shape, no matter how complex, into a flat shape by taking all the triangles and laying them out within a rectangle. So, no matter how complex a 3D surface is we can always cut up our texture into lots of separate triangles and pack these into a rectangular map for texturing. This will always work, but it's messy, wasteful of space, and creates lots of technical problems blending the edges of all those triangular texture pieces.

The goal is to come up with a minimum stretch, maximum connectivity mapping from 2D (UVW) space to 3D (XYZ) space. Ideally, the 3D mesh and 2D UV mesh have the same topology. There are a number of ways to approach this problem, but one of the most successful ways is pelt mapping. In this procedure, you think of the 3D model as a skin you want to cut open and stretch—like real-world pelting.

Finally, you want to consider the use of 2D texture and how it maps to your 3D model. As humans, we focus on the front of the face—the triangle between the eyes and mouth in particular. Your UV mapping should reflect this natural focus and give preference to this region.

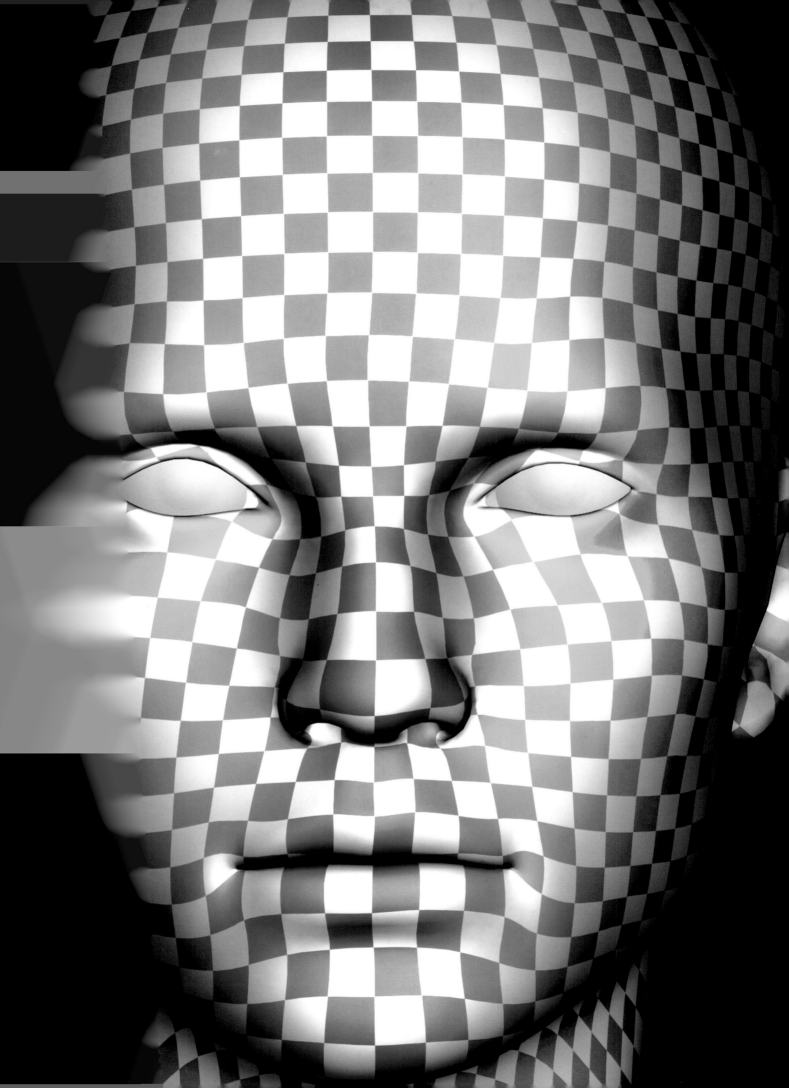

⬇ Step 1: Mesh triangles

We like to build quad meshes that subdivide optimally. However, the 3D object is always reduced to triangles at render time. Here, we see the triangular faces that make up the quad mesh in the selected region. When initially modeled, the 3D vertices have position coordinates and connectivity information. What is missing is a matching set of UV coordinates so we can map 2D textures onto the 3D model. The trick is to generate a set of UV coordinates with the same topology as the 3D mesh with minimum distortion from one to the other.

⬇ Step 2: Efficiency

We could just lay out every triangle separately in UV space, but this is very inefficient and leads to shading difficulties. Here, I have focused on one small section of the nose that is already UV mapped. I have broken one vertex apart in the UV view and pulled the resulting set of UV coordinates out a bit. As you can see, this results in one 3D vertex requiring eight UV coordinates—one for each triangle that touches that vertex. Ideally, we want one UV coordinate per 3D vertex which we can only achieve if the UV mapping is laid out with the same topology (connectedness) as the 3D mesh.

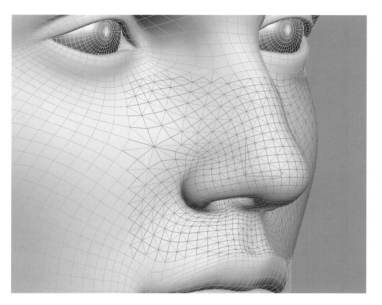

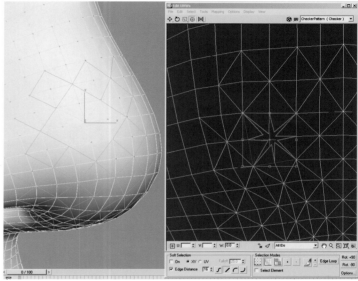

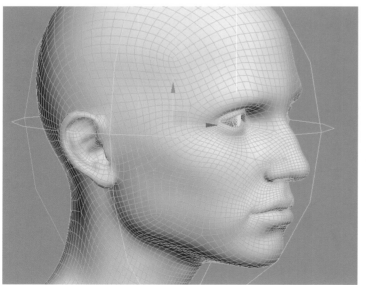

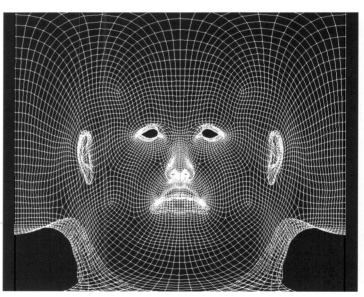

⬆ Step 3: Standard UV mapping

Every 3D system provides some basic ways of generating UV coordinates. For a face, spherical projection (with some squashing of the projection) does quite a good job. To get the best from spherical mapping, position the seam (green line in the gizmo) down the back of the head. Position the gizmo right between the ear holes and then scale it to fit the front of the face optimally.

The result of a well-placed spherical projection map is pretty good for the face. You can enhance this if you temporarily apply a Spheriphy and/or Relax modifier (3ds Max modifiers) to your head. As we will show later, you can then continue to manually clean up the mapping in UV space.

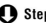

Step 4: Problem areas and edge distortion

In the close-up of the eye region, we see lots of overlap—which we can't have. We need to have a unique area for every triangle (unless we deliberately want to reuse the same 2D texture in many places). This display from 3ds Max's UV unwrap utility is also color-coding edge distortion—green is good and red is bad. So this simple mapping has overlap and distortion problems.

Step 5: Getting ready to relax

One approach to fixing the problems of overlapping and distorted UV mapping is to treat the connected UV coordinates as if they were a mesh and apply an iterated solve to "relax" the "mesh". The goal is no overlaps and minimum distortion from the 3D mesh. In the first step we select the edge of the mesh around the eye—this is not seen as it's on the inside of the eye so we can, in the next step shrink it to a point.

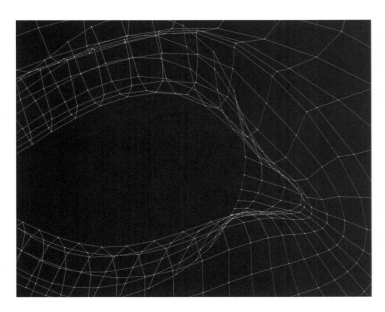

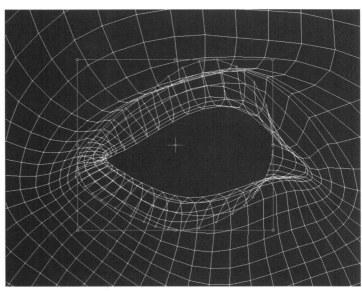

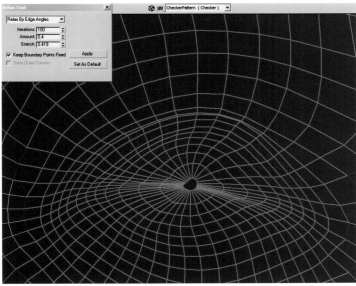

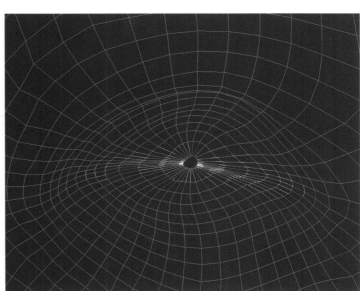

Step 6: Shrink and relax

We set up by selecting the UV verts around the edge of the eye mesh—these verts are on the inside of the eye. Use a soft selection and shrink them right in. Then we run the relax using face centers on the region surrounding the eye. Note, that you have to set a theoretical stretch factor for the simulation to work properly. The stretch tells the solver that the "mesh" starts out stretched. You can be heavy-handed with the relax at this stage. Face-centered relax is crude, fast, and effective in pulling things apart, but it won't give minimum distortion results.

Step 7: Reviewing the results

The UV Unwrap tool we are using in 3ds Max has an excellent display option to show edge distortion. Using this display option we see that most of the eye UV maps are still badly distorted—this is compared to the 3D mesh. In principal, we have followed the right steps but we would get a better result if the inner edge of the eye had not been shrunk so much, and if it better reflected the shape of the eye.

Step 8: Creating seams for pelting

There is an alternative to starting with coordinates generated by standard UV projection methods: pelting. Think of the 3D mesh as a real skin that you want to slit open and stretch out, just like an animal skin. As a first step you need to define any seams along which your model will be split open. For a head, a single seam is all that is needed. You specify pelt seams in the UV Unwrap modifier at the edge sub object level in 3ds Max. You can see the seam marked in blue here.

Step 9: Working with low-res meshes

To get the best result from the pelt simulation you want to start with a minimal mesh. Fortunately, Hong modeled our head at low resolution and built in detail at each successive subdivision step. The full set of detailed meshes can all be packed into one HSDS (Hierarchical Sub Division Surface) or into Edit Poly/Mesh/Patch modifiers in a stack. This means that we can work on the base mesh and every change—like UV mapping—will be propagated to the higher resolution meshes correctly.

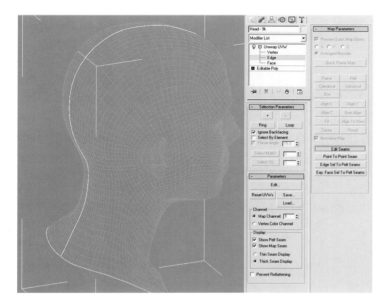

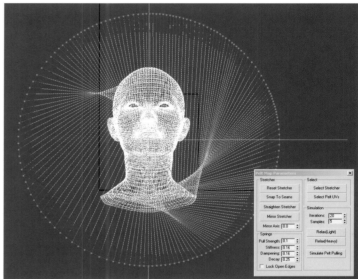

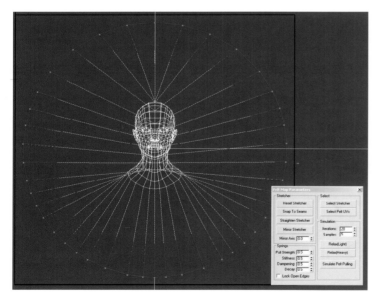

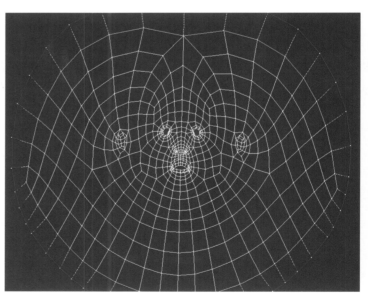

Step 10: Shrink, pelt, relax and repeat

A tip here is to shrink your UV faces to a really small size so the pelt simulator can pull your mesh apart successfully. It can take a lot of playing around to get it to work. You will have to run a relax periodically followed by the pelt simulator again. Fortunately, this is fast to do. As soon as you are happy with the result you should exit out of the pelt mapper and continue refining your mapping with the Relax tool targeting face angles and edge angles as required.

Step 11: Was it really worth it?

Pelt mapping can be the answer to your prayers. Unfortunately, it's more likely to be a descent into mapping hell. You have to be heavy-handed to get pelting to work at all. You have to toggle between heavy relax and pelting repeatedly. Try it. Be quick about it, and if it doesn't work or if it doesn't give you significantly better results than spherical mapping then don't use it! Even if it does work well, you will still have to refine the mapping.

Step 12: Final UV map tweaking

As a final step, you should refine the mapping in two stages: soft selection and symmetrically scale parts of the UV map while watching the distortion display; followed by selection of regions and relaxing them with face angles and edge angles as goals. The distortion display is updated in real-time. Your goal is to minimize distortion (green) around the front of the face while making that portion of the UV map as large as possible without distorting the overall map. This final hand-tweaking stage adds a lot to the final quality of the UV coordinates you generate. The minimal distortion in this UV map is about as good as it gets.

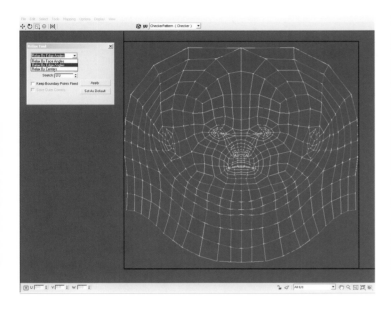

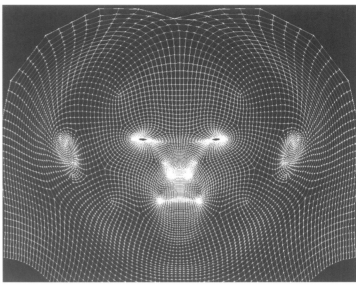

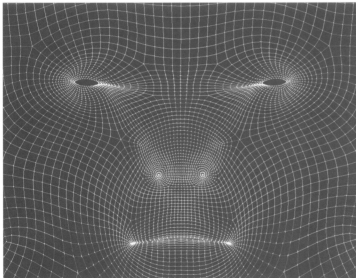

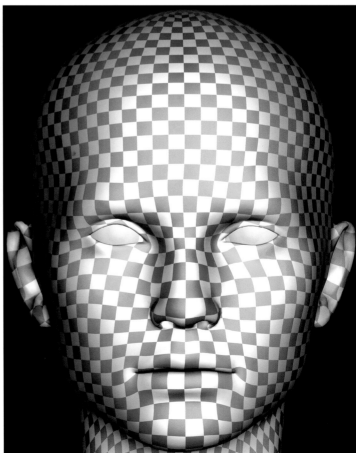

Step 13: Final check

As a final check, apply a gradated grid or checker pattern, and check the smoothness of the mapping. UV coordinates are a fundamental part of your generic head model, and you should get them as perfect as possible. This is the final result on our head model which already matches the average human morphology and is now ready to input into an application like FaceGen which will then automate the bulk of the retargeting we will ever need to do—including automated photo-matching.

MARK
SNOSWELL

PERFECT FIT
MODELS AND MAPS FROM PHOTOGRAPHS

Model fitting and projection mapping

With a good generic model and UV mapping, we can move on to combining the photographs into a single texture. First, we need to alter our generic model to match the photographs. Hong Suck Suh and Paul Fedor show the best practice for doing this in the traditional way: modeling by hand with the photographs as a reference and then morphing the photographs to fit a plane projection onto the model. I will show an alternative approach here, and highlight advances that can be achieved with some DirectX shader tools that I have developed for blending multiple photographs onto one model.

In the first step, I use FaceGen to generate a fitted head model using the front and two side photographs. I do this on the 2K version of the model from which I know all changes can be easily propagated to the 9K and 36K models. FaceGen is a parametric head modeler from Singular Inversions that we will take a close look at in the chapter on 'Parametric head modeling'.

There are several approaches to combining photographs onto a modeled head, but all of them share one common element—the projecting of the photographs onto the 3D head using one UV (projection) mapping per projection and rendering out (called unwrapping or baking) the projected photograph to the desired (unified) UV mapping. You repeat this with photographs from many angles and combine all the unwrapped photographs. There are a number of approaches to the core problem of accurately projecting, warping and combining the source photographs:

1. You can leave the model as is and warp the photographs in Photoshop to fit the projected mapping. You can also do this in your 3D application where you'll get the benefits of floating-point color representations and a richer set of 2D warping tools than in Photoshop.

2. You can temporarily alter the model to fit each projected photograph (this does not alter the target UV mapping), render out the unwrapped photographs and combine them all in 2D and apply them to your original 3D head. This approach has the benefits of doing everything in the floating-point color space in your 3D software. An even bigger benefit is that there is a far richer set of tools for warping a 3D model than you can possibly get in any 2D software like Photoshop.

3. You can alter your 3D head model to fit all of your projected photographs, unwrap and combine your textures which you then apply to the refined 3D model. Your model now fits the photographs as precisely as possible and you get the best quality texture possible. This is the best overall approach, but it requires a very good fit of the projected photographs to the model.

Whichever method you use, you will have to color-match the individual unwrapped photographs. This has to be done by hand and in small pieces—even with consistent lighting there are color variations. The relative color and luminance will vary across each photograph as a function of the diffuse, sub-surface and specular properties of the skin.

I will show solutions to both the color-matching and accurate projection problems which make the third approach both the easiest and highest quality. For this chapter, I developed a DirectX shader that was meant as a tool for displaying multiple projected maps concurrently on the one model. The shader development went so well that I was able to add an automatic tone-mapping function that does a perfect blend of all the projected photographs in real-time and at every pixel. As you'll see the results are astounding!

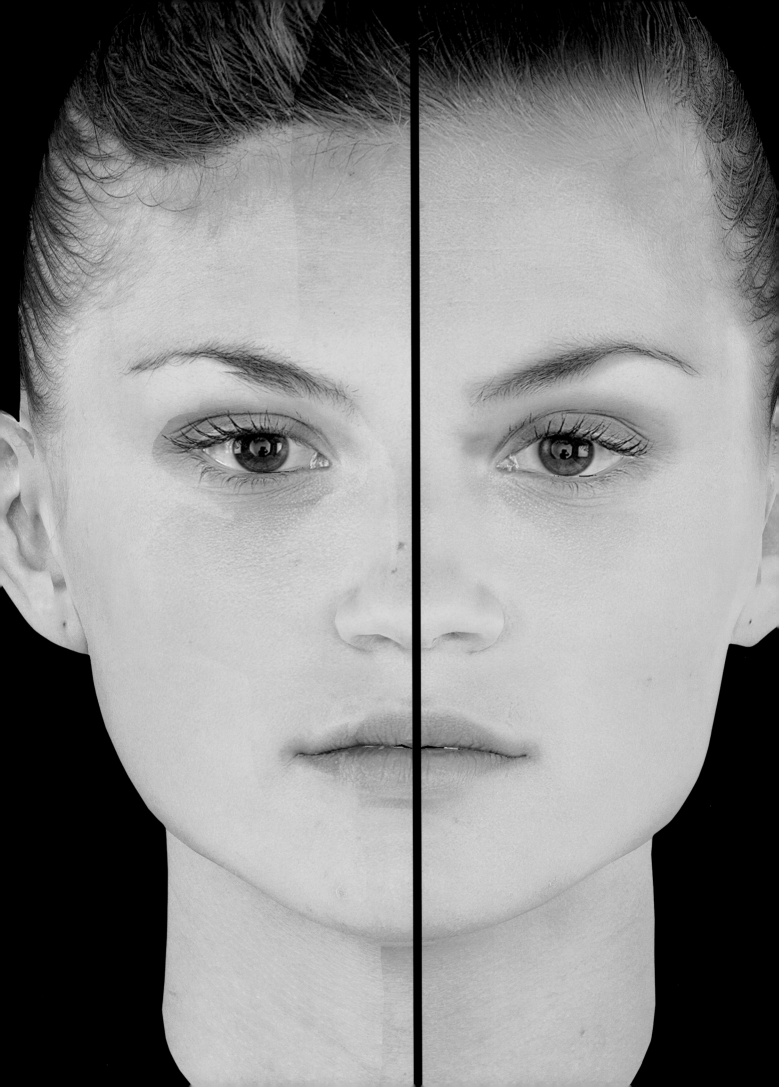

Step 1: Photo fit with FaceGen

FaceGen is a parametric head modeler based on principal component analysis of a large database of human heads. As such, it is free from any user (or programmer) bias and is mesh-independent. I used the FaceGen Customizer to generate a version of our head model to import into FaceGen. Generating a fit to a photograph is an easy process that takes just 10 minutes or so. The fitted head is parameterized and can be applied to any topology head model. Once fitted, the head mesh is exported out to obj format and brought into 3ds Max for the next step.

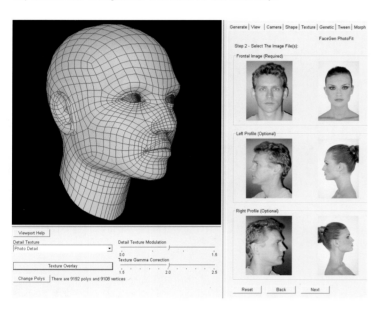

Step 2: Projection mapping good. Planar mapping bad

Photographs should be projected back onto the model with the same camera optics that they were taken with. The correct mapping method is projection mapping. Flat (planar) mapping is wrong and leads to quite large errors—the whole front of the face being incorrectly enlarged. This leads to problems like Paul found with the ends of the eyebrows stretching out and down the side of the head. If you use projection mapping, then matching up all the photographs to the one model becomes relatively easy while flat mapping will always get it wrong and generate a lot of fix-up work for you to do! Projection (left) and flat mapping (right) results.

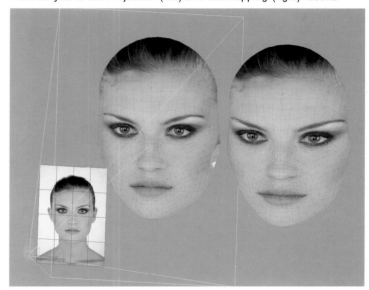

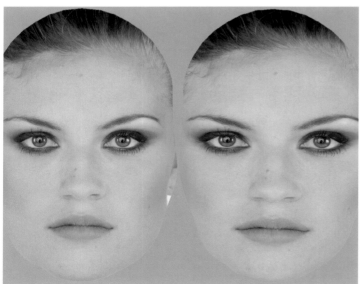

Step 3: Correct camera mapping

From the front, we see the errors flat (planar) mapping makes when projecting onto a 3D surface. The front of the face does not have a lot of depth compared to the distance the photograph was taken from. However, the distortion in the flat mapping is obvious. Compared with photographs and the correct projection on the left, the flat mapped projection looks quite different—rounded and fatter. In 3ds Max, projection mapping is not available with any of the UV Map modifiers. Instead, it is available with the World Space, Camera Map modifier.

Step 4: Getting started

The first task is to bring the photographs and model into the one file and do a rough (by hand) camera match for the photographs. The more information you start with the better. You should use un-cropped photographs. This at least tells you where the camera was pointing—right at the middle of the image! Next are the camera optics. Fortunately, modern digital cameras save a lot of meta data with the file. Examining this information (File > File Info in Photoshop) tells us what the lens settings are for every photograph—eliminating lots of guess work for us.

Step 5: Shots, angles and color matching

I will be using just four shots for the rest of this chapter. This is due to current limitations in DirectX 9. Whatever approach you use, you should select the complete set of images you are going to use and name them consistently. Most importantly, we need to make sure that the overall tone mapping is consistent among the photoset we are going to use. With the methods developed here, this will improve the per-pixel automatic tone-mapping methods. For the same reason, it is also important to select a set of photographs that are roughly equally spaced around the head—which gives full coverage as well. Ideally, this is at least the basic set of 10 shots—eight shown here plus top front and under chin (not shown here). You can get a lot of camera information from the File > File Info utility in Photoshop. Using this information the photos could be matched. Unfortunately, these settings (exposure, brightness, contrast, etc) were applied in-camera on the raw data before gamma correction. It's not straightforward to apply the back corrections plus Photoshop is weak at accurate tone-mapping. An acceptable compromise is to select the skin regions and use Photoshop's Match Color adjustment to match all the photos to one selected master. Here, we see the resultant set of images we will be using.

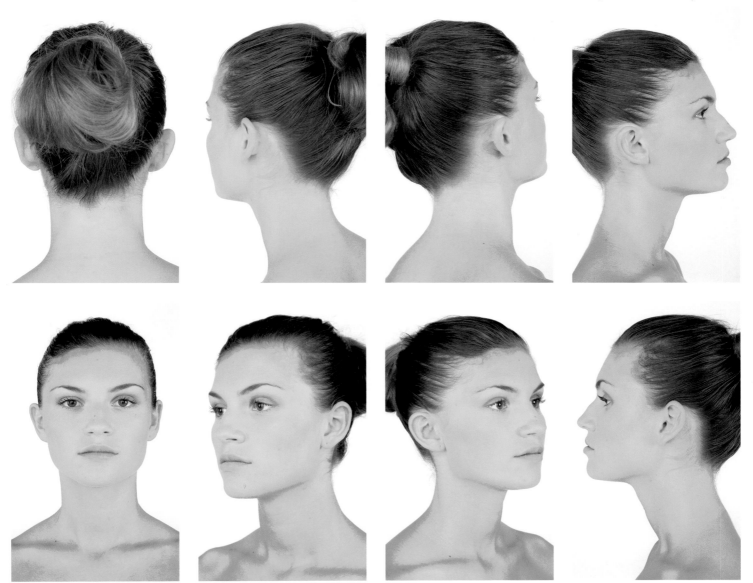

Step 6: Overview—a new DirectX Shader tool

I am skipping ahead a bit here to give an overview of the file setup. Here is a screenshot from very early on in the process. I have just done an initial, rough, camera line-up for four photographs at this stage. Here, you see the four photographs (2K resolution) and the model with the photographs projected onto it in the center. On the right you can see part of the interface for the DirectX shader tool that is doing all the work. It is taking in: eight images (4 x 2K photographs plus 4 x 2K smoothed photographs); four lights (used to indicate camera locations); six UV map channels; and the vertex color channel. It's combining all of the incoming information in one pass in real-time and outputting a balanced and blended map. There is no blending of maps where they join—they are joined with hard cuts—as you can see the match is already looking remarkably good. The shader can also output the unwrapped 2D maps in real-time. The patch of green on top of the model is where there is no camera data available.

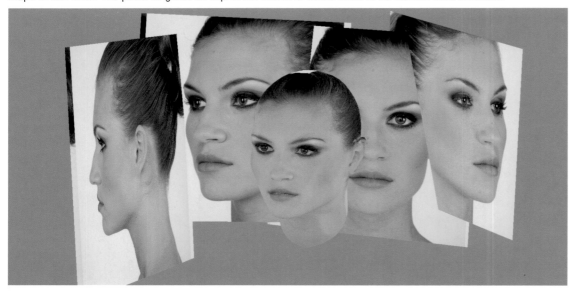

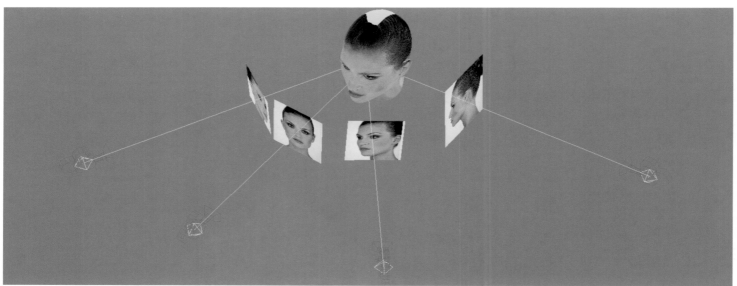

Step 7: DirectX 9 limitations

At present, DirectX 9 limitations mean that I can only combine four photographs at one time. By the time you read this DirectX 10 will be available under Windows Vista, and we should have a drastically expanded tool set available. In the meantime, I am working on a few methods to break the current limitations—multi-pass shaders with accumulation of intermediate data make it possible to use an unlimited number of photographs or even video. For now, I have chosen these four photographs to illustrate this chapter with: front right; front; front left; and left. The more photographs with even spacing, the better.

Step 8: File setup

Once you have done one head with this method, you have a standard file with all your cameras and projection planes set up. Because we are using projected camera mapping you have to set the render size to match the photograph's aspect ratio—the messy alternative is to scale (X and Y) all the cameras. I link the projection planes to the cameras via a helper—by scaling the helper you can move the projection planes in and out keeping them matched to the projection cone. You size and position the projection plane to fill the full frame in the camera view. The projection planes are used in the camera views when doing the camera matching—as you adjust the camera it looks like the mesh is moving against a constant background image. In fact, you are changing the UV mapping as you adjust the camera.

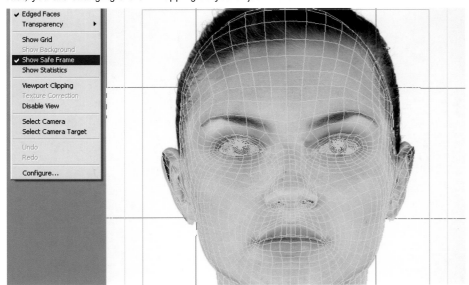

Step 9: Materials and filtering

Set up a set of 100% self-luminant materials for each of the camera shots. I use a custom object (a plane) for the material slot views. You need to match the UV channels with the Camera Map UV modifiers stack on the head. UV Channel 1 and 6 are reserved. Channel 1 is used for the main head UV mapping that we will be baking all the maps to. Channel 6 holds Hong's UV mapping for the combined collar, neck and head.

It is best to go through and make sure that all your maps are displayed with minimum filtering (set the blur parameter to lowest setting for all material maps) and that the DirectX display driver is set to match bitmap size as closely as possible.

Step 10: Start camera matching

In a Camera view, the View controls adjust the camera. You can zoom in and out by turning Safe Frame on and off. You can also toggle to Projection view which will match the camera view exactly. Once in projection mode, you can use the field of view screen control to zoom in and out while altering the camera directly. Make sure to place the camera target right on the surface of your model. This will make the orbit camera controls work properly—the target at the center of the image will not move around on the 3D mesh.

Step 11: Front line-up

Things are looking pretty good here. We still need to tweak the jawline and the neck. You should also pay particular attention to the corners of the eyes and the nose from the front view. The ears are not so crucial as we will primarily rely on projection of maps from other views (side and three quarter shots) at this stage.

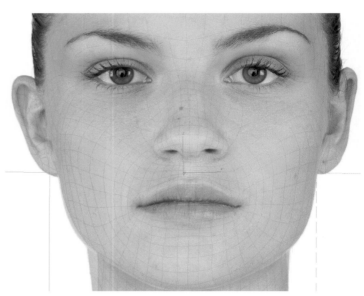

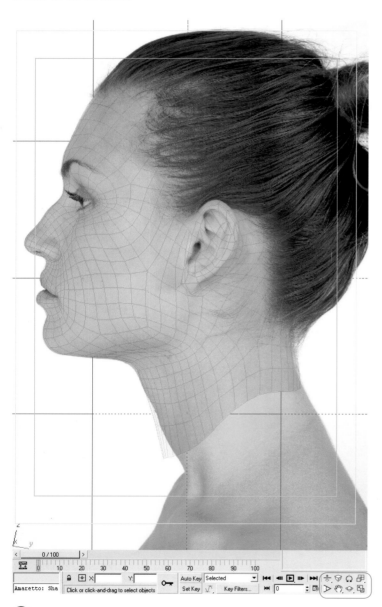

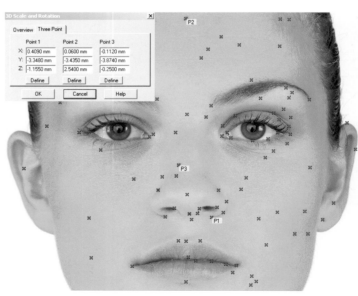

Step 12: Refining the camera match

Once you are happy with your camera match, go ahead and make any adjustments to the profile of the mesh required to match the projected image perfectly. It's a bit of an iterative process—refining camera projection and tweaking the model until you get a perfect fit for all of the projections.

Step 13: Automated camera match

It's not hard to do a pretty good camera line-up by hand, but you'll never be able to achieve the accuracy of automated camera calculation. Now that we have a fitted model we can use any of the good photo-reconstruction or camera-match (match move) packages to do an automatic camera extraction for us. Of the match move software, I can strongly recommend Russell Anderson's Synth Eyes and of the Photomodelling software I have found Eos Systems PhotoModeller to be excellent for extracting camera data. Whatever system you use, you want to take the coordinates from three points from your mesh to use for defining the coordinate system for the camera match. This way all the camera positions are calculated in your coordinate system.

Step 14: Using accurate camera data

You only have to use the camera locations from your camera match software. After you tweak your manually-aligned cameras with the exact camera position, you can easily rotate and move the camera target manually rather than trying to interpret the camera match rotation angles. With only 10 cameras, I manually transferred the accurate camera positions from PhotoModeller to 3ds Max and then manually tuned the rotations and camera targets. Depending on how you did the camera solve, you may find that the solver interprets the focal length slightly differently to your original setup. In this case, I had to change all the cameras in 3ds Max to 113mm focal length from the actual camera setting of 105mm. All in all, the use of a full camera solve is a very straightforward procedure if you have done a good initial model fit.

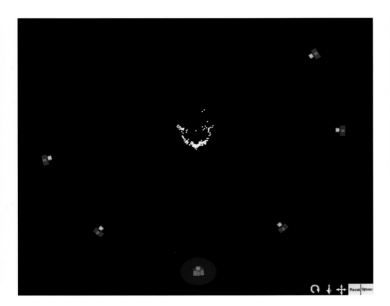

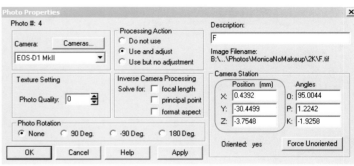

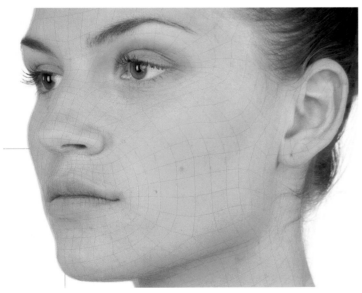

Step 15: Final model fit

Now we have the accurate camera positions we can go ahead and do the final fitting. You should not have any problems making the model fit exactly to all the photographs from every angle. Here, I have just finished the final fitting of the left ear. You should be very careful to make sure that the mesh model fits just within the projected photo outlines. You don't want any surrounding color to map onto the model—this will cause errors to occur in the automatic map balancing. You should be prepared for a little misfit in the eyes. In our set of photos, Monica is looking (up and down) at slightly different angles in some of the shots. You will have to choose which eye shot (for each eye) you are going to use in the end.

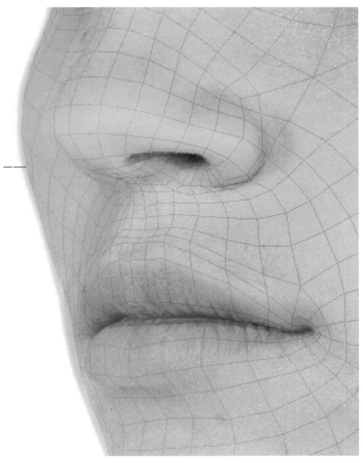

Step 16: Composing it all

This is where the new DirectX shader tool I have written really comes into its own. It takes the projected photographs and combines them in real-time. It also balances the maps and generates a true (very close to) diffuse map. This calculation is done at every pixel and mostly eliminates the specular component from the photographs and results in a perfect match between maps. Even though the maps are cut together, with Balancing Maps on, it is impossible to detect the seams even with a ridiculously extreme close-up. What the shader is doing is automatically choosing which projection is best

(closest to normal) at each pixel. It then determines a continuous blend based on incident angle and uses low-frequency (4-pixel width Gaussian blur) versions of the images to determine the correct (RGB channels calculated independently) adjustment to the high-frequency (full resolution) images. For now (in future versions the shader will do everything), we need to feed the shader sets of the high- and low-frequency images along with UV data and camera positions. DirectX does not support multiple camera views so we use lights to pass in the camera positions.

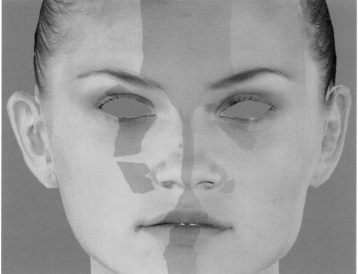
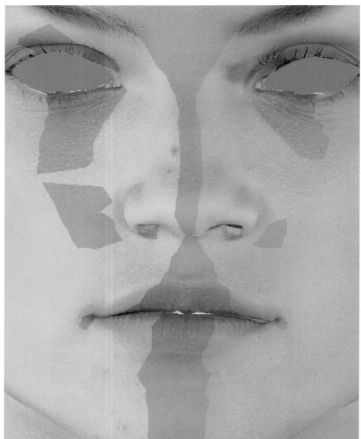

Step 17: Manually selecting projection maps

You may want to override the automatic selection of projection map for a specific region of the face. To do this, I have designed the shader to look at the vertex color channel after it has done its automatic calculations. We have four different photographs being combined at once, and they are coded with four colors: red; green; blue; and yellow. If there is nothing in the vertex color channel then automatic map assignment is carried out. You can paint into the vertex color channel to override its automatic map assignment. There is an option to display the maps tinted with their tag colors—this is also a good way to see where the maps are as the seams are usually undetectable in the balanced shader!

Step 18: Single maps for flexible face parts

Here, I have manually selected single projections for parts of the face that are likely to have moved between photographs: the eyes; and the mouth. The automatic map blending works so well that, unless the face has moved, you don't have to worry about seams. It really isn't difficult to get the blend seamless through the eyebrows and the hair.

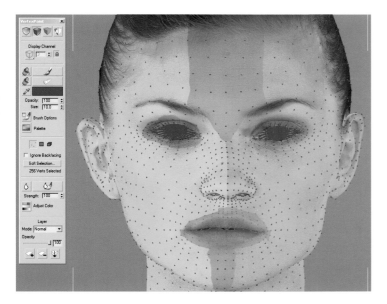

Step 19: Real-time UV unwrap

When I set out to write this chapter, I just wanted to make a shader that would display two maps from a single material at once—something you can't do in 3ds Max. As I got into writing DirectX shaders, I just kept adding features. It's now clear that you can do anything or everything in the shader. It's been staggering just how much can be done in one shader, but this is really pushing the limits of DirectX 9. With DirectX 10, most of the limitations will go. I am also considering a multi-pass accumulating shader that will allow unlimited photographs to be combined at once. For now, the single shader has a whole suite of material methods which we will look at more in the next chapter.

One of these features is a real-time UV unwrap. Unfortunately, I haven't found an easy way to render to a file (a limitation of HLSL development vs C++ development), but you can view your unwrapped maps from the shader and even animate the unwrapping if you want. For now, you can do a number of screen captures of the unwrap and combine them to make a single large map—a bit tedious, but easier than replicating the shader functionality in mental ray, Gelato or another user-programmable renderer.

See the ESSENCE section of www.BallisticPublishing.com to get the shader.

MARK
SNOSWELL

SKIN DEEP
REAL-TIME MAP MAKING

All the maps

Not so many years ago (OK, 15 years or more), you used a single texture map for materials. The same map was used for diffuse color and bump mapping—that was all the renderers coped with. Now, the average graphics card is capable of rendering far more complicated materials than most designers can create. So, although things like sub-surface scattering and pre-computed transfer functions are a walk in the park for graphics cards, many designers are still making materials for last millennia's hardware.

We are on the verge of being able to do completely physically correct shading for all materials. Along the way, the demands for defining materials and their interactions with light have risen sharply. This is particularly so for skin which is perhaps the most complex, and changeable, of all materials that we will ever want to render.

It's not just photo-authenticity that we want to achieve anymore. It's a degree of believability that a material is real and that it works in any environment we care to put it in. This means getting the light model correct. The great rendering advances over the past few years have come mostly from improved lighting and interaction of light with materials. For skin this means understanding and reproducing translucency—sub surface scattering of light.

We have a chapter devoted to skin structure and sub-surface scattering, so I won't go into detail of how to re-create the skin here. However, all of the problems that translucency give for rendering turn into benefits when extracting textures from photographs of skin. This is because so much of the incident light enters the skin. Once in the skin, there is a dramatic difference in adsorption of different wavelengths. The shorter the wavelength, the greater the attenuation. So, the blue light hardly gets in into the skin at all, green gets in further and the red light penetrates deeply.

During the development of the map blending DirectX shaders it became clear that I could add automatic generation of a lot of new maps that characterize sub-surface scattering in skin. It also became possible to generate bump and specular maps better than was previously possible. This is a work in progress, but the results are already a quantum leap forward.

Very shortly these tools will allow you to preview your final material (with full sub-surface scattering if you want) in real-time—they will be generated and applied in real-time. When you like the final resultant material, you will be able to hit one button to "bake" the entire material—maps and all.

As the DirectX shader tools I have developed will become widely available to the digital artists community through our CGSociety (www.CGSociety.org), I have taken time to show what they are doing here in some detail. Being DirectX-based, they will also work everywhere—in every 3D software package and even in games and other standalone environments.

As you look at the illustrations here, remember that in most cases when I talk about the maps I will be showing the map on the 3D model surface rather than as an unwrapped map. The map will not be rendered with lighting—just applied to the 3D surface. With all the map blending and tweaking being done in real-time, you get used to looking at the maps like this rather than flattened out. Of course, you can also tell the render to show you the maps flattened out in real-time.

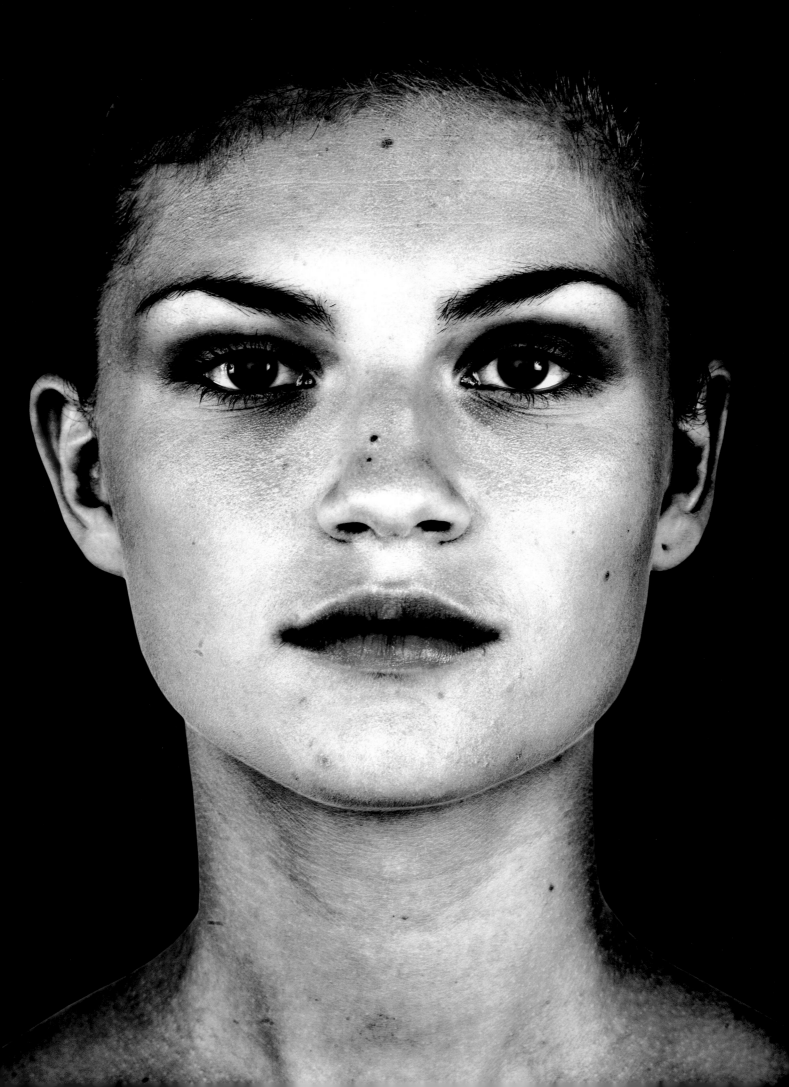

⬇ Step 1: Looking beneath the skin

Here are five images that tell a lot. When you look at the full color photograph, you are not consciously aware of the dramatic hue shifts and what they are telling about the condition of the skin. What we are good at is looking at skin and knowing whether it's healthy or not: dry; moist; oily; sweaty; thick; thin, clean; or dirty. In physical terms, we are assessing the surface diffuse color, specular reflections, surface bump, subcutaneous scattering, epidermal scattering, and surface blocking (by dirt, moles, freckles etc). Rather than despairing at working this all out and re-creating it, we can use the vast difference in penetration of red, green, and blue to our benefit.

⬇ Step 2: Revealing all with false color

This false color image is made by equalizing the red, green, and blue components so they have roughly equal response ranges for the bulk skin regions. Now, it is easy to see the massive variation in response to different wavelengths across the skin. The face has a complex variation of responses. Some of these are due to the surface reflectiveness—because there is more reflection of short wavelengths at low angles, the edges are all tinted blue-green. The shiny skin below the eyes also reflects a lot of the short wavelengths. The lips are absorbing a lot of green, but also reflecting the blue a lot with the result of a red-purple color.

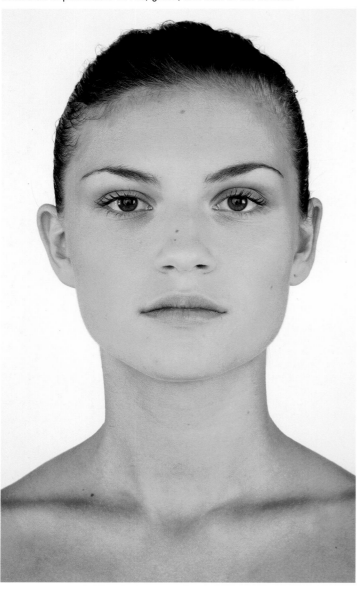

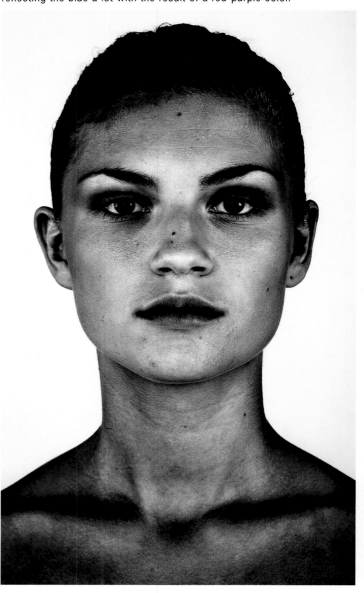

⬇ Step 3: Blue

The shortest wavelengths (blue) hardly penetrate the skin. For this reason, the blue component looks very graphic with no depth to the skin. In general, you can use the blue component as an excellent bump map. It is far superior to using the full color image. The blue does have both surface diffuse and specular components—so we can't use it as a sole guide to specular, but at least it is almost devoid of any sub-surface scattering component.

⬇ Step 4: Green

The mid wavelengths (green) penetrate well into the subcutaneous layer of skin. This is the layer just under the surface. Carefully compare this image to the blue channel. You can see lots of variation (mottled patterning) in this layer of skin. You won't see large blood vessels in this layer, but there is a lot of local blotchiness. Note that the reflected (bump detail) and scattered light contributions are roughly equal for the mid wavelengths.

⬇ Step 5: Red

Short wavelength (red) light penetrates deep into the skin scattering a lot resulting in the general blurring out of all features. There are some surface diffuse and reflected components, but they are minor. Compare this to the green and blue channels. Note in the right temple region the deep blood vessels—these are blurry and dark.

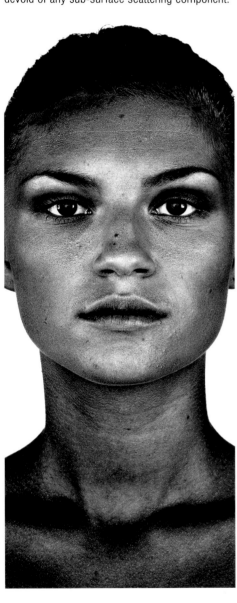
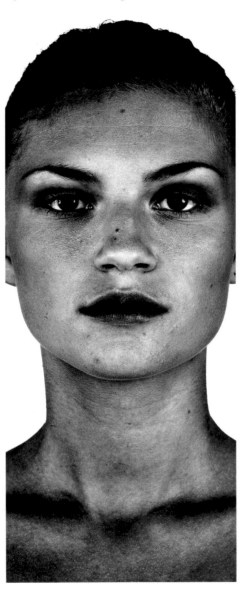
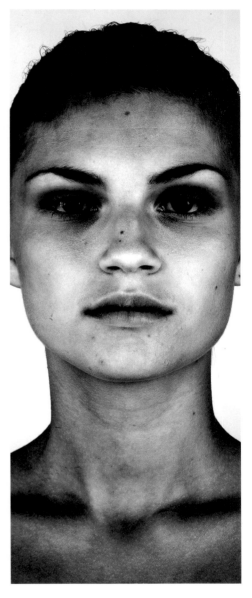

Step 6: Diffuse color

It's impossible to light and photograph a subject in a way that eliminates specular reflections. For single photos, the best we can do is use uniform lighting. Another problem is that a lot of the green and most of the red light energy is from sub-surface scattering and not diffuse surface scattering. For now, we will just look at suppressing the specular component. Fortunately, skin has very little reflectance normal to the surface (looking flat onto the skin), but it is very reflective at low angles. If we take a whole set of pictures under the same uniform lighting, but at different angles, we can do a good job of suppressing the low-angle specular component.

To do this the shader weights each of the blended photographs by the dot product of the surface normal and the camera angle. We do this on a low-frequency (softened version) of the photographs and use this RGB value to correct the high-frequency (full resolution) photographs. Looking at the photograph on the left, and the blended maps on the right we see that we have managed to flatten the lighting. Unfortunately, the photographs were taken with strong side-lighting—see the reflections in the eyes. This side-lighting results in strong specular highlights towards the camera. So, we end up with a very uniform blended map with a significant specular component.

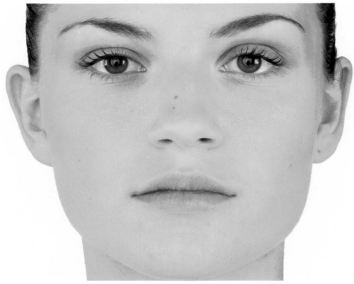

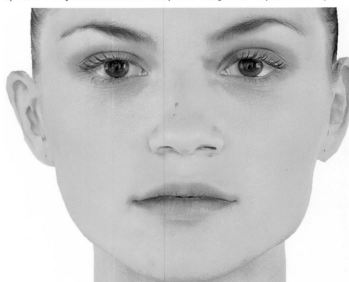

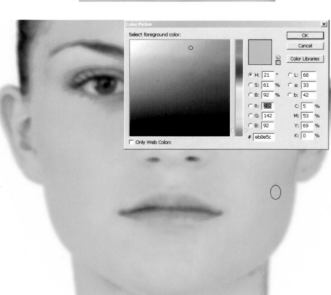

Step 7: Correcting the diffuse for side-lighting

At least we have a nice flat-lit blended map to start with. The contamination with specular light is fairly even, and we can easily remove it for a good approximation. We take a sample of the skin color in the photograph at a point that is free of strong specular component, but not so low an angle that we are starting to get falloff. Gaussian blur the images first and then take a 5-pixel box average in the cheek area. We will also take a black point-sample in the pupil inside the reflection shadow of the photographer and a mid-sample in the lower iris area. You correct the blended map using these comparative samples.

Step 8: Corrected diffuse map

Here, we have applied a 3-point correction curve to the RGB channels—you see the correction curve for the blue channel here. The diffuse map is now both flat and as free of specular as we can get with a simple method like this. In the future, I will add methods for the DirectX shader tool to automatically remove the contribution for the reflected lighting. We can estimate the light sources from reflections on the eye. For now, we have a diffuse color map that is way better than most used for even the best film work. Now that we are done you can see that we have also removed most of the specular component from the hair and eyebrows.

We still have small scale (bump) specular component—but this can easily be averaged out with a softening filter—averaging out the bump highlights and the shadows. Although this is way beyond what most people have done before, it's worth remembering that our diffuse map is still predominated with the sub-surface scattered light for the red and green channels. For Caucasian skin, the true diffuse would probably be nearly white with perhaps a slight blue/green tint because most of the red light penetrates into the skin and is scattered.

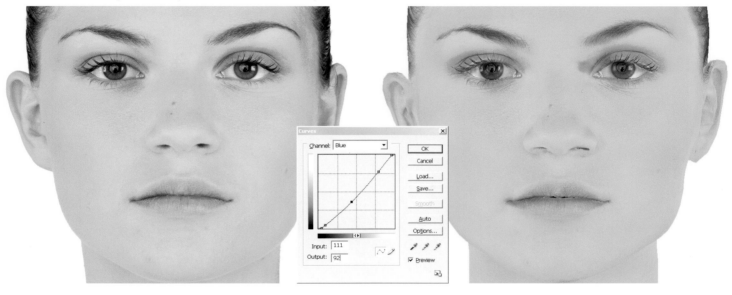

Step 9: Materials and filtering

It's worth a final look at our blended diffuse map in false color. Here, I have equalized the red, green, and blue channels to have equal representations. Looking closely at the differences, we have lost a lot of the obvious specular shine on the front of the face. But, what is really pleasing is that the blue-green fringe you can see at low angles on the photograph (left) is almost completely eliminated on our blended map (right). So, we have been very successful at suppressing low-angle specular, and this all happens in real-time in the DirectX shader tool.

Look closer at the low-angle suppression—you can see that we have done a lot better on the left side of Monika's face. This is because, in this blend, we had a side photograph for her left, but not the right. It's clear that when we can blend all the different angle shots at once that we will do a lot better in suppressing the specular component. Also, take a close look at Monika's left chin region. Note that we have completely eliminated the large scale specular bump component.

Step 10: Bump maps

Blue—one word that about sums it up. As I mentioned earlier, the blue light really does not penetrate the skin at all. If we extract the blue channel from our blended maps, we get a better bump map than most people are used to. Here is a comparison of the overall luminance (which most people use) vs just the blue component.

The only reason you might want to use the luminance is noise. By taking a single channel only—blue in particular—we will get a noisier bump map after processing. If noise is your biggest problem then regular old luminance may give you a better bump map compared to blue-only. This will depend on the quality of your photographs.

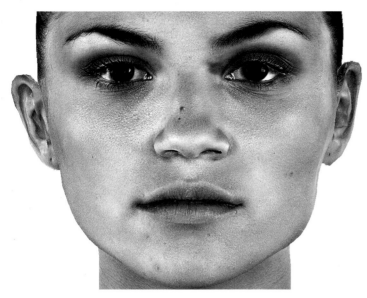
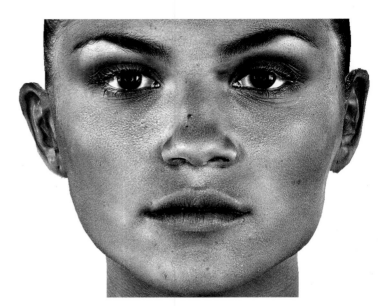
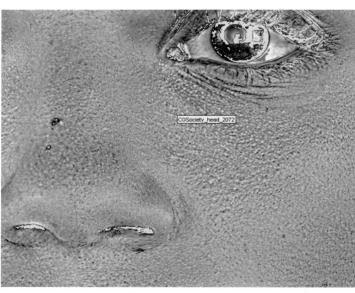
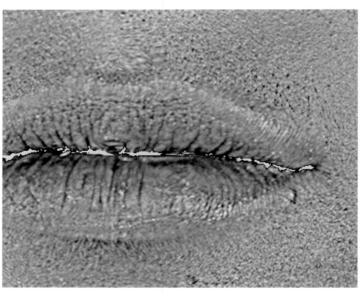

Step 11: High-frequency bump

We have two problems with taking just the luminance or blue component—we have low-frequency and pigmentation information mixed in as well. Let's tackle the low-frequency information first—it's the easiest problem to solve. The methods that apply bump mapping are designed as a cheat for rendering medium small-scale surface variations, i.e. surface detail bigger than micro bumps that influence diffuse characteristics, but smaller than anything that you would want to notice in profile. For us, that's all the small pores, bumps and fine hair. The easy solution is to simply subtract out the low-frequency information—which we get from the blurred images that we supply to the DirectX shader tool.

The downside here is that this can also introduce noise as we push the processing of our photographs. For that reason, I have included a LF rejection spinner in the shader tool so you can choose just how much of the low-frequency information to remove. Here is a close-up of the blue component with default removal of 65% low-frequency information. The DirectX shader tool provides black-point, exposure, and gamma controls for all of the processed maps. The green and red areas indicate clipping of the image: green for low; and red for high. This makes it easy for you to set the tone-mapping controls and it's easy to remove the clipping info from the maps later—you just fill green with black, and red with white.

Step 12: Better bumps

The next problem is pigmentation in the skin—things like moles and freckles. Left alone they will cause big dips in your render. They shouldn't be in the bump map at all unless they are due to huge pocks in the skin! Fortunately, these are features that are dark in all the color channels and we can use a red/blue ratio to suppress them. Here is a close-up of Monika's left cheek where a freckle has almost been completely suppressed by this method.

Step 13: Specular maps

Strictly speaking, the specular map should be just a fairly soft map that indicates where the skin is more or less reflective. However, because of the way many of the skin shaders work, you often get a more realistic looking render if you give a more detailed specular map—something that looks more like a blend of bump and specular. Here, we see a specular map that is created from the formulae 2b-g. In future, I will extract specular, along with diffuse and sub-surface components directly in the DirectX shader so that the result matches the photograph using your target render shader.

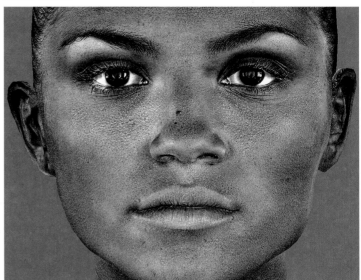

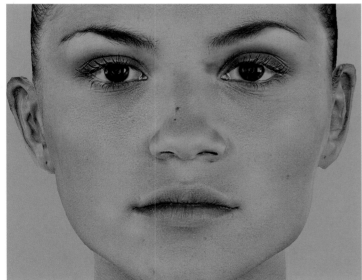

Step 14: Specular color

It can add realism to many skin shaders if you can specify the color tint of the specular color. The specular map generator in the DirectX shader tool gives you the option of winding up an approximation of the specular color. This is the full blended color minus increasing amounts of green and red as they penetrate the skin and are reduced in the specular component. Thus the specular color map looks very cool compared to diffuse color and original photographs.

Step 15: Sub-surface color

As you go deeper into the skin, more of the short wavelengths are lost. By modeling the loss as increasing logarithmic falloff of intensity with depth, you can generate maps that show you color at different depths. I have added a sub-surface map generator to the DirectX map shader tool that lets you go from the surface to a maximum depth. As you go down, the light goes from neutral, through yellow (red and green), to deep red. You can see different sub-surface features appearing at different depths.

PAUL FEDOR

MAKING A START
BUILDING UP MAPS

What is 4K, and why 4K?

Nyquist–Shannon sampling theorem says to pull off photo-real resolution you need to have double the pixel ratio to generate the necessary anti-aliasing. If you're an artist and not a mathematician, simply take a 2K (2,048 x 2,048 pixel) face map and zoom in on it—you'll see pixelization of the character's close-up. To avoid pixelization in close-ups you really need 4K maps (4,096 pixels x 4,096 pixels). Which means if a human is seven heads tall, you are looking at least 28K worth of texture maps. The industry is in for a big wake up call—there is nothing that drives me crazier than the bad airbrushed look of some CG models.

Shrinking resolution is a basic rule in print. When doing a book cover illustration you paint four times larger at screen resolution (72dpi) and change it to print resolution (300dpi) to fit on the cover. You don't create extra pixels, you're just fitting more pixels into each square inch. The same laws apply with 3D textures. 4K is the maximum resolution Maya can bake maps (3ds Max can bake 8K maps—8,192 x 8,192).

When introducing the concept of 4K textures to video game developers, I got a lot of cross-eyed looks. If you're not using compression you have to shrink these massive maps. I did a test one day with some skeptical developers who commonly use 1K and 512k maps. I had a 4K map on the right side of the screen and took a down-rezed 4K map and put it on the left. I asked the developers to guess what resolution the down-rezed map was. They all guessed 2K and when I revealed they were looking at a 512 map, their jaws dropped. Most game developers never think above 2K and certainly don't work at 4K where you can properly manipulate pixels and down-rez effectively.

One of the challenges I faced with the high volume of asset orders in video game production was the quality of textures. I was contracting out work to some of the masters like Chris Thunig (MPC London, Blizzard) and Paul Campion (the lead texture artist for 'Lord of the Rings') and had a stable of young kids fresh out of art school. How was I to maintain quality?

The result was to create a massive texture library that all artists would draw from. Working in conjunction with Peter Levius (3D.SK), we created a massive archive of creature, skin, vehicle, and weapons photography. With hi-res photography, a young artist with proper art direction, can churn out face maps like the pros.

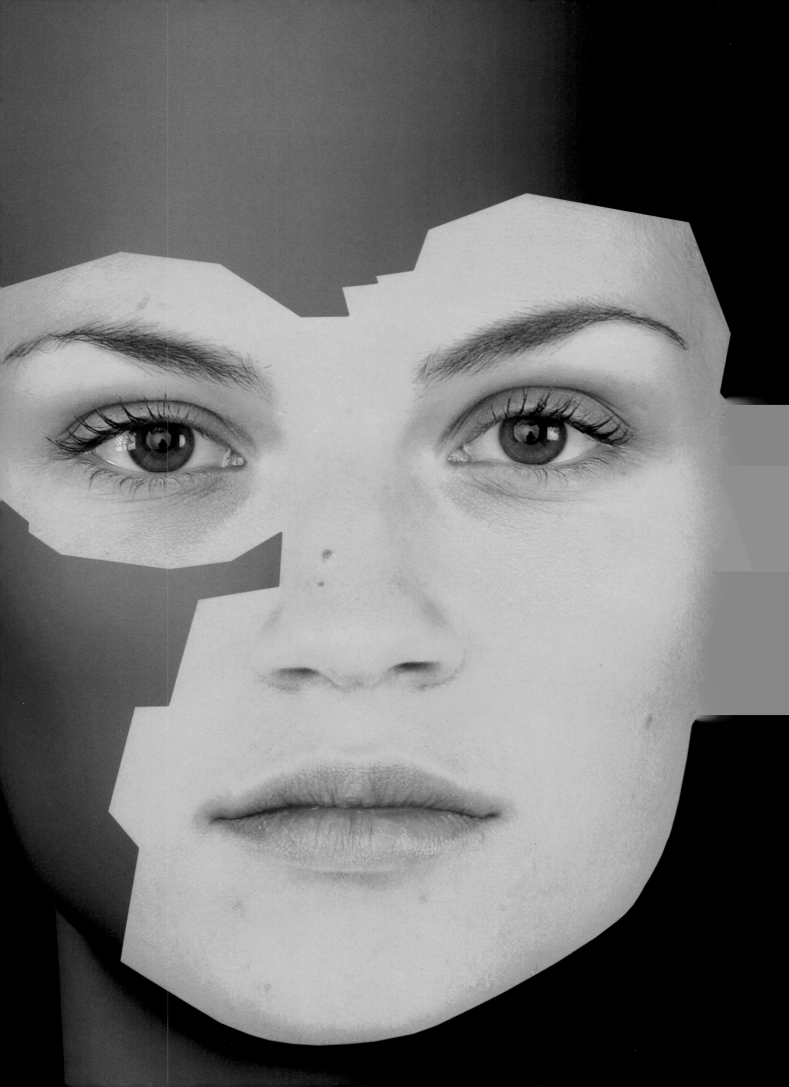

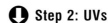

Step 1: Lambert (faceted, flat, diffuse shader)

The beauty of a scalable model is that I can begin work on an early model. Because the UVs don't change, I begin working on this 10,000-poly model which will get higher. The modeler will continue to sculpt and dial in the model in ZBrush without holding me up. We'll start with the initial alignment on a Lambert, but soon switch to a surface shader once we have the underpainting. Save your Lambert render for registration overlays.

Step 2: UVs

Don't be scared of UVs as most houses have proprietary UV unfold tools. The average consumer now has access to similar tools. My team uses Unfold 3D (www.polygonal-design.fr/e_unfold). Maya's unfold tools suck, but 3ds Max and XSI have unfold UV tools that are pretty decent. Because of cost, speed, and quality we've adopted an all-projection pipeline. When doing mass-production photo-real characters, a standardized UV template became essential—because the UVs never change, the maps become recyclable. This is huge in saving time and money. We adopted starter maps for all types of faces: male; female; Asian; African American; Caucasian; and even children.

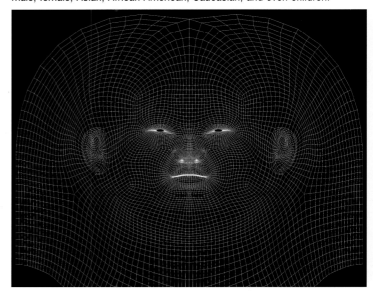

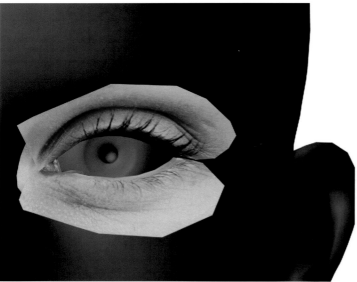

Step 3: Beginning the eye

All you need for photo-manipulation is Photoshop's Erase tool, the Warp tool, and maybe a Levels change. The whole idea of a photography-based pipeline is to protect the resolution of the photos. If you have great photo reference to work from you shouldn't have to do much—say no to cloning! It's all about the registration.

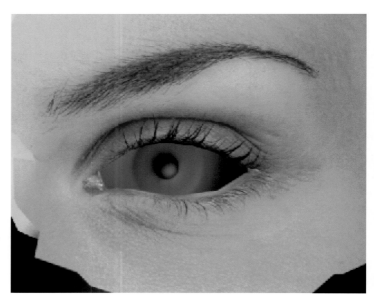

Step 4: The facial road map

The face is like a road map—the eyes lead to the eyebrows which lead to the forehead, and then the nose, lips, cheeks, and neck. The human face is full of corner pins (anchor points). Your brain is programmed to know how a face is put together—you're hard-wired to perceive beauty as symmetry. Your brain tells you big eyes and big lips are attractive. Monika's eyes are slightly offset.

TEXTURING
Making a start
Building up maps

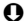

⬇ Step 5: Brow construction

If you're careful you can slide the eye photos right into the lip of the eye. Photoshop's Warp tool becomes essential. I use the Overlay, Hard Light and Color Burn blend modes to manipulate translucent pieces of photos. This allows me to perfectly register to the model. Once you have the eye, you have the eyebrows. Often, I throw a surface shader and photo on the eyes for placement so when I give it back to modeling they have reference for the eyelashes. For presentations, we always use surface shaders. It's a pain to render eyes, and it also depends on an environment map for reflection. The eye surface shader is a nice way to get an eye in without giving the client a head with two holes.

⬇ Step 6: Eyebrows and sockets

Once you have one eye socket, you have one eyebrow. Once you have one eyebrow you have two eyebrows and two eye sockets, then you can place the nose. The nose, lips, and the rest of the face are pretty straightforward: Warp; Overlay blend mode; and feather the hard lines. Remember, no cloning!

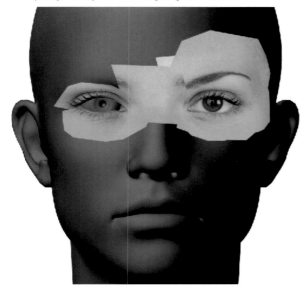

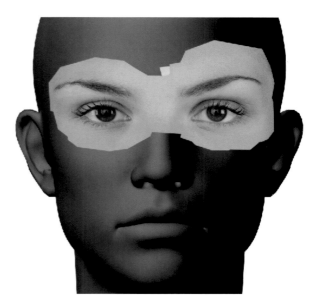

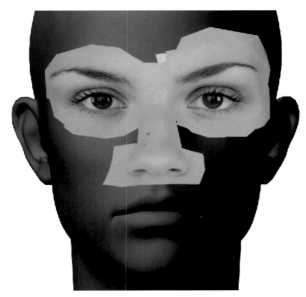

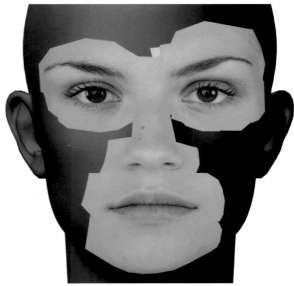

⬆ Step 7: Nose

Once you have the brow, you can start on the nose. Keep checking registration with a Lambert overlay. The nose has several key anchor points: the tip of the nose; the edge of each nostril; and the brow.

⬆ Step 8: Lips

For the lips, you want to always pay attention to upper and lower lip. Build each separately in parts paying close attention to corners of the mouth. Again, registration is key so double-check the lip with a Lambert overlay. The bottom lip will lead you to the chin. Once the upper lip is built, it will lead you back to the nose.

TEXTURING
Making a start
Building up maps

Step 9: Cheek

The cheeks have several anchor points: the corners of the eye; the nostrils; the lips; and chin. You can do the cheek in one large patch and align all these points with the Warp tool. To mark your way use opacity changes, turning the patch layer on and off, and use the Overlay blend mode.

Step 11: Projections

Projections are a weird thing to grasp. Whatever you paint through your projection camera gets flushed through to the other side. Notice Monika now has a face on the back of her head. Some programs like ZBrush let you control how much can be projected through an object. On more complex models, ZBrush fails to project fully through. Overall, it takes time to get used to the blurry, streaky mess, but over time you will be able to use it as a guide.

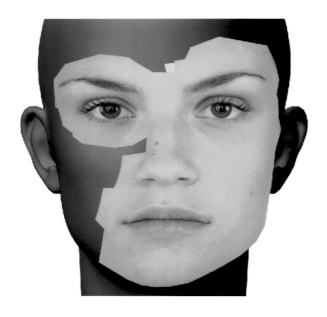

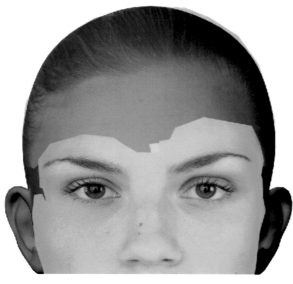

Step 10: Forehead

Once the lower half of the face is complete, it's very simple to patch the forehead. Warp the forehead to the corners of the eyebrows and to the top of the head. Make sure you take into account where your hairline is. If you leave a little forehead when you do your eyebrows, your forehead will slip right on. Make sure you do a final alignment check with an overlay.

TEXTURING
Making a start
Building up maps

Step 12: Getting baked

Now it's time to bake your projection. For your bake settings make sure you have all options turned off except the UV range default. One important Maya bug to remember is under your background mode select "Extend Edge Color". This will give your UVs a slight bleed. Without this option clicked you will get thin black lines on all your seams.

Step 13: Starting the map

Most artists will paint their background color skin tone. I paint mine neon green to see everything that needs to be covered with a photograph. With this pipeline, we don't paint or clone anything! It's for a good reason. We pound all this data into a photographic map which we will split into six separate maps later on. There is information in these maps that we will need for displacement. A clone mark or blurry patch will be clearly seen when it comes to bump and displacement.

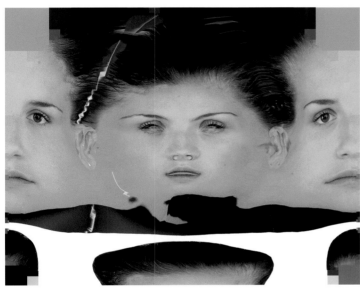

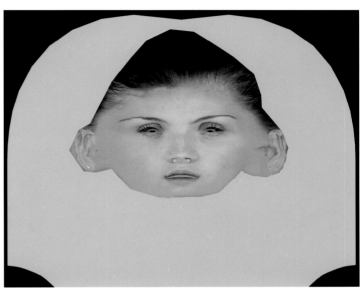

Step 14: Lambert

After getting to know the initial model, it looks like the eyelid is a little off. The eye, nose, and jaw may change. Often during production if sticky clients make changes you see the model change several times. The power of standardized UVs is that it can handle pesky modeling changes. The texture map can withstand some of the most ridiculous changes. I always pull a Lambert for registration overlays.

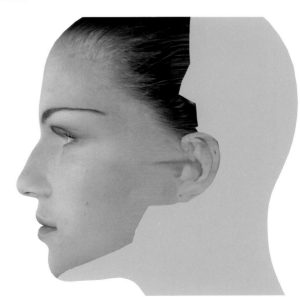

Step 15: Surface shader render

It's time to start pulling surface shader renders. The surface shader (Maya term) is a 100% self-luminant shader that gives you a completely neutral view of the progress of your map, nulling all shading and lighting. I also make my whole team render on white. It is very important to see exactly what and where the projections are. Right off the bat I see streaking in the eyebrow edge as well as covering up all that nasty green.

TEXTURING
Making a start
Building up maps

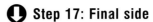

⬇ Step 16: Cheek build

It's important to find the jaw line. The initial model's jaw is a little longer than the photography. I'm going to have to Warp the cheek more than I like. Your anchor points are the ear hole, the temple, the edge of the eye, the corner nostril, corner of the lips, chin, and the jaw shadow from the Lambert. In this case, I actually had to do the jaw in two pieces. Once you have the jaw to cheek, you have a temple patch and side of forehead patch.

⬇ Step 17: Final side

Don't forget about the side of the nose. Every part of the final map should have NO streaks. I quickly slapped on an ear with Warp, because there may be modifications to the ear. The hair easily falls into place; be sure to align the forehead hairline. I quickly do a Lambert check to see what the side projection can be pulled off. I left a grey lambert overlay visible to show the areas best left to the front.

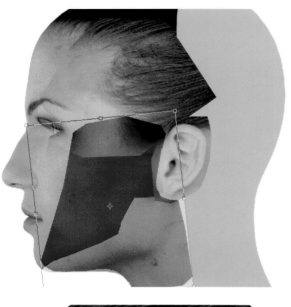

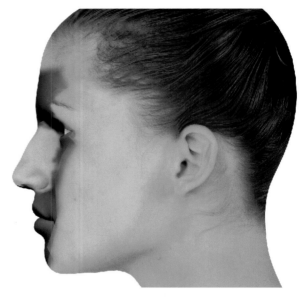

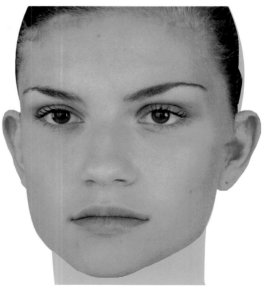

⬆ Step 18: Final side

The key to production faces is to do as few projections as possible. Sometimes you can get away with doing a side projection once. If you're lucky with a model you can pull off just five projections: front; side (repeated and flipped); top; back; and under chin. In this case, I think we are going to have to do a 3/4 view projection as well. Modeling changes may still occur. Don't get hung up about how many or few projections it takes. Every model is different and requires many projections. A good artist does as many as are necessary.

⬆ Step 19: Progress

The map is shaping up nicely for a flip. Don't get attached to the work you've done so far. Right off the bat the eyebrows are still off. The lips, nose, and eyes are looking solid. You have to look at the map just like a painting on canvas. This is just the underpainting. Right now, my concern is to cover all the green and then start to dial in the map. I am going to try to flip the right side projection and use it for the left just to kick start this underpainting.

TEXTURING
Making a start
Building up maps

Step 20: Left build

The face is full of unconscious details and subtleties. A real face has variations, and we are working with a perfectly symmetrical model. It's that much more important that we go ahead and vary the photography on the left side and right side. Most people don't know why something doesn't look photo-real, and more importantly neither does the artist. The jaw, neck, temple, and nose are all usual suspects for replacement.

Step 21: Safety checks

Although this projection looks good, I want to do a final Lambert overlay as a safety check. Here's the projection overlaid on Lambert—notice the ear is off. As much as great photography makes a texture artist's life easy, in the end what makes quality CG is a ruthless tenacity for detail. Picasso said: "It's 1% talent and 99% hard work." What will really make this map sing is a little artistic elbow grease.

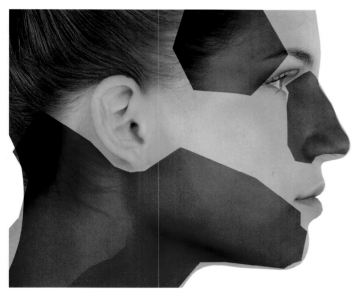

Step 22: Nasty ears

The Lambert overlay reveals that the earlobe is in fact off. The jaw line and nostril seems dead on. The Lambert will play a key role. Make sure to align all parts with the Lambert's shadows. The ear is a tricky thing. Sometimes you have to do three projections to finalize the ear. This is why starter maps are so important. I don't want be doing ears all day. Usually, it takes a profile ear projection and a rear projection. In this case, I probably won't do a front projection for the inner ear, because the hair will cover all this.

Step 23: Progress

The map is shaping up nicely. I want to get the model covered so I will skip the front ear projection. You could go ahead and clone out the smears in the ear (one of the few times I condone cloning).

Step 24: Nasty neck

We are now getting to the pain in the ass parts of the map. The advent of the starter map plays a key role in mass-production pipelines. In the past it would take an artist 2-5 days to finish a facial map. He spends 1-4 days doing stupid stuff like stretching under the neck and behind the ears. The neck is split into five parts: front; left; right; back; and the nasty under-chin.

Step 25: Front neck

Anchor points for the neck are the base of the chin and the collar bones. Don't worry about under the chin—it will be a separate projection. Warp and overlay will get most of the front neck on.

Step 26: Neck to chin

One trouble area for the neck will be the chin. Since we are going to do a lower angle projection, it's very important to nail the chin. As in this case, I am going to extend the projection all the way up to the lower lip so I have room to erase. Often in the neck area you run into color changes. Often with photographs depending on photographer, you will see a stop or two difference in exposure.

Step 27: The jaw

It's important to get the jaw alignment right. Overlay checks become key. The model's jaw is different from the photo, and a little Warp finesse is called for. Always be mindful of how much stretching you are doing to a photo. Once the middle neck and jaw outline are finished, I will lay in the sides of the neck and the upper chest.

Step 28: Feather check

Paul Campion loves to heavily feather the edge of the lasso when cutting and copying photos. I prefer to give my lasso a 1-pixel feather and gently work into the edges of patches of photos by hand. When looking at this map I caught some hard edge lines around the chin. Often, you will not see lasso lines in the wide shots. I always inspect the map on a macro level and usually turn on grey view to see whether I lost any nasty feather lines. If you don't catch them now, they will jump out at you when doing the bump map.

Step 29: Toned skin

3D.SK did a fabulous job with the photography. Often, a texture artist gets handed a bunch of crap photos. They look good at first, and then you get to that one angle the photographer missed, or it's out of focus, or it's a completely different exposure. The map has nice tonal consistency, but my eye is picking up some white patches around the chin. I need to get under the chin before I tackle those pesky exposure patches.

Step 30: Final projection

This is the final projection. I want to hit the under nostril and under the chin. You also can see that the eyelashes and eyelids are smeared. I will tackle these later when Hong finalizes the eye and gives me a closed eyelid blend shape.

Step 31: Lambert

Until the underpainting is finished, I will be pulling Lambert views. Sometimes with the Lambert overlay you have to mess with Levels to get a true reading. The Lambert comes with the default lights baked in. Don't be afraid to play with transparency settings as well.

TEXTURING
Making a start
Building up maps

⬇ Step 32: Nostril patch

The nostril patch is always a pain. Make sure to do this right the first time. Often, this is where the photographs break down—you will get exposure problems, or the photographer forgets to shoot them entirely. Peter did a great job with the photos, and this patch will slide right on. Always double-check that the nostril orifices are perfectly aligned.

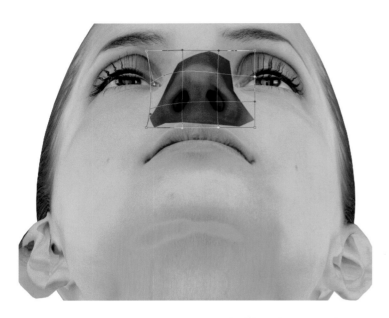

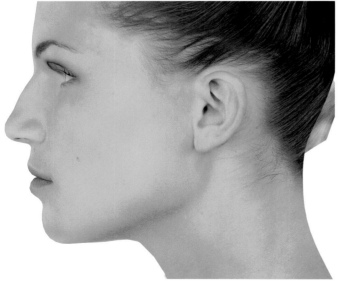

⬆ Step 34: Chin patch

Everything seems to be lining up. It's time to move onto the lower sides of the neck. A little bit of inspection shows some specularity around the nose. I don't think I will remove it. A lot of my maps aren't completely neutral. I sometimes leave in specular highlights if they're not too bad, or create darker eye sockets for villain characters. I am also leaving in a bit of shadow to show off Monika's sexy jaw line.

⬇ Step 33: Chin patch

The chin patch has three anchor points: each end of the jaw bone; and the tip of chin. My first attempt is a big chin patch. The photography underneath the neck wasn't too great. Peter shot her with her head tilted back which caused a whitish skin as she tilted her head back. I would have preferred to have the camera shot low angle with Monika in a neutral position. In the end it's fixable. This proves the importance of starter maps—they have all the annoying parts for the neck worked out already. If you come to a photo that you are missing, find a similar face and skin from another person with 3D.SK. If you can't do it in one patch try splitting it up into pieces.

⬆ Step 35: Neck touch-ups

Ordinarily I would probably frame the whole neck and jaw for one giant single projection. Monika has such a beautiful neck I didn't want to take chances with resolution. Splitting the jaw and neck into two projections will pay off later in other maps. Every inch of skin is important.

TEXTURING
Making a start
Building up maps

Step 36: Left neck final

Watch your photography! In the end, what makes guys like Paul Campion, Francisco Cortina, Chris Thunig, and Steve Geisler great is their eye. The trained eye sniffs out complexion problems, exposure imperfections, or something that doesn't look right. In the end, a great artist has an alarm bell inside his/her head that goes off when the illusion of reality isn't being performed right. A great artist has a well-exercised power of observation.

Step 37: Right neck

I didn't like the hairline behind the ear (which I will have to fix anyway). I like the skin complexion on the left side of the photographs. I am going to go ahead and rebuild the right side of the jawline as well. I also look at texture creation the way I paint one of my huge 20-foot oil paintings. Although you are using photography, you are still painting. All the principles associated with painting still apply. If I had time I could paint Monika's face on a 20-foot canvas like Chuck Close does. Unfortunately, to paint Monika by hand is too time-consuming for production so we use photos.

Step 38: Neck bake

Match the power of the universal UV template with starter maps and you don't have to do the pesky areas again like under the chin and ears. A good artist with a starter map can do a head in eight hours or less. In this book we obviously did this from scratch. The neck bake is done. Time to slice off the pieces we don't need and blend with our final map.

Step 39: Final map

The final map is comprised of about 20 baked projections that have been blended together. Nothing but erase and the Warp tool were used. Peter's photos are so well-produced there is no exposure or specular problems that have to be painted out. All that is left to be done is remove the eyelashes, hair, and fix problem areas on eyelids.

PAUL
FEDOR

PRE-HAIR
CREATING A BALDNESS MAP

Preparing for hair

A good texture artist should be able to pull a rabbit out of the hat. Old age, makeup, tissue damage, or a baldness map. Usually, in video game land I am using a hair base. If a high-profile character comes up, I will have to generate a bald map.

Hair is a complicated beast in itself. It's a much easier process to go ahead and paint the hair in. This allows your hair artist to have a guide on hairlines. Once the hair artist sets the hairline, they can swap out the maps with the bald layer.

It's a good idea to do hair and no hair options. You get into complicated issues with the shadow of the hair falling on the scalp, and a number of other issues. Sometimes the hair just doesn't work, depending on what production and what post house you are at. It's a safe bet to have the hair map standing by.

As you work with skin more and more, you begin to apply medical procedures. Often, you start thinking like a plastic surgeon or a dermatologist. You think about how to stretch skin and how to protect it from damage. You run into tricks on how to hide your scars or seams. A baldness map is nothing more than skin grafting.

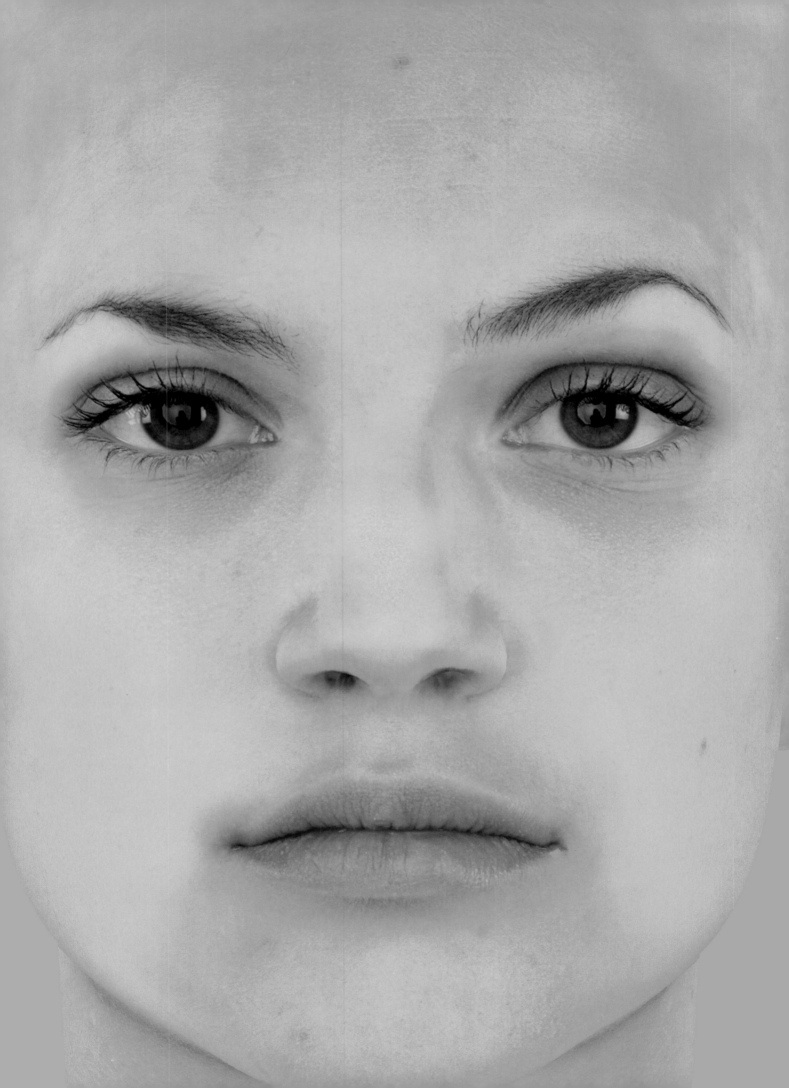

⬇ Step 1: Front hairline

We will start with the front hairline. This bald map is a great exercise in photo-collage in preference to cloning.

⬇ Step 2: Front baldness

I will sample large chunks of skin with big pores. The forehead, neck, and shoulder make for nice samples. I want to stay away from tighter skin samples from the face. I will keep building up patches of skin and erasing the edges to blend a seamless patch of skin. I will not use any cloning.

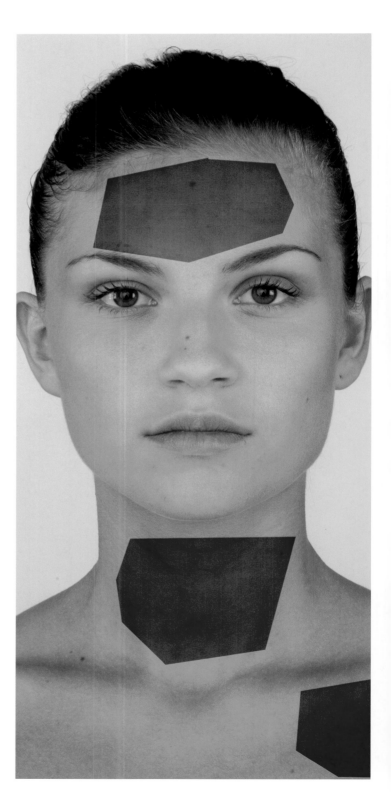

⬆ Step 3: Sample of skin

Don't resort to cloning. The whole purpose of a photography-based pipeline is that the artist uses the power of the photo. I will be using large chunks of skin and blending edges instead of cloning. I will start my underpainting sampling of nearby skin of the forehead to set my skin tonality.

Step 4: Skin pathology

I was watching the medical channel one day and they were surgically grafting skin, when I noticed how close it was to the way I was working. Often, plastic surgeons use the naturally hidden areas to hide stitches. I want to use a large skin graft and slowly build up where the hair meets the facial skin. I know I will have overlap, and I want to protect the base temple, cheek, and forehead as much as possible.

Step 6: Clean extension

If you do your job right you will have a nice seamless tone. I was slow to build up the painting, yet I still have a lot of pore data. If you clone, you lose your data for the bump.

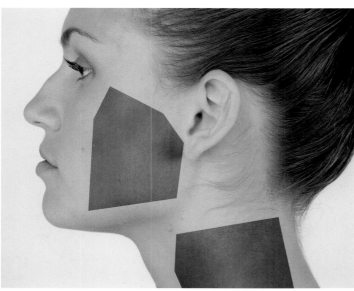

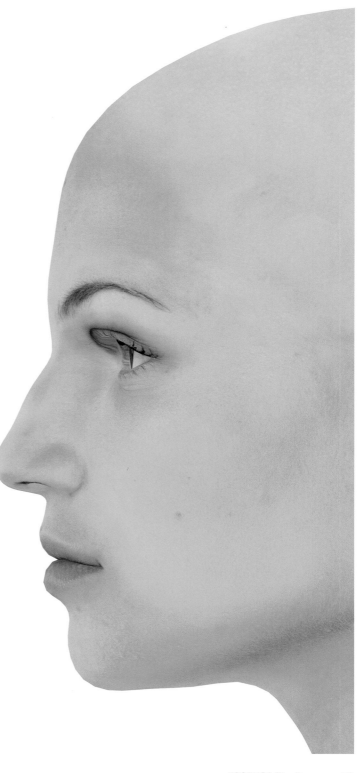

Step 5: Skin grafting

I am watching the tonal variations. It's easy to sample the wrong skin and make for noticeable patches. The last thing I want to do is create patterns.

Step 7: Shoulder patch

I really like the skin graft from the shoulder. It has the goose pimple skin pattern that is rounded. I will continually use this patch to match the roundness of her head. With a little Warp and flip-flopping the sample, I am able to create large areas of photo.

Step 8: Back

Often, you just find a piece of a photo that will get you a long way. The shoulder sample can get me through the sides and the back. Although you will not see the deep under-scalp, I am going to make this nice and clean. I can reuse the bald map on a lot more characters.

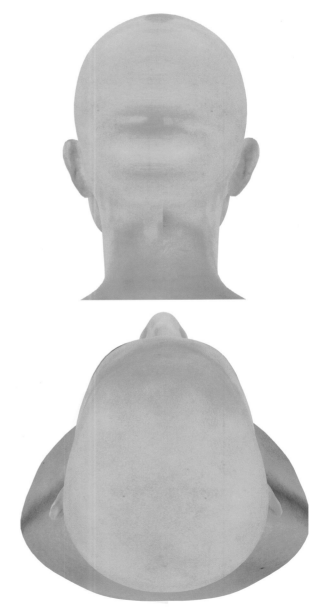

Step 9: Mrs Clean

Once you build a side patch you can resample it. The back head slides right on. I add another sample from the front neck to take out the back neck. The more I generate larger patches of tonal skin the easier it gets to patch baldness.

Step 10: Mop top

As you can see from the top angle, the skin is consistent tonally. If I had to, I could use this as a base underpainting and head back to 3D.SK. 3D.SK has shaved head pictures on it. I could easily graft a male shaved head onto Monika to further lock down solid skin data in the map. Since hair will be added, I will stop here.

🔻 Step 11: Bake and blend

I will pull my collection of bakes together and overlay it on the original color map. I will blend the facial skin with the bald layer. I'm happy with the overall tone. I want to keep the bald layer separate so I can use it for other character variations or for other characters entirely.

Step 12: Front surface shader

The importance of working in a surface shader reveals the true prowess of a texture artist. Never hide behind lighting and surface shading. I always save my look renders on white. I want everyone to know that these maps are clean and free from patches.

Step 13: Side surface shader

The evenness of the photos will pay off later when I throw a shader on it. If it looks this good now, imagine when you add bump, specular and shading.

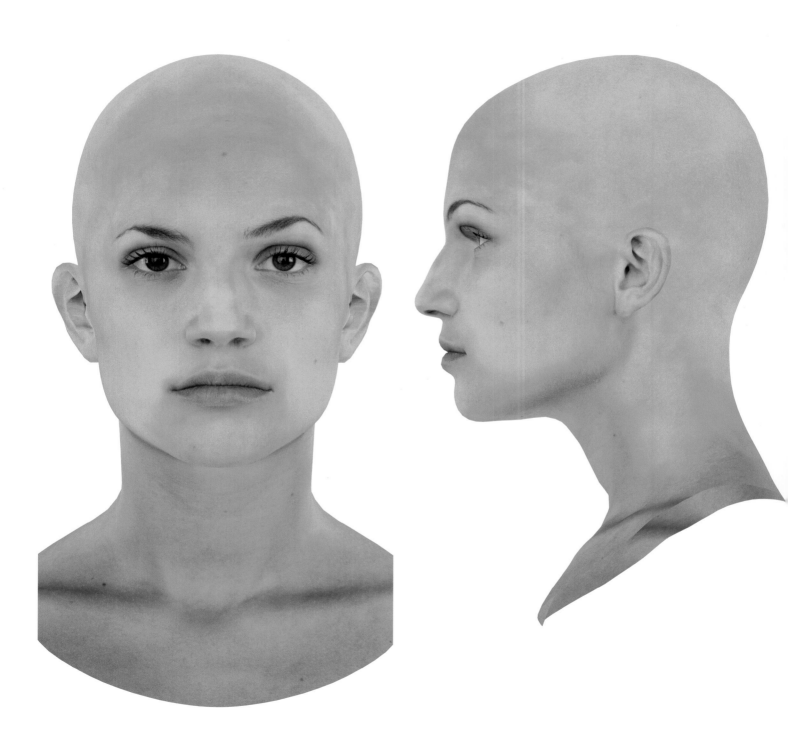

Step 14: 3/4 surface shader

Typical trouble spots are ears and temple. I did have to clone out a few minor hairs. There is an even blend between the face, ear, and bald head, and I would call this angle done.

Step 15: Back surface shader

If you really want to take your bald maps the distance, try searching 3D.SK for shaved heads. I kept an even skin flow at this point so I could add stubble if I needed to. Save your baldness maps, because you will always have to do one. After checking all sides, all that is left is to fix Monika's eye sockets. Then she's off to the hair artist all clean shaven.

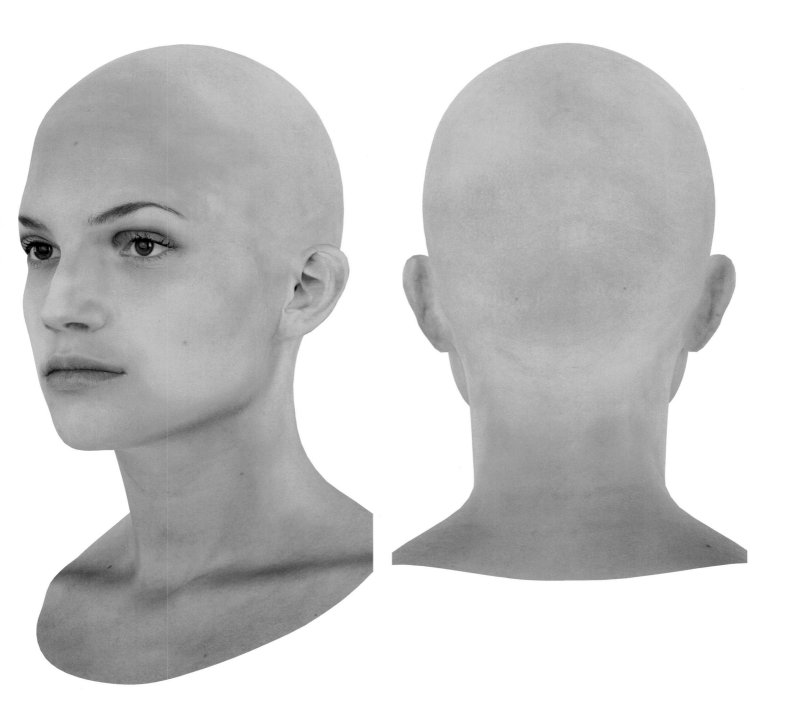

PAUL FEDOR

TIME FOR UPDATES
REFINING THE DETAILS

Durable UVs

A scalable character is essential for any mass-production pipeline. With displaced subdivision surfaces paving the future for games and movies, it's the only way to work. Recyclable starter maps with unchanging UVs play a key role in the workflow.

Often, we will send off grey models for approval to the client and start texturing. Without final client approval on model revisions, you are rolling the dice if you start to texture. This is not a worry with standardized UVs. Smart typology and well laid out unchanging UVs makes the texture maps as tough as metal. Often, the client comes back after a week and finally realizes he wants a stupid change on a brow, or a forehead extended. My texture team usually have the maps finished. Nine times out of ten you make a texture fix if the model changes. You have to fix the eyebrow or a corner of the mouth, but that's it. Standardized UVs cut back on texture fixes even with the most dangerous clients.

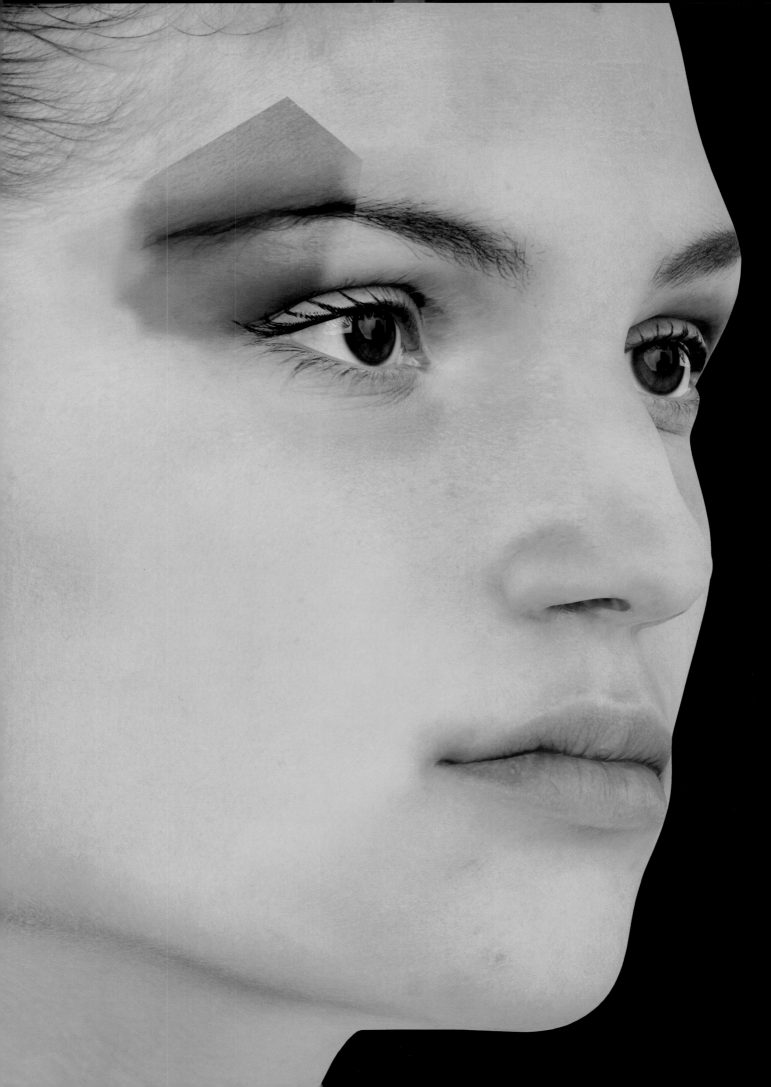

Step 1: New model

Hong has completed his high-res model. He will be giving me a level-four head which is about 70,000 polygons. Hong has gone in and worked on some spots like the eyes. It's time to dial in the hot spots.

Step 2: Ask for hi-res

I actually prefer to texture on high-res models—it's the only way to dial in serious detail. I recommend it to any texture artist to ask for the high-res geometry. Particularly when doing creature work, smooth is the way to go.

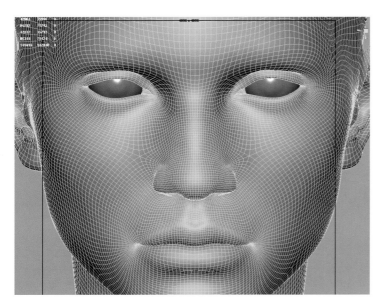

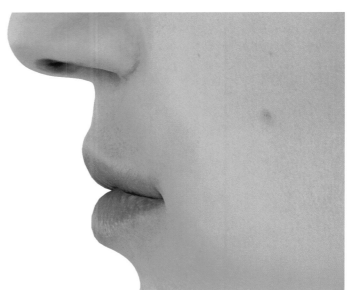

Step 3: Checking alignment

Once you get the new model, it's time to check your trouble spots. First and foremost, from a side angle, check to see whether your texture lines up with your model.

Step 4: Nooks and crannies

The edge of the nose looks outstanding—no work to be done there. The lips seem to be holding as well. Be on the lookout for any clone marks, blurs, or stretching.

⬇ Step 5: Eye damage

As you can see I am getting some mis-registration on the eyes. There has been some modification, and the eyelid has been redefined with the new model. I'm now getting a stretched lash with an overextending lid. The bottom lashes are still holding up.

⬇ Step 6: Lambert

Back to the Lambert. Because of the modeling change, I will pull another Lambert render. This is final map time, and I need to have 100% registration.

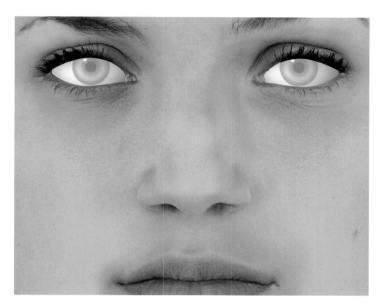

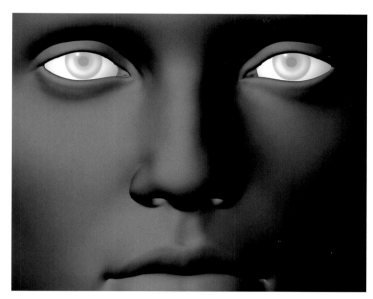

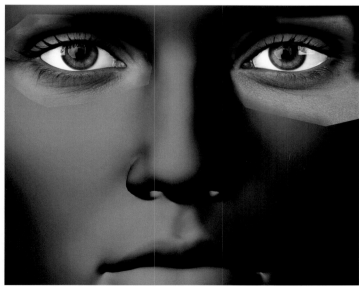

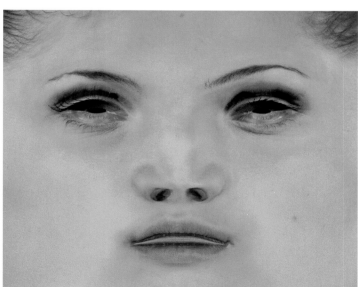

⬆ Step 7: Patch projection

Always look at your map as a painting. It's never done until all the kinks are worked out. Just to be on the safe side, I will reconstruct the eyelashes and pull another eye surface shader. I want to make sure I have perfect alignment in the upper lid.

⬆ Step 8: Bake

Although I pulled off a perfect front projection, you can see some stretching in the eye sockets. The sloppy way to remove this would be cloning.

Step 9: Fake eyelashes

After closer inspection we also see the eyelashes are starting to fall apart. On wider shots, we usually don't remove the eyelashes or do eyelashes as geometry. Because the book deals with a lot of close-ups, I will dot my "i's" and cross my "t's".

Step 10: 3D.SK to the rescue

One of the things I love about Peter Levius' 3D.SK website is that he understands 3D because he worked in games. If you're using a traditional photographer, they just don't know about hidden spots like a closed eyelid. My recommendation for all photographic pipelines is storyboard out a shot list for your photographer. You should have a strict rules list if you're not using 3D.SK.

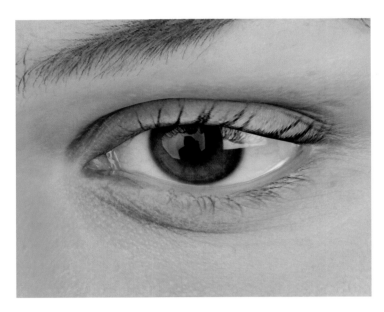

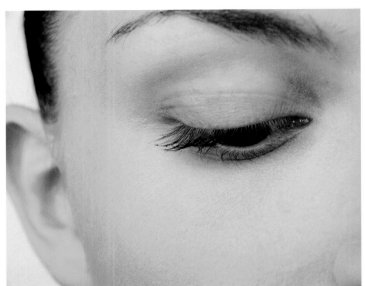

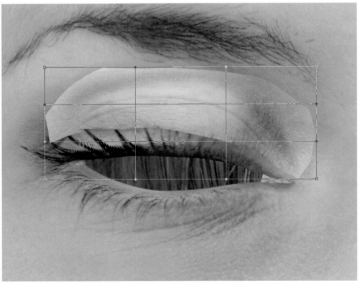

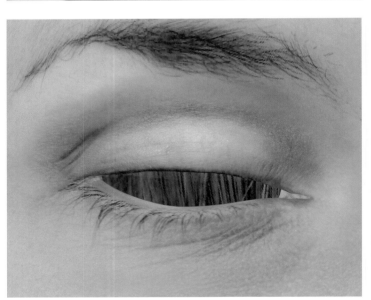

Step 11: Removing the eyelashes

To really dial in the hidden eyelid, I'll order up a temporary shape with the eyelid closed. I am also going to start the painful process of removing eyelashes. Unfortunately, I have to do some cloning. I Warp as much of the upper eyelid photograph as I can. I want as much pure photograph to clone from as possible.

Step 12: The trick to cloning

The trick to cloning is using 90-100% opacity. You don't want to clone at lower level transparencies, which will produce fogged photography. The reason I don't recommend cloning is because it relies heavily on the artist's skills to prevent repeating patterns. Only really good texture artists can make cloning invisible. My eye can always pick up sloppy cloning.

⬇ Step 13: Comparison

The original bake has a lot of good things about it. I really like the dark crease in Monika's folded eyelid. I don't want to lose that.

⬇ Step 14: Got my lid

I will ghost my bake over the top of my original map. I will then slightly erase and blend the two. Notice I am still keeping some of the original projection. Unfortunately, all this work was done for that split second moment in the rare event of a close-up that we would actually catch a streak in her eyelid.

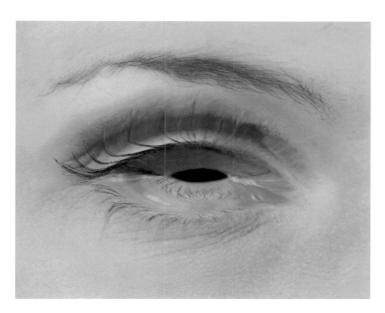

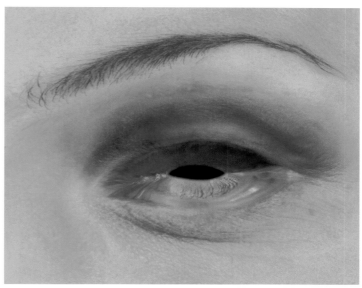

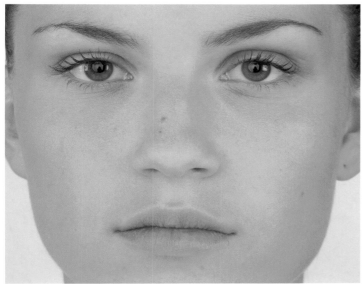

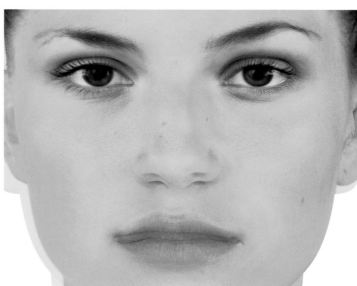

⬆ Step 15: Back to the original

We have two versions of Monika with makeup. One with and without the eyelashes. I want to go back to compare the original for a second.

⬆ Step 16: White glove test

Because there has been a modeling change, I want to make one final test. I overlay 3D.SK's photograph over the model. The eyes seem to have dead-on alignment. If there's ever a place you don't want to be off it's the eyes. The eyebrows are also off.

⬇ Step 17: Getting the eyebrows right

You might miss it, but Monika's eyebrows are off—they aren't the same size, and the right one rides up a bit. This isn't a big deal because Monika is not super famous and viewers wont know her face too well. If I were doing a digital stunt double for Angelina Jolie, the director and Angelina's agent would be all over me.

⬇ Step 18: Not quite right

I fixed Monika's eyebrows so at least they are symmetrical. I tried to even them out a little in this frontal projection. However, I have a gut feeling that something isn't right.

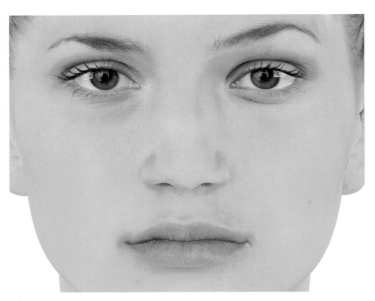

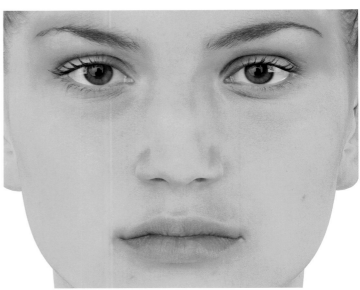

⬆ Step 19: Back to the Lambert

When all else fails go back to your Lambert. Eyebrows can be nasty areas for a texture artist. If the temple has too sharp a drop-off, you will get streaking as in this case. This will take some artistic elbow grease to get the eyebrow on correctly.

⬆ Step 20: Troubling brow

There is no way around the stretching. I will have to pull a 3/4 projection. I will go back and forth noodling the 3/4 projection and frontal projections and try to find a perfect balance between the two angles even though the geometry is slightly off. Something has to give.

Step 21: Eyebrow comparison

Modeling and skin are a strange thing. Skin is merely stretched over a surface. Nobody sees the model like a texture artist. If there is a flaw or an angle that is irregular, the texture artist will find it, and will usually have trouble with the photo sliding onto the geometry. It's easier to model and texture a made-up character. Especially when doing real-life models, the true challenge is accuracy to the original photograph shown here (below right).

Step 22: Full comparison

Even though I nailed the left eyebrow, it curves off sharply around the sharp temple fall-off. I had to float the corner piece and eyeball it, constantly nudging it, and pulling renders. For the right eyebrow, I actually have the length right, but the temple fall-off is even more severe on the right side. Overall the direction and balance of the eyebrows are solid. After hours of tweaks, I'm going to have to make a compromise. I have to make a decision to move forward. Monika CG still retains her beauty, and I still find her eyes attractive despite the corner fall-off. I am calling her done, and moving on to generate other maps.

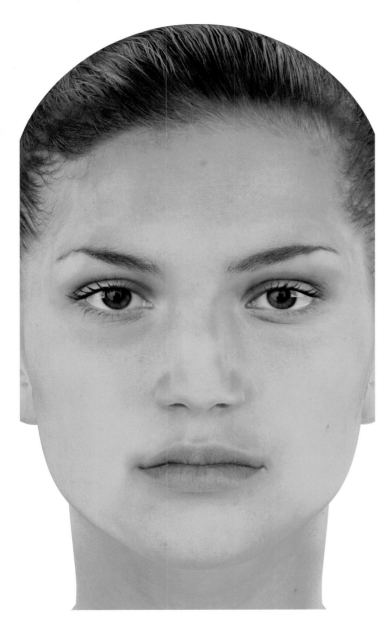

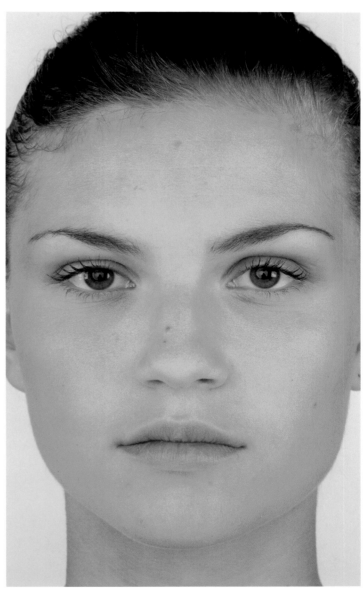

PAUL FEDOR

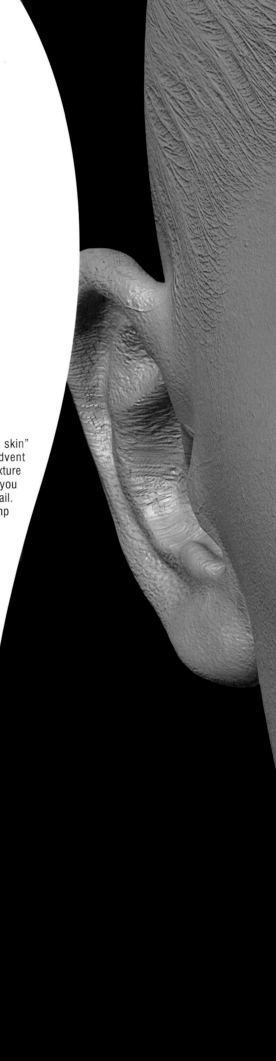

GETTING THE BUMP
BUMP-MAPPING

I hate bump maps!

Have you ever seen what a bump map truly does? As an interesting experiment play around with different settings. Basically, all a bump map does (at least in Maya) is cast an offset shadow on things like pores. If you ever played with the Emboss filter in Photoshop, it's the same thing. It's kind of nasty especially when you put it in lighting situations. In my opinion, it's one of the hardest things that lighters have to deal with.

Bumps are lame. Real photographic shadows and detail come from displacement maps. I file normal maps in the same category as a bump on steroids. With displaced subdivision surfaces, displacement maps will give you the exciting detail wrinkles you see on ZBrush Central.

Bumps are very tricky for tight skin. Many bumps that you see generated on CGTalk are the repeating "orange peel skin" from a procedural texture. With the advent of ZBrush you dish off your model to the texture team and then back to modeling. With ZBrush you can extract all that wonderful photographic detail. Never use a procedural or hand-paint a bump again—it's all in the photograph.

With the Inflate tool in ZBrush you can take a wonderful 4K image map and "inflate" the surface detail to create your high-frequency detail displacement. This not only works for skin, but also ground planes for environment scenes. If you examine skin on a macro level, a ground plane (concrete or rocks) is just like the surface of skin. You can take a simple photo of rock from 3D.SK, slap it on a simple plane, pull it into ZBrush and boom! You can inflate all the detail in the photography into a displacement for ground plains, buildings, or mountains.

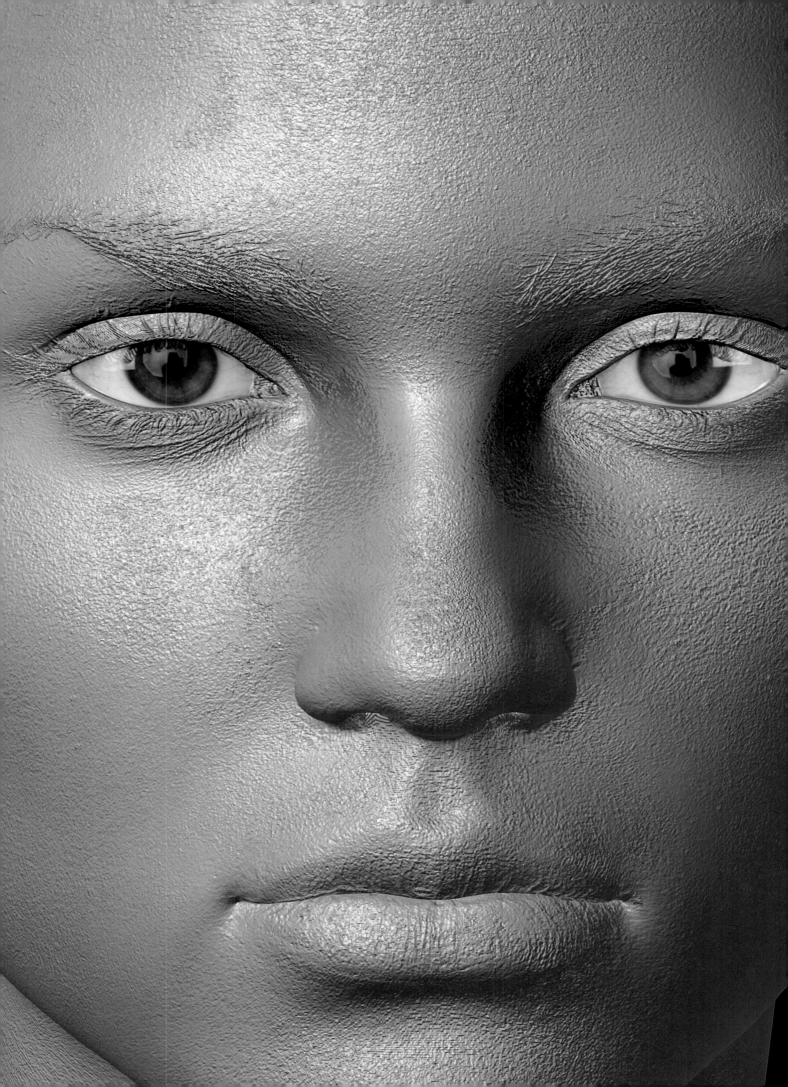

Step 1: The power of 4K resolution

All the hard work put into our image will now pay off. You are about to see the power of 4K resolution. I start by taking my image map and invert it. Because of 8-bit color, sometimes you see banding in greyscale imagery. Sorry, the resolution just isn't there. To counter it, and because Maya shaders pick up more than your eye detects, I create a "fog" layer. The fog takes down the image a little. I sample an average grey and fill an entire layer with 30% opacity. Time to plug it in after just 30 seconds of work.

Step 2: Blinn

For a simple invert and 30 seconds worth of work this is pretty spectacular. I will plug our fogged greyscale invert into a simple Blinn with a ".2" bump depth setting. The ".2" setting works in conjunction with the fog to prevent your 8-bit banding or at least control it. I never liked Maya's default setting, and tend to work at lower bump depth levels when using Blinns. Sometimes with the SSS you don't even have to fog the bump.

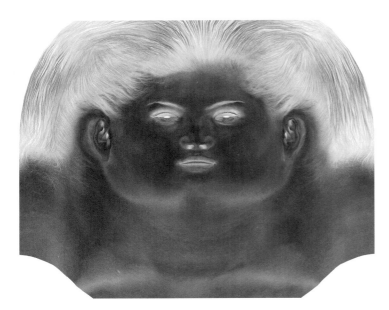

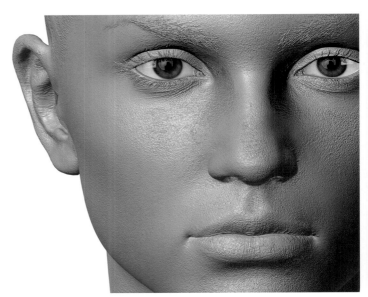

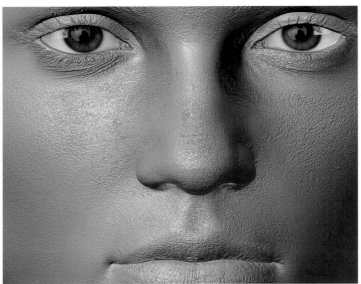

Step 3: Nose and lips

Like I said, I hate bump maps. The usual areas that get kind of funky are the tip of the nose and lips. If you go back into your bump map, you can tone down your trouble spots. Sampling your average grey, go in with a 9% airbrush and ghost in a little grey over the tip of the nose and lips. In another 30 seconds, your bump is touched up and done.

Step 4: Lips

The power of hi-res photography is at your fingertips. At Sony, we had all the high-tech toys including photogrammetry-based scanners to the ATTOS which NASA uses. The ATTOS will give you 50 million vert clouds with details like fabric-weave, pores, and pieces of dust. So you can have hi-res photography in 30 seconds! In fact, our character ZBrush pipe has toasted our scan pipeline. Because we protected the detail of the photograph it now can be used for extraction in other maps like the bump, normal, or displacement.

Step 5: Blinn

The Blinn is a nasty white glove test of your bump. If your bump can hold up against the Blinn, it says a lot about your bump. This map is giving us extraordinary detail everywhere. Look at the eyebrows, which sometimes you have to beef up. You can even detect Monika's eyelashes, and the peach fuzz on her face! You can easily mix this high-frequency surface detail together with major displacement flows in ZBrush. There's no excuse for not having exact, highly-detailed normals or displacement maps.

Step 6: Back to the Lambert

The bump will react differently from the Blinn, to the Lambert, to the SSS shader. The Blinn really toasts the bump, the Lambert dials it down, and the SSS dulls it even further. Pull renders from multiple angles to be thorough.

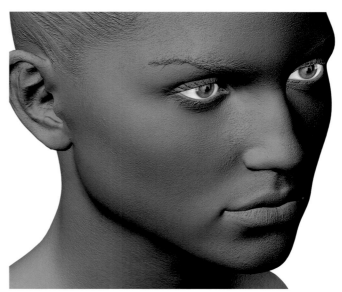

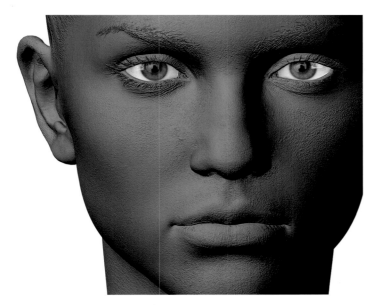

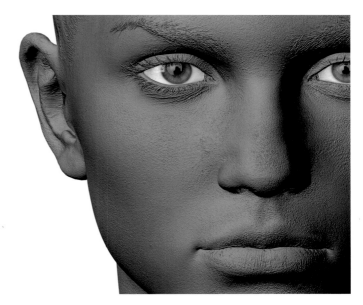

Step 7: Photogrammetry

Using hi-res photography is basically "photogrammetry". Everything you put into your photograph will be revealed in the bump. The one reason I am such a "Texture Nazi" about cloning is because you will see it in the bump. If you forget to erase a line or leave clone marks it will show in your bump. If your photo has compression it will also show in your bump.

Step 8: You can't hide from resolution

I can see the nasty smearing in the ears from a sloppy projection. I will have to go in and remove that. If you do your job in the image map, you shouldn't have to spend more than five minutes on your bump and specular maps. With a starter map and universal UV template you can do a face in about eight hours fully-customized! Let's see a scanner match that.

PAUL FEDOR

SHINY HAPPY PIXELS
SPECULAR HIGHLIGHTS

Specularity maps

I have a slightly controversial way of doing specularity maps. I actually paint with light that gives you highlights on every bump, ridge, and pore. In the end, whatever works and looks good is the right way. This method was developed for a mass-production pipeline of 40-60 character orders. Its key selling feature is a specular map done in five minutes that any artist can do. Traditionally, spec maps are a greyscale version of the color map. The artist would go in and selectively lasso patches of skin and mark them for shininess with level changes. Anything white was greasy, and anything dark would be matte. Not easy in video game land where half your crew are not Paul Campion.

Specularity is misunderstood. The question is: "how much do you see specularity in real life?" When I came back to CG, I had the benefit of being: a trained illustrator; a studied photographer; and a music video director known for my cinematography. On a shoot, I would pay the "Glam Squad" US$4,000 a day for rockstars (especially female artists), to make sure every time I pulled the trigger there was NO shine on anyone's face. Have you ever seen a makeup commercial with the model looking greasy?

90% of everything you see on TV and movies hides the talent's greasy/oily dark side. Most makeup artists come with a box of makeup gags to hide or bring out specularity. Most of the time they are hiding it. They have cream that gives a healthy sheen to skin. Some have shiny bits of metal mixed into the cream to create a weird metallic specularity. The only time you see serious gloss on a model, is usually in a cutting edge fashion spread where they put "baby oil" on the model. Fashion photographers have created some of the most ingenious lighting schemes, crazy color corrects, and have produced some of the most exciting images in film in the last 15 years.

My advice to any young CG artist is before you make digital images, you must understand how they make analog images. If you want to have serious discussions about specularity, research top photographers like Albert "Cyclops" Watson, Phillip diCorcia, and Helmut Newton. Modern fashion photographers to catch are Nick Knight, David La Chapelle, Sean Ellis, Andrea Giacobbi, and Zach Gold. Just because you work in CG doesn't mean you turn a blind eye what's going on other fields. An artist's purest function is to perfect their power of observation.

Step 1: Light rig

The idea of baking a specular map is a slightly "out of the box" idea. We take a light rig that creates a neutral overall lighting on the skin—almost like a turtle or 'G.I. Joe' light rig. In this case, we take multiple directional lights and place them 360 degrees—dispersed evenly on all angles of the head.

Step 2: Blinn

I take an average Blinn or shiny shader with just the bump map. I usually have the bump depth set to ".2". One of the problems with 8-bit color is that you get banding in grey maps. The information is in the map, but Maya 8-bit can get sensitive sometimes. The ".2" setting dials down the map and shader for Maya. This is the only setting you need to remember for this trick. Refer to the Bump tutorial.

Step 3: Even lighting

The idea is everything that our lights generate as white will be the specularity. If you get really tricky with this method, you can create layers of specularity highlights by simply adjusting the rig. High-powered lighting will get you a sharper highlight. While lower level lighting will get you a more diffused spec.

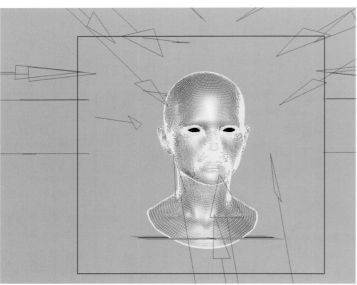

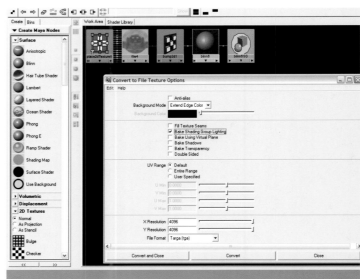

Step 4: Getting baked

We are going to pull a bake just like we would a regular projection. This time we'll enable "Bake Shading Group Lighting". Although this is a pretty proven way of doing specs, play around with some settings. Choke the Blinn's default color from grey to black and you get tighter specular highlights for layered specular shaders.

Step 5: Backface scattering

This rig is meant to generate an even grey. Most people pull high-contrast spec maps—this one is not. The medium grey bake will give you an overall healthy skin sheen. Just enough to kiss some life into the skin. It also puts your specular settings in the middle for the lighting team. You choke it down or push it up for an oily skin sheen. It gives the lighting team a nice neutral default map.

Step 6: Touch-ups

Usually, I do two things to finalize the map. I matte out the hairline black. A simple feather lasso and the hairline is gone. The other is the corners of the eyes. You want to over-crank with Levels to really white in the corners of the eyes. You can do nose and lips if you really want to be a stickler. Not bad for five minutes worth of work. The light bake will guarantee a highlight on the crest of every pore and every ridge on the face, with 100% registration down to the last zit. Other spec maps can't promise that.

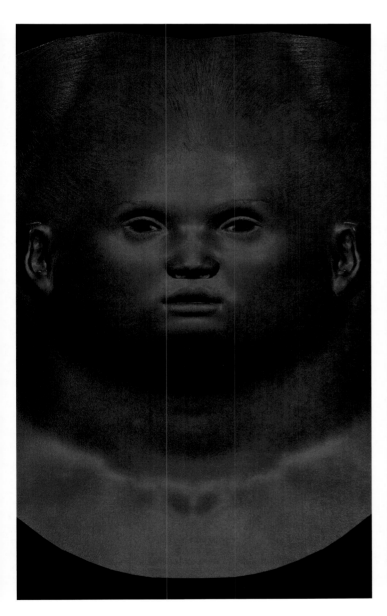

STEVEN STAHLBERG

EYE OF THE BEHOLDER
SIMULATING THE HUMAN EYE

Eye on the prize

The eye is probably one of the hardest body parts to create. It's hard even if you don't go for 100% realism—perhaps not the modeling so much as overall strategy, and shading. There's translucency, refraction, reflection, caustics, and lots of details that have to fit together very exactly. We also use the eyes to communicate body language more than any other body part, so everyone knows how it should look most intimately. The easier part is modeling and shading the eyeball. I'll show you how to do that first. The harder part is fitting the eyelids to the eyeball and the lashes to the lids.

I'll go through some common mistakes concerning the basic shape of the lids at the end of this tutorial.

Only a few years ago, the eyes used to be much harder to do. But, with HDRI, sub-surface scattering, caustics, and much better reference on the web they're much less scary—almost fun. The modeling is easier if you approach it with measurements and reference. The hardest part is shading, and troubleshooting the test renders. This comes with experience, so don't get impatient and lose heart—once you've perfected an eye you can use it as the basis for almost any other character's eyes.

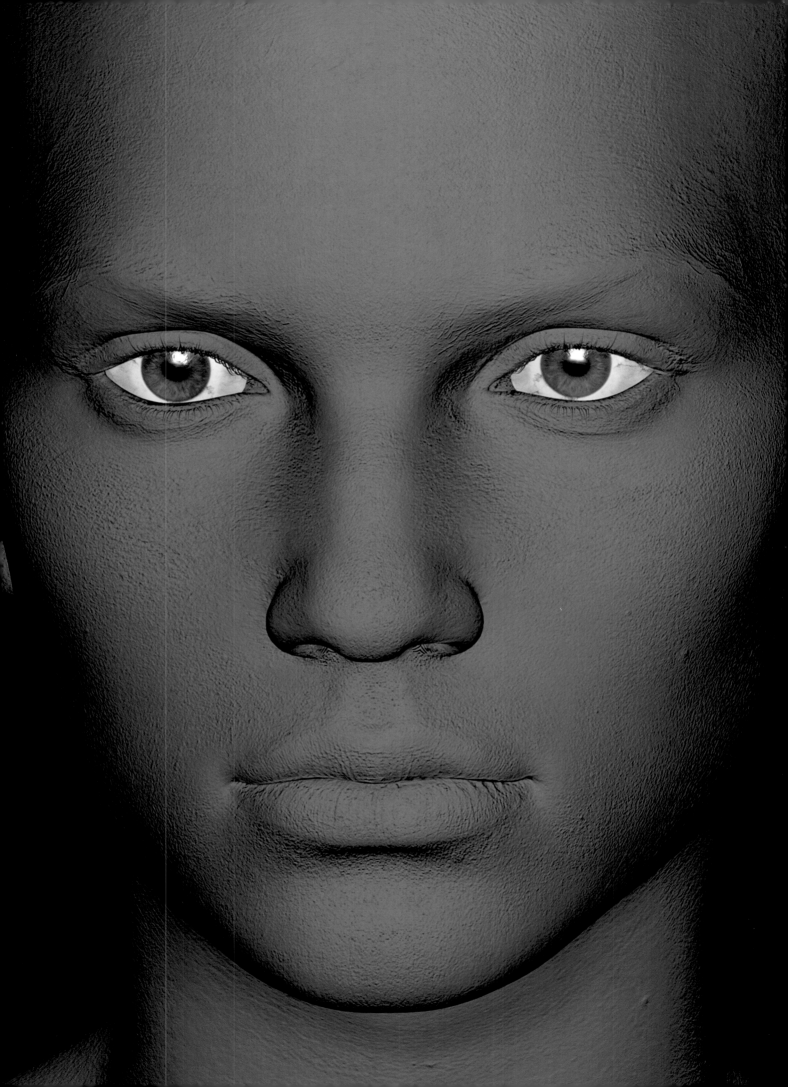

Step 1: The anatomy of the eye

Everyone hopefully knows where the upper and lower eyelid, and eyelid crease are located. This image also shows the caruncula, the sclera, and the cornea. For more reference use Google and 3D.SK. Look up 'iridology' in Google as this usually results in some nice iris textures.

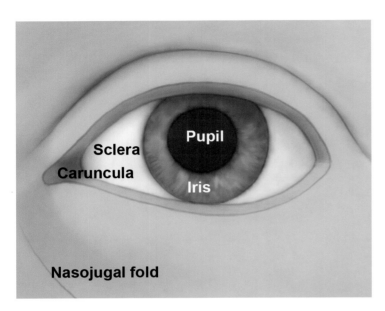

Step 2: Cornea/sclera border

An interesting feature of the eye, which is not immediately obvious, is that the sclera overlaps the iris by a millimeter or so. Note where the red arrows are pointing in this illustration—the Cornea/Sclera border. It's one surface, but milky-white up to the border, where the white fades and leaves only the transparent cornea—like a sheet of clear glass that's been partially, and softly spray-painted white. This soft transition 'overhanging' the iris almost always leaves a shadow on the outer edge of the iris. This creates the darker edge we usually see in most photos, on the circumference of the iris.

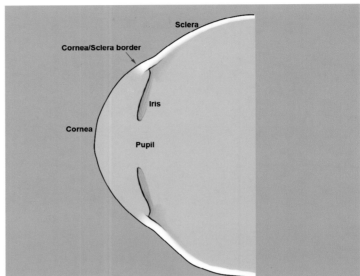

Step 3: Constructing an eyeball

This illustration shows how we should construct the eyeball, as opposed to how it's constructed in real life. I'm using three shortcuts here. One is to make two layers—the outer transparent layer, and the inner opaque layer. The shadow around the edge of the iris will have to be faked—added in the color map. You'll want to apply bump-maps only to the specular layer, not to the diffuse layer. Another is because the pupil is just a hole, it can be faked just as well by using 100% black on the color map saving modeling and rendering time. Finally, you can make the iris bowl-shaped (concave, instead of slightly convex). When shaded correctly, this can give us a believable and fast-rendering fake for the caustic highlight often seen in eyes.

Step 4: Modeling

First make a polygonal sphere (default 20/20 resolution is fine). Turn it so one pole faces forward (you can optionally delete the back half). Use polygons for better compatibility with other applications. Then make a copy of the sphere, slightly larger. "Dent" the copy outward at the cornea, and dent the inner original sphere inward for a bowl-shaped iris on the circumference of the iris.

MODELING/TEXTURING
Eye of the beholder
Simulating human eyes

Step 5: SoftMod tool

One of the easiest ways to model the eye shape is to use Maya's SoftMod tool—pick the polar vertex with the tool active, and pull it out. Then adjust the region of influence of the tool, scale it a bit, maybe add a row of edges, and tweak it until it has the cross-section shown below. Then Smooth it once.

Step 6: Two surfaces

Here are the two surfaces shown side by side with wireframe versions at the top. Note that the Cornea/Wet layer will be totally transparent (PhongE), while the Iris/Sclera layer should be either mental ray SSS Fast Skin in Maya versions earlier than 8, or Blinn in v8 (due to the addition of the subscattering attribute there).

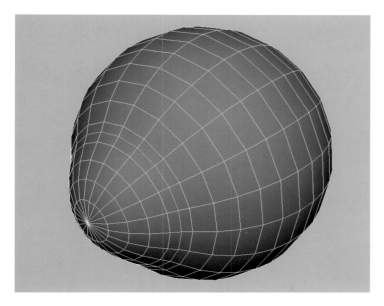

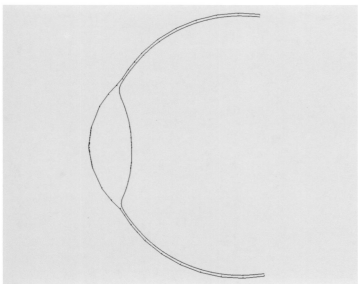

Step 7: Cross-section

This is what the model in my rendering looks like in cross-section. To find the cross-section just pull the clipping planes of the Side camera close together. I could have a slightly bigger and thicker cornea, but sometimes that can lead to problems interpenetrating the upper eyelid. When the modeling is done, I fix the UVs (by just using a frontal projection), then apply and tweak shaders.

Step 8: Physical measurements

The average diameter of the eyeball is 24mm while the diameter of iris is half that of the eyeball. The average width of a face is roughly 135mm (measured at the temples, not the widest part of the skull). That would make it about 5.6 eyeballs wide. The average female skull is 216mm high, 190mm deep, and 152mm wide (measured across the widest part of the skull). The average distance between the pupils is 65mm for women. In this top view I haven't kept the center axis of the eyes pointing straight forward, but have tilted them outwards 3-5 degrees. This moves the irises out towards the outer corners of the eyes, which is good as the outer eye-corner is further back on the eyeball than the inner one, normally making the iris look un-centered looking ahead.

Step 9: Shading

These are the settings and the shader network of the mental ray SSS Fast Skin shader I used for this eye. Start with the default SSS Fast Skin shader (or if you have Maya 8 you can also use an ordinary Blinn with a bit of scattering). Attach texture maps similar to these examples (these are for blue eyes). You can use the same color map in both Overall and Diffuse. No bump is needed. Set the Primary Specularity to zero and only use the secondary.

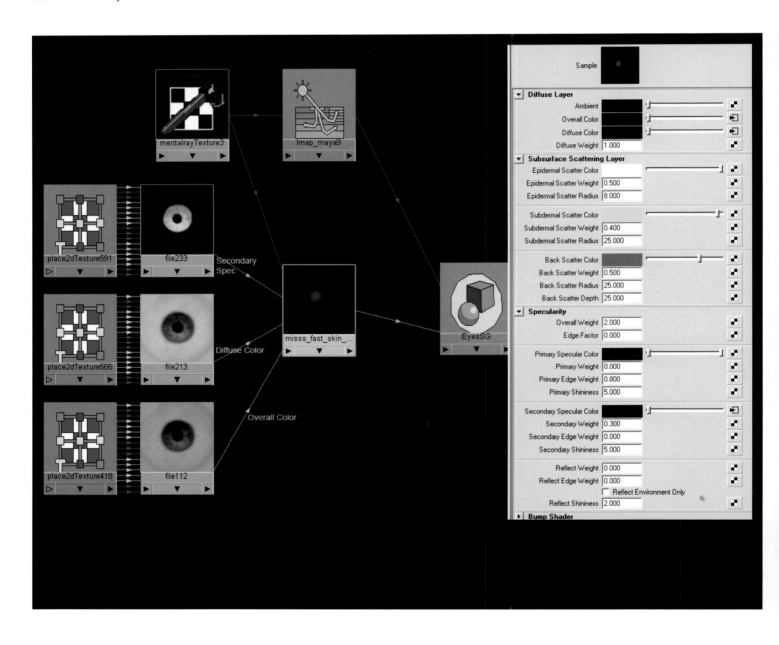

MODELING/TEXTURING
Eye of the beholder
Simulating human eyes

Step 10: Brown-eyed girl

We want brown eyes, so the color and spec maps should look something like this. Note that on the color map for the sclera, there's a blue-grayish transition where it meets the iris. Also note the slightly blurry edge on the pupil. These blurry edges are very important, sharp edges in the eye area are a dead CG give-away. The iris is slightly bulging, but I've pushed it into a concave bowl shape to catch a highlight on the side of the iris opposite the direction of the light—with the right kind of shader this simulates a caustic hot spot. The Blinn is perfect for this, but in this example I'm using the mental ray SSS Fast Skin shader, because only in Maya 8 did the Blinn have the sub-surface scattering attribute.

Step 11: Specular map

The specular map should be black over the sclera and pupils, and a hot vibrant version of the color map over the iris. If it's brown, as in this case, it should be orange-red. If the color is blue-gray, it should be a 100% blue or cyan.

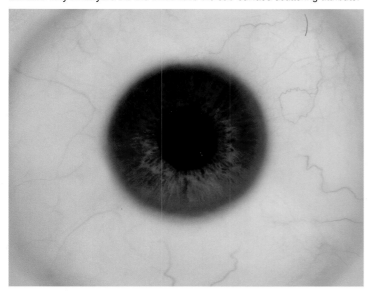

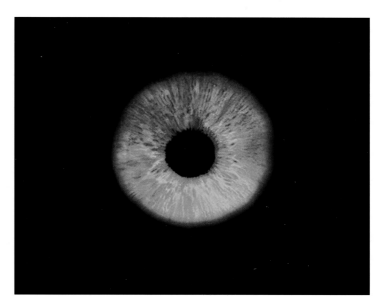

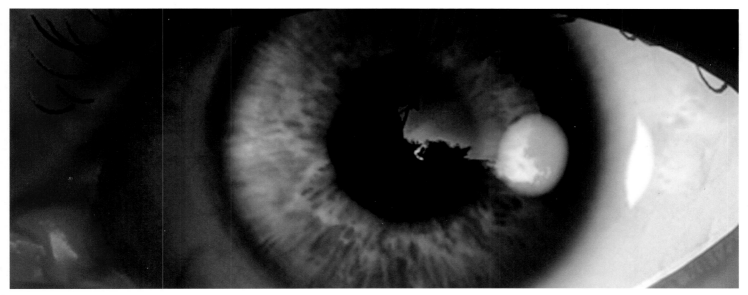

Step 12: Caustic fake

Here you can see how the Blinn highlight simulates fairly accurately how light interacts with the iris. Blue is used here since it shows up the effect more clearly. This was rendered in mental ray, with HDRI and a single spotlight (raytraced shadows; not very strong intensity; the HDRI did most of the work). Lastly, we have the cornea/wet layer, simply mapped with a PhongE shader to make it look glossy. The PhongE settings are: Dark color; fully transparent; Diffuse left at default; Roughness: 1.4; Highlight Size 0.04; Specular Color: 0.58; Reflectivity 0.1; and Index of Refraction: 1.38. Note: the bump map goes in this shader, not the lower layer. Note also that I'm using a subtle noise bump map on the wet layer to be more realistic, but don't let it cover the cornea. The cornea is always perfectly smooth (or we'd all have trouble seeing clearly). Since the wet layer shader is also covering the sclera, the sclera-shader itself shouldn't have specularity or reflectivity at all (only some specularity on the iris, as described above). That's why the sclera should be colored black in the specularity map. The pink wet inside of the inner eye-corner is tricky, semi-hidden, and fitting snugly to surrounding tissue. It needs to visually blur into the sclera somehow, either by a transparent soft edge, or by using a similar color at the edge. The shader is SSS Fast Skin, very similar to the sclera, plus a wet layer, slightly redder but not too dark or strong pink.

Step 13: Common errors

Here are some of the most common mistakes people make when creating eyes. Too symmetrical—taking the abstract notion that the eye is almond-shaped way too far. The real eye is only very vaguely shaped like an almond. The solution: use good reference and study it closely, add more complexity and subtlety to both eye corners.

Step 14: Too symmetrical?

Still too symmetrical, except now the pointy almond corners are replaced by a very common problem generally speaking in all CG modeling—excessive softness. This happens because not enough edges are present to give enough resolution. Solution: again, study reference, and add edges.

Step 15: Too large?

Iris too small or too large? Solution: read the previous measurements, and apply them to your model. There's also a problem of placement in this example. The iris is too low. Solution: study reference. As you can see, the upper lid should cut off or hide more of the iris than the lower lid.

Step 16: Too dark?

Iris edge too dark? Remember it's a cast shadow, and as such it may be wider and thinner, and even disappear at certain angles of light. Solution: don't make it 100% black, which means that no matter how bright the light, it will always be too dark. The iris edge is also too sharp—another common problem. Make sure your test renderings have the same kind of softness that your references have. In this particular image, there's also a problem with the eyeball model—it's a plain single sphere with no modifications. The cornea is missing. Other common mistakes include making the eyelid's edge too thin, too rounded, or not evenly the same thickness all around.

MODELING/TEXTURING
Eye of the beholder
Simulating human eyes

⬇ Step 17: Getting better

Only a few years ago, the eyes used to be much harder to do. But, with HDRI, sub-surface scattering, caustics, and much better reference on the web they're much less scary—almost fun. The modeling is easier if you approach it with measurements and reference. The hardest part is shading and troubleshooting the test renders. This comes with experience, so don't get impatient and lose heart—once you've perfected an eye you can use it as the basis for almost any other character's eyes.

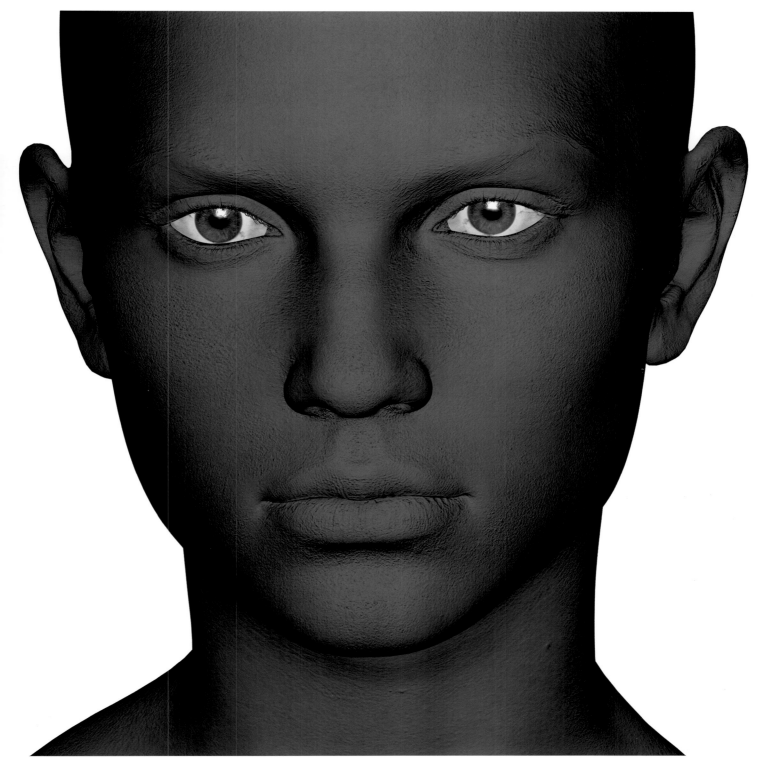

MARK SNOSWELL

A HEAD ABOVE
PARAMETRIC HEAD CREATION

Making human heads

Everyone wants to build their own ultimate head model—just once. Either you manage to build your ultimate head model, with perfect topology and UV mapping, or you don't. Either way you probably never want to do it again! If you do succeed, then you want to reuse your model again and again. You want to retarget it to any shape head you need. You want to be able to lower and increase the resolution as you want. You also want to keep all the rigging and animation data you build up on one project and reuse it on every new project. You also hate the idea of using someone else's parametric head. You hate the limitations that the software designer imposed. Worst still, you hate the aesthetic decisions some designer made when choosing the base head models and facial features. You're right. I totally agree.

You should have the best, and it should be your choice. You should be able to reuse all your animation. You should have complete control over the topology, and you should be able to access the best of photo-fitting and hand-modeling features. Fortunately, you can.

There is one mathematical approach to parametric head modeling that can do all of this and a lot more—principal component analysis. Let me explain: if you examine a big enough set of similar data then you can do an analysis to see whether there are groupings (principal components) of features that define the variations in the data. If you do this for scanned head data—you take a large sample of full 3D scans (including color data) of people's heads—you come up with about 140 principal components (parameters) that define a human head, including skin and eye color maps. This is the basis for one remarkable piece of software, FaceGen. This standalone application can encode and generate any human face.

It is based on a large set of full-color 3D scans of people's heads. It has no designer bias—it's based on real data. Because it's parametric, you can: load any topology head mesh you like, and everything still works; do automatic fits to photographs and generate fully parameterized heads ready to animate; blend face parameters or randomize them to generate sets of "relatives"; work with the most powerful and efficient manual modeling tools; and choose race, sex, and age properties with ease because it's based on real population data.

I am belaboring the parametric point a bit here, but that's because some things are just right—principal component approach to head analysis and reconstruction is one example. If you want a human head, this really is the best way to go. As you will see, I have imported in the head and UV mapping we created earlier into FaceGen, so I get all the benefits of our own head model and mapping without losing anything FaceGen offers.

I am using FaceGen as an example of the best features you want from a parametric head modeling system. Whether you will ever use FaceGen or not, the point is that human heads share a lot of common properties and once you have a good head model, you want to reuse it as much as possible—if someone else has done the work for you, then use it and get on with the interesting aspects of customizing, animating, and bringing your character to life—it's not cheating!

FaceGen is a standalone system that outputs models that you can bring into any software, and it has a free demo version. FaceGen also has a commercial SDK, so you can integrate its features into your own game like Bethesda Softworks did with 'The Elder Scrolls IV: Oblivion'.

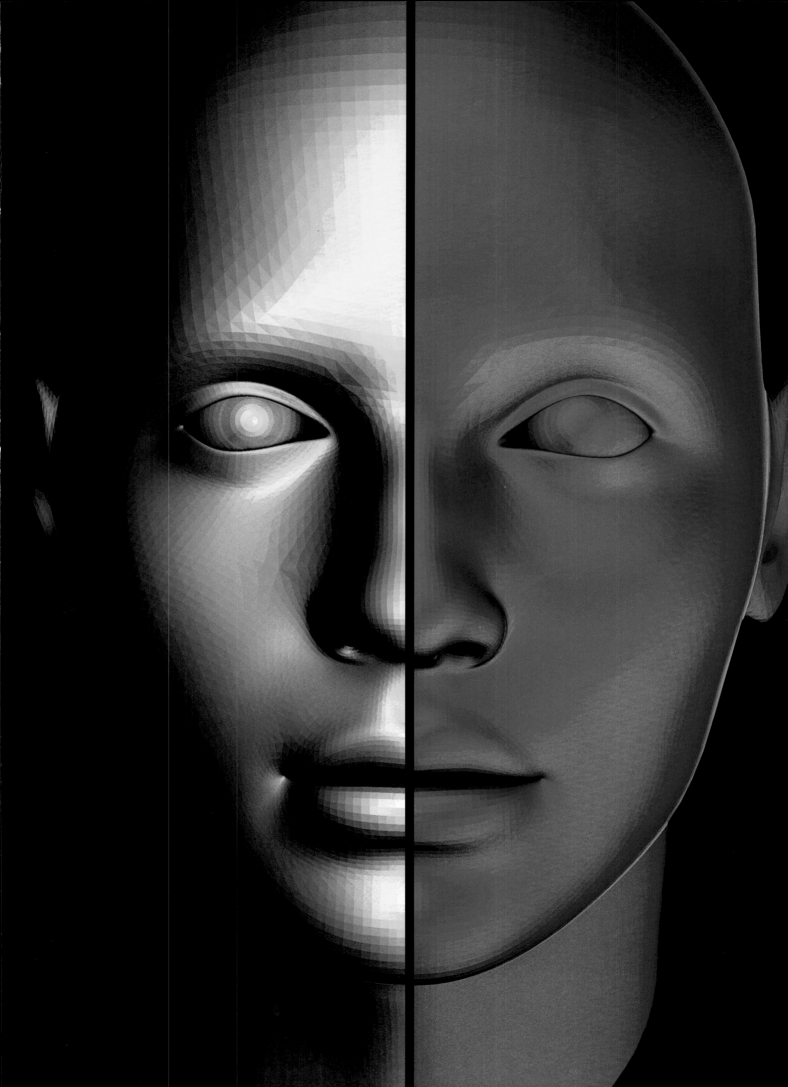

Step 1: Any topology

FaceGen (FG) has 140 parameters that define the head and its coloring. The parameters are all based on the average head shown here. Because the head is parameterized, we can use any topology mesh we like. Here are the FG2, FG3, and our head models—the base texture is also part of the parameterization. I do most work with our 2K model as it's easy to propagate the changes from this model up or down to other res models back in 3ds Max. There really isn't any benefit to loading higher-res models into FaceGen when we can propagate changes to any res model ourselves.

Step 2: Face parameters

FaceGen encodes the face with 140 different parameters for both shape and texture. Here, we see just a sample of the parameters. There is support for both symmetric and asymmetrical parameters. These parameters have been derived from principal component analysis of a large database of full-color 3D head scans. The analysis applies to the face region and overall head shape. It does not include the ears or neck which you will have to tweak yourself. Everything FaceGen does is in this parameter space; it does not care about the topology or UV mapping of your particular head model.

MODELING
A head above
Parametric head creation

Step 3: Sex

FaceGen has a number of high-level controls that let you vary your model starting from any face shape. These high-level controls are for: sex; age; caricature (distance from average human); asymmetry; and race. Here, we see the sex variation around the average human face, from very female, through indeterminate sexuality to very male. It's easy to create your own face (by hand or fitted to a photo) and then generate its brother or sister—or an exaggerated sexier version.

FaceGen varies parameters from the average human face, but doesn't limit you to just the range found in the human population. You can exaggerate any characteristic beyond the normal human range, so creating super-sexy or exaggerated characters is easy and it's predictable. Predictability is the key thing. Because of its statistical basis, FaceGen will always give a predictable result based on real human morphology—exactly what we want from a parametric head system.

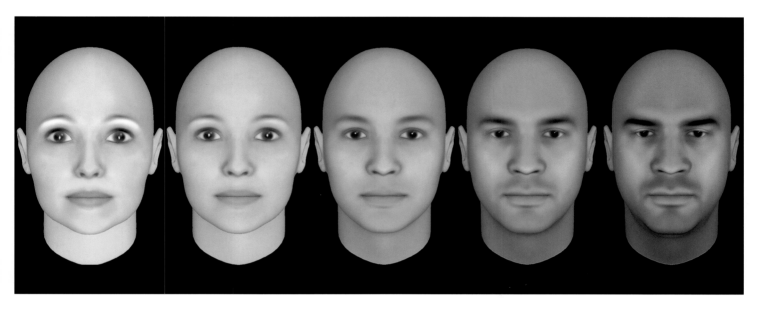

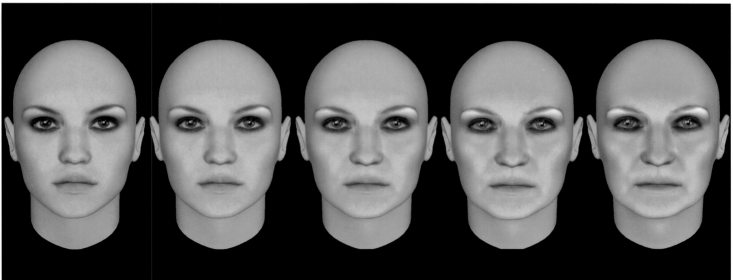

Step 4: Age

Here, we see the results of taking a photo fit of our model and aging her from 25 (the age FaceGen determined from photo analysis) to 65 in 10 year steps. Note, that both the face shape and texture are affected with age. This will work with any model you start with. You can then export the models and use them as shape targets and texture modifiers to tweak your own aging models—like those Paul Fedor shows in his chapter 'Aging Monika: Painting in the years' with textures alone.

The data set that FaceGen is based on does not include children. If you want to use FaceGen to create children, then you would make a set of age targets based on the average face and use these as additive morph targets in your own software. This works fairly well, although it is restricted to the one topology model you choose to use, and the results will be based on your own guesses of average young faces—not any real population data.

MODELING
A head above
Parametric head creation

Step 5: Race

The database FaceGen was built on included people of African, South East Asian, and East Indian decent. Because of this, you can alter a model based on race. Here is Monika with her African, European, South East Asian, and East Indian virtual cousins. Interestingly, when you do an automatic photo fit, FaceGen automatically sets the high-level parameters—so you get an unbiased prediction of

sex, age, asymmetry, and racial makeup of your subject. It's then very easy to tweak your 3D model to be a "little sexier", or younger. This sort of high-level tweaking is very efficient and invaluable in an entertainment environment where you are often asked to "enhance" the features of an accurate representation of someone.

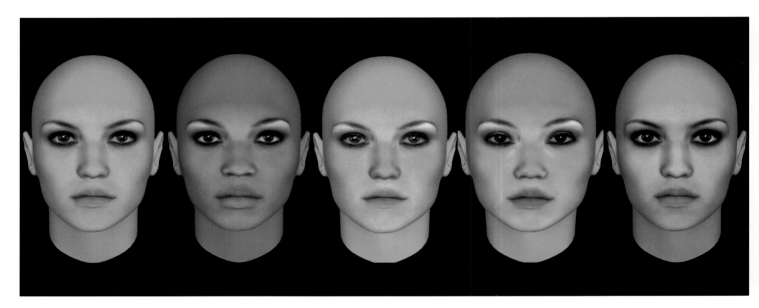

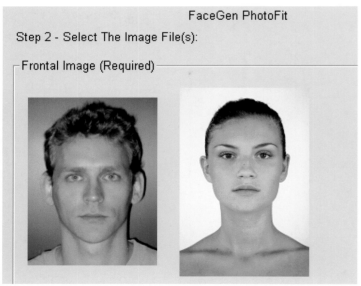

Step 6: Fitting to photos

FaceGen does a pretty good job of creating a model from photographs. This is a fully automated process that requires just two (front and profile) or three photographs. It always works, and the fit is pretty good. If you do need to go in and hand-tweak the fit, it's very fast and easy. You will certainly need to hand-tweak the back of head, ear, and neck shape once you export the model into your favorite 3D software. However, where FaceGen really shines is that the fitted face is fully parameterized. FaceGen uses the photographs as a simulation target and varies its facial

parameters until it gets a good fit. It then applies a blended version of your photographs as fine detail texture. Other photo modeling software just produces a mesh and texture that looks like your target, but it doesn't know anything about it. By contrast, the fitted FaceGen head can be applied to any mesh you load into FaceGen. It can be used immediately to generate variations of the original as we did with the race and age, and it will work with all your pre-done rigging and morph targets provided within FaceGen.

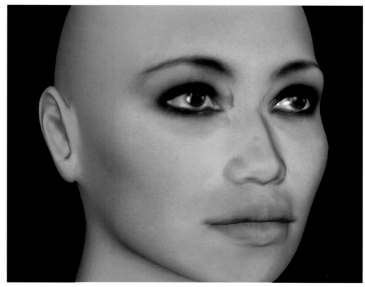

Step 7: Genetic variation

One of the benefits of working in a parameter space is that it's easy to generate variations and mixes of facial characteristics. An alternative to manual tweaking is genetic variation. One you have created or photo-fitted a face, you can wander through the parameter space by generating random variants on your base face. Any variant you select becomes your new face and a new set of genetic variants are generated around this new face.

Step 8: Parameter modeling

With a parametric modeler, you change your model by varying parameters—not by editing a mesh. In FaceGen, you can do this via the parameter sliders or simply by Ctrl-dragging the 3D model. As you do this, you can see the changing parameters affected by the region you click on. By restricting the modeling to parameter space, you get a degree of control and efficiency that is impossible any other way. It's truly astounding how intuitive and fast hand-modeling can be when it's restricted to the human parameter space.

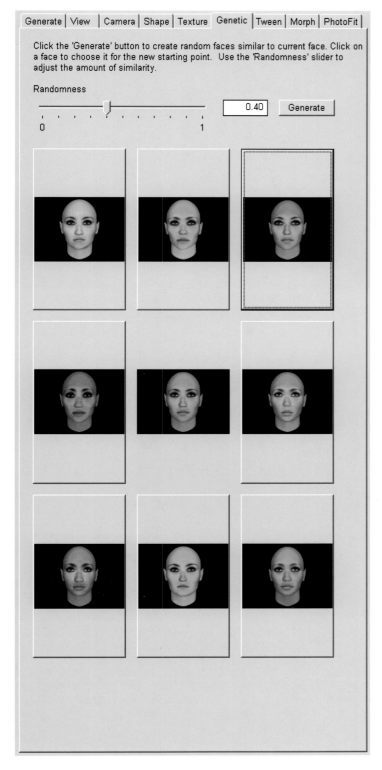

MODELING
A head above
Parametric head creation

Step 9: Extreme features

FaceGen allows its parameters to be pushed beyond the normal range found in the population. This means that you can create some pretty strange-looking people. However, everything you create is clearly human-based. This is a limitation that is both good and bad. It's really fast, and easy to create human faces within a parameter space based on real humans. However, it's not possible to make gorillas, pixies, gnomes, cats, or other faces that significantly differ from the human norm.

Step 10: Distance from normal

For any model, you can vary its distance from the average human face. This means that you can exaggerate the features of a head you have made, or you can tone them down. Here, I have taken our extreme face shape and simply moved it back towards the average. This feature works flawlessly—I have never seen any results that weren't totally predictable with this approach. By comparison, I have wasted days with parametric head generators that were only based on some software designer's idea of what a face generator should do. In my experience, these are worse than useless.

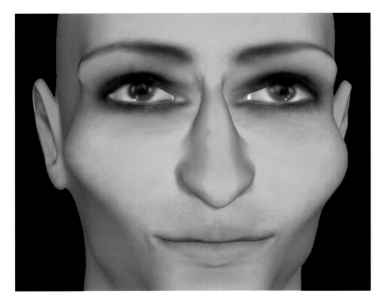

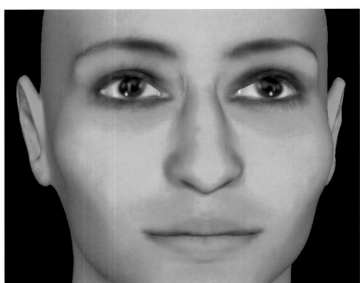

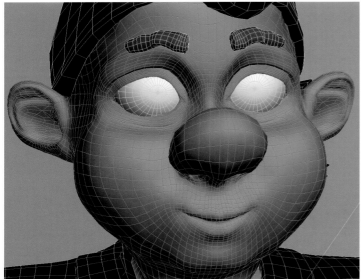

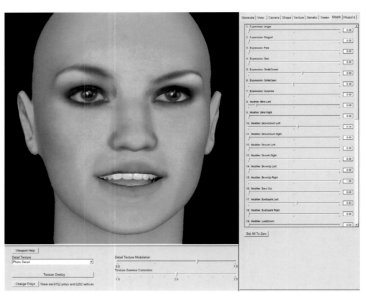

Step 11: Fantasy faces

You can use software like FaceGen to do fantasy races. All you need to do is add a single morph difference from the average human head to your average Gnome (or whatever). Then you get all of the human range of variations, but based on your new fantasy race model. FaceGen now supports this additional morph step internally, although I still like to do this step in 3ds Max under my control. Here is a gnome head done this way. By basing it on the average human head from FaceGen, we were able to complete the modeling live with the director sitting next to us.

Step 12: Morph targets and rigging

FaceGen comes with a basic set of morph targets for all the emotions, possible human facial expressions, and phonemes—the range that most humans are capable of. In this picture, you see that our model has teeth and a tongue. You are also free to add as many additional facial components as you like. These will change to fit whatever head you generate. Similarly, you can embed special objects just for rigging if you want. These will undergo the same solid deformation that FaceGen is applying to the head.

MODELING
A head above
Parametric head creation

Step 13: Mesh smoothing

I do most of my work on a 2K (2,000 quads/4,000 faces) head model. This is sufficient to encode good detail for the eyelid thickness, nostrils, mouth, and ears. You can do pretty much all of the rigging and facial control you want at this resolution. Additional detail can be added by subdivision and difference edits in the graphics pipeline. Changes to the 2K model propagate to the higher-res models correctly. Here is our 2K mesh subdivided up one level. Unfortunately, all of the mesh smooth subdivision methods also smooth out detail. This is a real problem in areas like the eyelids where we really want to keep the detail. See how the subdivided (cyan) mesh has smoothed out our eyelid detail.

Step 14: Patch subdvision solution

The solution to this problem is to turn the polymesh into a patch, flatten the tangent control handles and then subdivide. In 3ds Max you do this by applying a Turn To Patch modifier, then an Edit Patch, then select all verts at the sub-object level and Reset Tangent Handles (right mouse click menu). Next you subdivide the patch, then you apply a Turn to Poly modifier. Now you have a mesh that has been subdivided through all your original verts as you can see here.

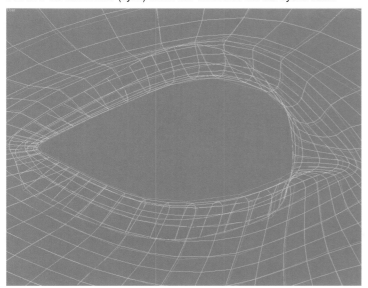

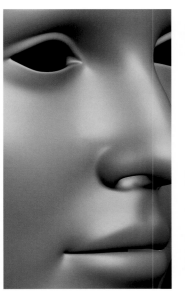
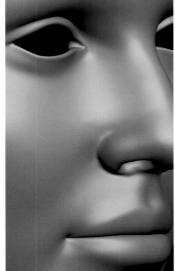

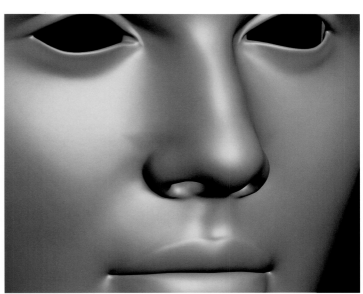

Step 15: Comparing the subdivision methods

Here is a render of the result of the two different subdivision procedures. Both renders have a final subdivide (both the same type) applied in the renderer. The bad mesh subdivide is on the left. You can see that the smoothing has opened the mouth. It has also thinned up the lower eyelid and smoothed out detail around the nose and the corner of the mouth. The patch subdivide model on the right has kept all of our fine detail. Efficiency tip: add an Unwrap UV modifier and weld UV verts after you do this.

Step 16: Adding detail

No matter how good any parametric head generation system is, you are inevitably going to want to add your own detail. The trick is to always try to get your parametric head model to a point where custom detail can be added without any concerns about losing detail if you change the parametric head model. Starting with the 2K base parametric head, this is nearly always OK. After adding a level of subdivision with patches, you can convert to polygon and add an Edit Polygon modifier. All your tweaks are now based on relative vertex motion and should hold up if you change the base model shape. Here, we see the results of tweaks around the eyes, nose, and mouth.

MARK
SNOSWELL

REAL SKIN
SUB-SURFACE SCATTERING

Rendering translucent skin

Better lighting is the main thing that has improved the quality of 3D renders in the past decade. By that I don't mean better lighting design. I mean better simulation of light behavior. With hindsight, there are four areas of lighting simulation that turn out to deliver most of the jump in visual realism. In order of impact, these are: ambient occlusion; translucency; high-dynamic range; and radiance. Here, we will focus on translucency. For our purposes, translucent materials have a significant component of their look dominated by light that enters the material, is scattered and emerges back out again.

The current sub-surface scattering (SSS) methods stem from work Henrik Wann Jensen started in 1998. In a presentation at SIGGRAPH 2001, Jensen stunned the graphics world with his elegant method for SSS. Just three years later, Jensen received an Academy Award for technical achievement on SSS methods. Jensen's methods are a fast approximation to full photon-mapping and simulation that work very well for most common translucent materials. Rarely has a new graphics method leapt from academic to global commercial use so rapidly.

I had been working in the 3D field professionally for a long time before the advent of SSS. I learnt all of the best techniques (and developed some of my own)

for faking a good look for skin—a look that faked some of the translucency properties of skin. Combine these fakes with ambient occlusion and image-based HDR lighting models (we even wrote our own spherical harmonic shaders), and you get pretty good skin renders. I remember the excitement of Jensen's BSSRDF presentation at SIGGRAPH 2001—but, I figured SSS would be slow and hard to use although it clearly did a better job for skin than any fake ever could. So, like many others I hung onto all my cheats and avoided jumping to SSS until recently. Here is the link to that seminal paper Jensen presented at SIGGRAPH 2001: http://graphics.ucsd.edu/~henrik/papers/bssrdf/

Now SSS is widespread. All of the high-end 3D systems offer it. You can do great SSS in real-time on most GPUs (Graphics Processing Units on graphics cards), so it's starting to turn up in games. Having upgraded to SSS shaders recently, I can say that there is absolutely no reason not to use the SSS methods for skin—well that's unless you have a shot with the character lit only with blue light or very low-level light like moonlight.

We are going to have a look at the mental ray SSS Fast Skin shader as it's available almost everywhere now. It turns out to be surprisingly fast and easy to use—and the results are a jump above anything you can ever fake.

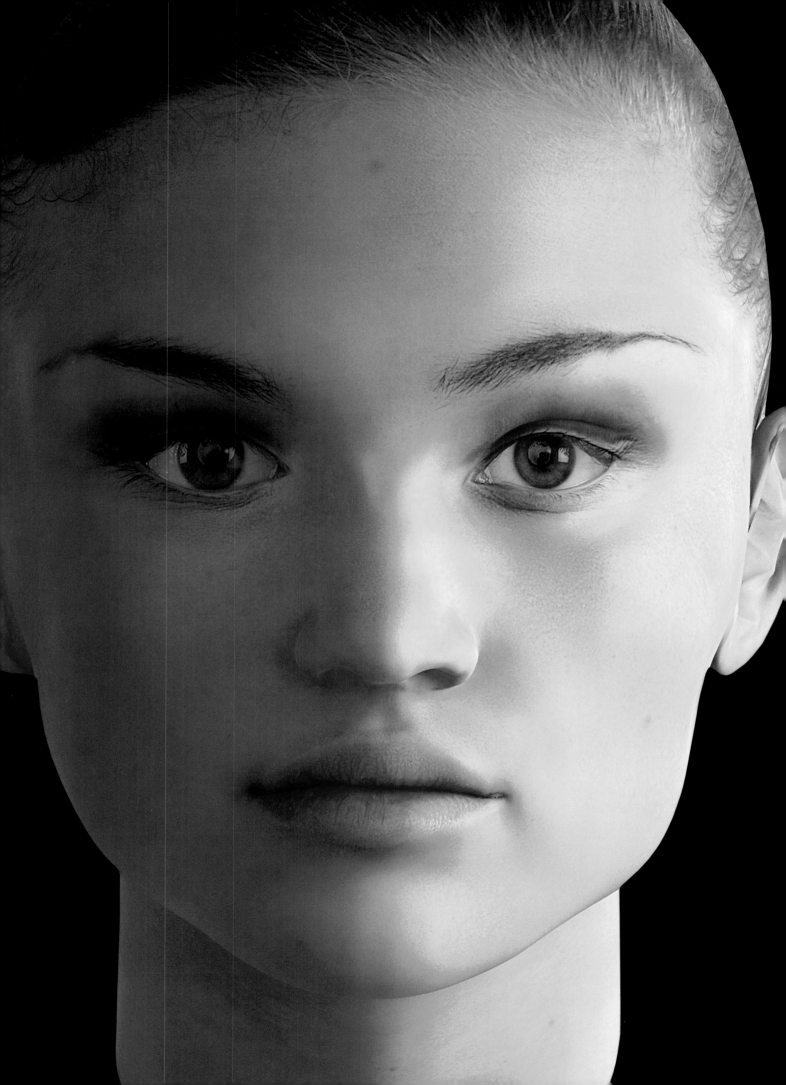

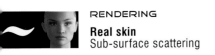
Step 1: What is skin?

Human skin has three major parts: epidermis; subdermis; and subcutaneous. The outer layer is the epidermis. There is no blood in this layer, and it is semi-translucent. It filters out most of the blue and some of the red light resulting in a pale straw color. As we go deeper more of the short wavelength (green and blue) light is lost. The Subdermal layer contains blood vessels.

Only the long wavelength red light can penetrate this deeply. To simulate the light scattering properties of skin the mental ray Fast SSS Skin shader adds scattered light from three layers to surface shader components. The SSS components are for the epidermis, subdermis and backscatter (light penetrating all the way through the skin).

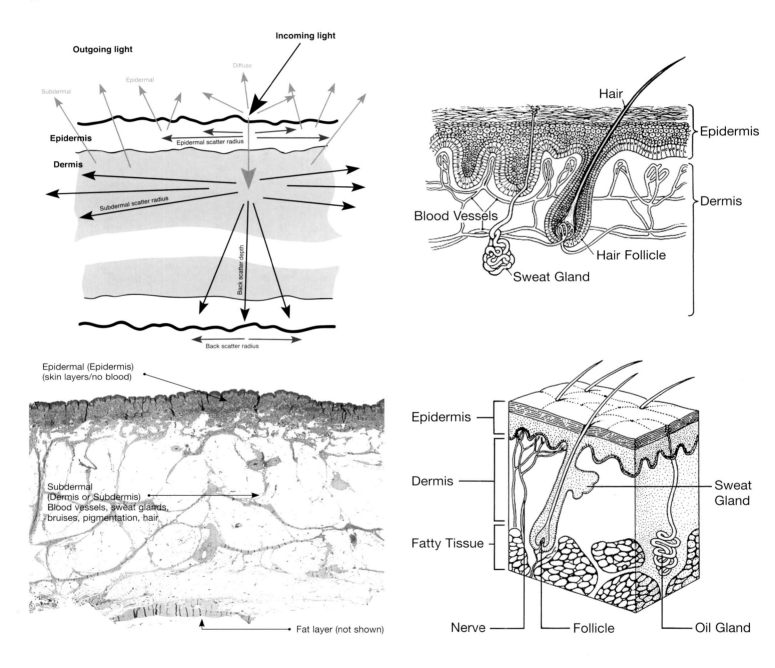

Step 2: Getting the scale right

All of the SSS shaders scatter light in real-world units, so you have to get the scale right for your skin shader to look real. If your model is too small, then light will scatter through it too much and it will look like some miniature transparent toy. Get the scale too large and there will be almost no scattering and your model will look massive (or just plain fake).

There is a Scale Conversion Factor that will let you scale everything in the shader to match the scale of your model. As a start, apply the default SSS Fast Skin shader and try a range of Scale Conversion Factors. Use the width of the nose as one unit for a guide. Here are the results of a range of scales, from too small to too large.

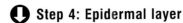

⬇ Step 3: Back scatter

SSS shaders have more components than you are probably used to. In addition to the normal diffuse and specular components, there are three sub-surface scattering components. Here, we see the output of the back scattering component. This scene is lit with one backlight, and a large area light on the model's left. This and the following component renders are using the mental ray's SSS Fast Skin shader with default parameters. Here, the Back Surface Scatter weight is 1.0. Unscattered Diffuse, Epidermal, Subdermal, and Overall Specular weights are all set to 0.

⬇ Step 4: Epidermal layer

For Caucasian skin, the epidermal layer scatters a creamy color mostly missing the blue component. Although we have a bump map applied for all of the test renders, it does not affect the SSS components. This is because the light entering beneath the skin and scattered is softened out so much that no bump detail is visible at all. In this image, all the component weights except Epidermal layer are set to 0.

⬆ Step 5: Subdermal layer

Here, all of the blue and much of the green components are missing resulting in a deep orange scattered light. This layer is even softer than the epidermal, but not as soft as the back scatter. In this image, all the weights except Subdermal layer are set to 0.

⬆ Step 6: Specular #1

Skin specularity can be approximated with two specular components of roughly equal weight. A broader sheen, and a sharper, oily reflection. Here, we see the result of the broad sheen specular component. This is tinted blue as most of the red from the incident light penetrates the skin. The blue hardly penetrates at all, and is dominant in the reflected specular component. In this image, all the weights except Overall Specular and Specular Color #1 are set to 0.

Step 7: Unscattered diffuse color

This would be your normal diffuse component in a regular, non-SSS shader. For pale skin, it is only a minor component—most of the look of skin comes from SSS and specular light. As the skin is quite translucent to the longer wavelengths (red), the surface diffuse map needs to have red, and to a lesser degree green removed from it.

Step 8: All but the diffuse multiplier

This is a scary shader. It looks like a soft silicone skin mask. We are missing surface detail. Not all of the skin is equally translucent. There are freckles, moles, dirt, makeup, and hair that are not very translucent. For this reason, the SSS shader has an Overall Diffuse multiplier. First, the shader adds the Unscattered Diffuse Color, Epidermal and Subdermal color components. These make up the diffuse component of the shader. This is then multiplied by the Overall Diffuse Coloration multiplier map. You should use a very desaturated map with high contrast for this so you don't affect the skin tone too much. You should also introduce all those facial features like freckles and makeup.

Step 9: The first rough SSS render

Turning it all on with the recommended weights gives us our first rough skin render. The default weights for the various components are: Unscattered Diffuse 0.3; Epidermal 0.5; Subdermal 0.4; Back Surface 0.5; Overall Specular 1.0; Specular #1 0.3; Specular #2 0.3. It's not a bad start and is probably what you will get with your first attempt with the shader. We need to tweak the maps and lighting now to get closer to reality.

Step 10: Improved bump and a bit of ambient

With all the components on, we have lost bump detail. I was also using a bump map without the hair in it so I switched to using our full-color map for bump. I also added a little ambient light in the shader. I like to develop shaders with a low angle, but soft (large area) side light. This shows up the shader performance under a harsh, but realistic lighting condition. It also gives me a feel for real render times for cinematic quality work. Now it's time to start refining the lighting as we tweak the shader.

Step 11: Improved balance

Now we are beginning to get closer. I have lifted the bump from 0.3 to 0.35. The Epidermal has gone from 0.5 to 0.55, and the Subdermal from 0.4 to 0.45. The biggest change is in the Specular where the overall weight had dropped from 1.0 to 0.65, and Specular #1 weight is down from 0.3 to 0.2. The forehead is looking a bit dry and the chin a bit greasy—but that could be due to the demanding lighting we are using. We are also still rendering with mental ray's default sampling with no antialiasing! Before we change lighting and crank the antialiasing up, it's time to see if the epidermal and subdermal maps we prepared earlier give any visible improvement.

Step 12: Blood vessels and darker hair

I have added the hint of blood vessels in the forehead and darkened the hair by adding a subdermal map. You create the map by starting with the flat color that the shader used for the subdermal and darkening it where there is hair or blood vessels. You can also redden up the lips at the same time, but that wasn't necessary here.

Step 13: Adding reflections

Using a plain white environment to the left and right, we add 0.045 weight reflection with and edge weight of 0.9.

Step 14: Post-render effect

Here is the final render sans eyes. I have toned back the specular components and adjusted the color balance with a post-render effect. I am not entirely happy with the lips. Now it's time to add the eyes in and do some serious tests with the antialiasing turned up.

🔻 Step 15: Final render

For the final render the hair and eyes are largely mapped on—but that's OK as we are focusing here on doing the skin. Overall, the result is pretty good for a fairly simple SSS shader with no hand-painted maps.

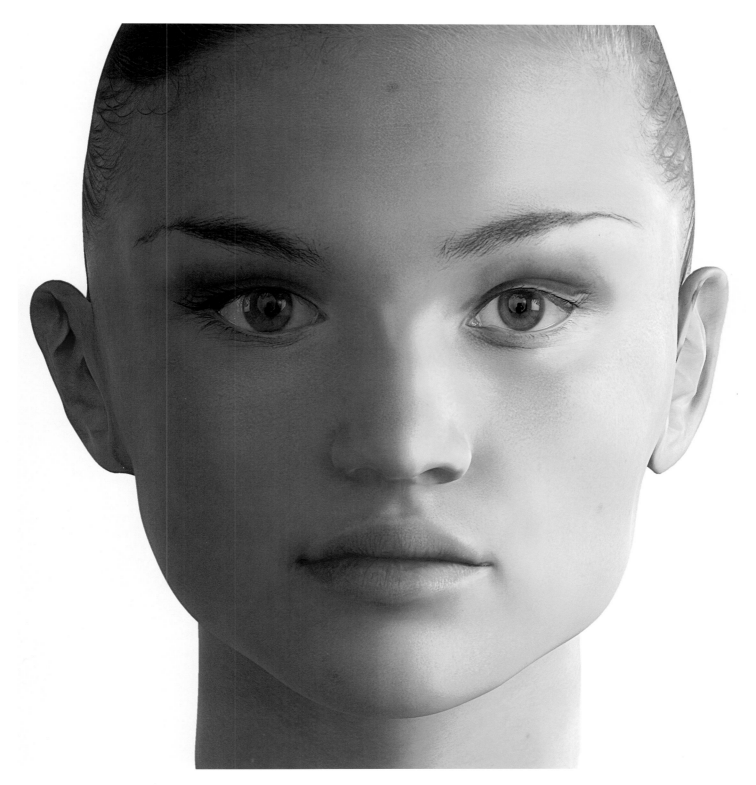

PAUL FEDOR

UNDER THE SKIN
POOR MAN'S SSS

Sub-surface scattering

Sub-surface scattering shaders (SSS) have been one of the most complicated and misunderstood subjects in CG. Video games usually don't have the time and money to pay heavy-duty shader writers. Often, there is not enough time for complicated sub-surface settings to be tweaked. Enter 'The Poor Man's SSS'. I decided to begin research on a map-driven SSS shader. All you had to do was to plug in the maps, and it would work in the default settings.

On every team, there will be a range of talent. I had to come up with a system that was usable on a mass-production scale, yet easy enough for kids coming out of art school to understand. In the end, shaders and textures depend on a lot of things, and this approach is just one

of them. It has been proven on several productions on more than 80 characters. It works with all types of skin including old, African American, Asian, Caucasian, and tissue damage. All this generated from one map, with 100% registration, down to a pore level.

There is much hullabaloo over skin, which is less than a millimeter thick. If you study Rembrandt's paintings he really only used about five glazes on his faces. If Rembrandt can do photo-real skin in five layers, why can't CG? The SSS shader is nothing more than a layered shader. Human skin is really not that complicated. Deep tissue, bone, and muscle are part of backface scattering, but that is not part of the skin. It's actually only two parts: the epidermis and the subdermis.

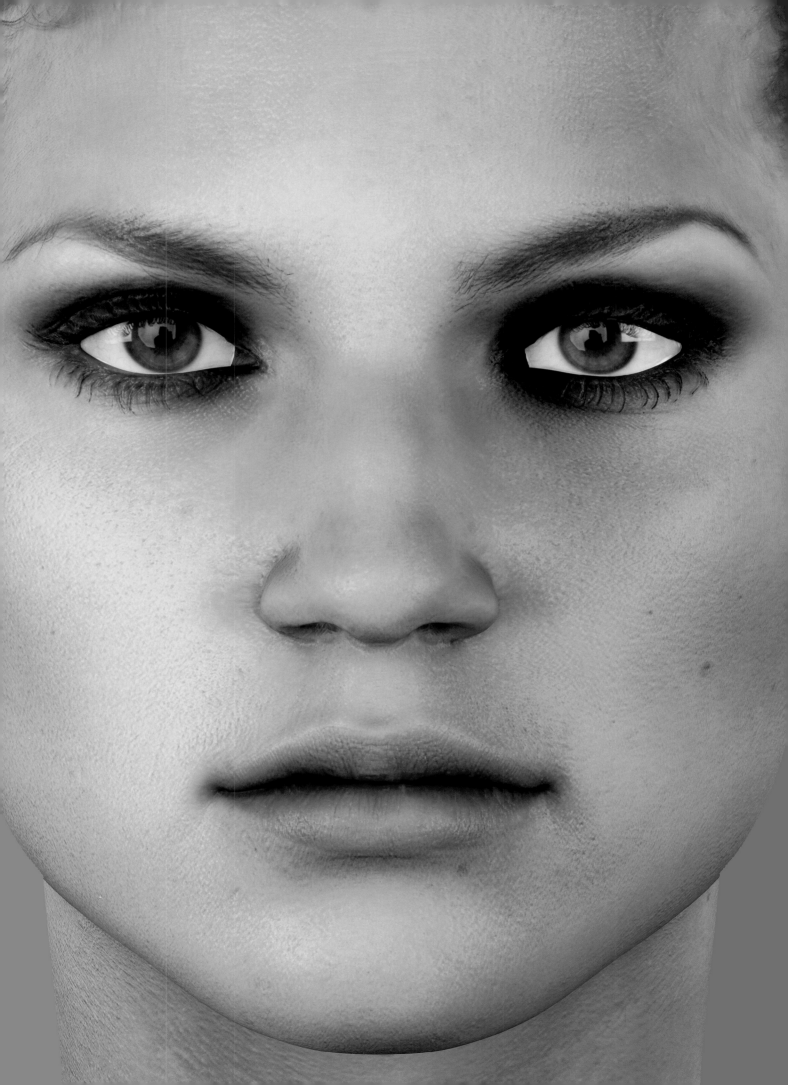

Step 1: Breaking out the color map

We start with the color map. Why put so much effort into one color map at 4K? Those hi-res photos hold more information than you know. From one 4K map, we can generate the bump, spec, and all blood layers with perfect registration.

Step 2: Epidermal color map

The epidermal layer is seven thin layers of tissue. To the layman, this is what is commonly believed to be skin. There isn't much to it—not even blood. It's a semi-translucent layer, kind of like a latex glove—not very exciting. This map is nothing more than a desaturated color map. For the epidermal color map simply desaturate the color map by 50%.

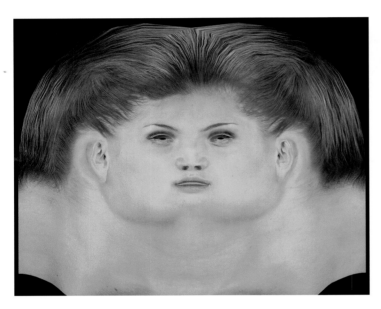

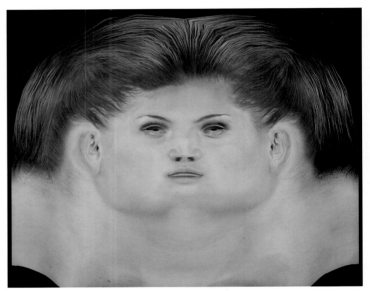

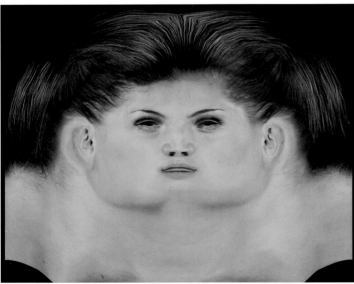

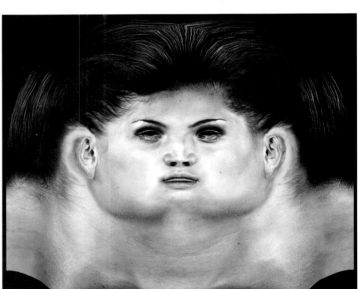

Step 3: Subdermal color map

The subdermal layer is where the action is: blood vessels (blue, red, and even yellow); pigmentation; blood clots; bruises; hair; nerves; and sweat glands. Therefore, the image map would be oversaturated. You simply take the color map and crank the saturation, bring up the midtones with Levels, or crank up red for blood. An example of how the subdermal layer works is when someone is sick. They'll often look pale because blood flow is reduced by illness. Blood drains from the skin vessels or looks blue instead of red due to lack of oxygen. This also applies to the elderly.

Step 4: Weight map

All sub-surface scattering does is split the skin into two parts and bounces some light around a substance no thicker than a piece of paper. This effect, if done correctly, will breathe life into a face. Often with SSS renders you'll see the "rubber eraser" effect. The problem is the weight map which controls how much light comes in and bounces around. Things like stubble, hair, dirt, and makeup should appear dark in the map. I take a greyscale color map and crank the levels, keeping stubble dark, and skin matte white. If you get milkiness in your SSS, the weight map is usually the culprit. I use only one weight map and in the subdermal only.

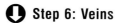

Step 5: Backface scattering

I consider backface scattering different from skin because it's only seen when a strong light is put directly behind flesh. This effect can best be seen in Georges de la Tour's paintings who realized that if you put a candle behind your hand you can see the glowing blood in your fingers. Only certain body parts have this effect. We will start with the ear.

Step 6: Veins

If you've ever cupped a flashlight with your hand as a child you would understand backface scattering. Basically, anything like bone and thick muscle will make your skin appear solid. In fact, biologically speaking you are a bag of water. When a strong light is close to skin we can see veins and cartilage as silhouette. We will start with medical photography of veins.

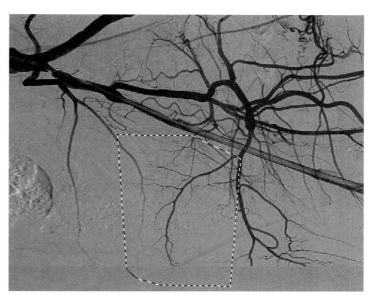

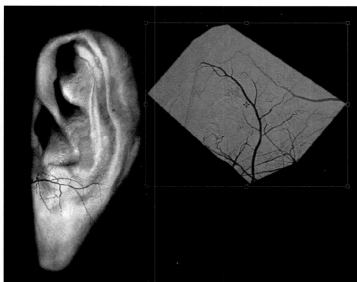

Step 7: Adjusting the veins

We adjust the levels on the ear map. Darker cartilage will appear opaque, and white will give the glowing blood effect. A simple Multiply blend mode will allow me to pepper the ear with some veins. Add some Warp and we are done.

Step 8: Translucent effect

Not bad for a couple of quick veins. Because the hair will be over the ears, I will call this done. If we had a specific close-up on the ear, I would spend more time on the finesse. I might want to relax the UVs in this area for further UV templates. There aren't many pixels for some cartilage areas, and I'm catching some pixelization in some veins. I like the overall glowing red.

⬇ Step 9: SSS neck

This neck part is a bit of a cheat. Technically, the whole neck is translucent except for the spinal column. You would see an inch or two of red flesh but that depends on what angle you are looking at. I know I am doing a front portrait so I will do a BS matte on the sides of the upper trapezius. I don't know where this is exactly on the map, so I am going to select the UVs with the Paint Selection tool to see where I'm going.

⬇ Step 10: Paint selection

The UV editor will reveal my selection from the Paint Selection tool. I am going to go ahead and pull a matte from this. The Paint Selection trick is always good if you get lost in your bakes as well.

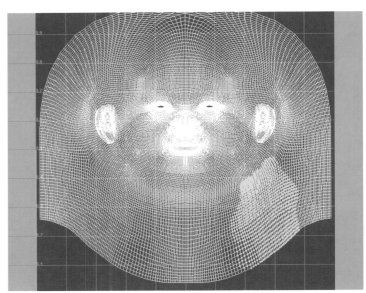

⬆ Step 11: Backface scattering map

I'm going to copy my greyscale color map and make a selection with a feathered lasso. Invert selection and delete. You might want to feather the edge with some spot-erasing. You can change this map if you need a blood flow shot from another angle.

⬆ Step 12: Nose

The last sometimes forgotten space is the cartilage in the nose. The nose is obviously a triangular piece of cartilage. Its shape makes the nostrils translucent. Go ahead and do the paint selection trick if you need help finding the nostrils. Be careful to take into account the triangular piece of cartilage. Just act like your cutting a jack-o-lantern. If you really want to be a stickler you can do the lips too.

Step 13: SSS check

Don't be afraid of close-ups! We did all this work on a 4K map, so you'll want to see the results. 4K really works on a macro level. I am liking the overall healthiness for the skin. The specularity is looking nice on the cheek. The power of SSS makes the skin feel alive. It's very hard to describe. If you have ever seen a dead body (I had to do cadaver training at Parson's), or if you've ever seen bad texture on a Blinn you'll know the difference.

Step 14: SSS check

One bad thing about SSS shaders is they can produce a "rubber eraser" effect. Maya doesn't make this shader easy for you. One of the annoying settings is the actual thickness of the scattering in the skin. The default setting in Maya is set for a foot-thick skin. Often, you will see "Rubber Eraser heads" on CGTalk. This is because the shader is bouncing light through skin that should be a millimeter thick. This is a photo-based pipeline, so don't kill all your photography maps by trying to get off on scattering.

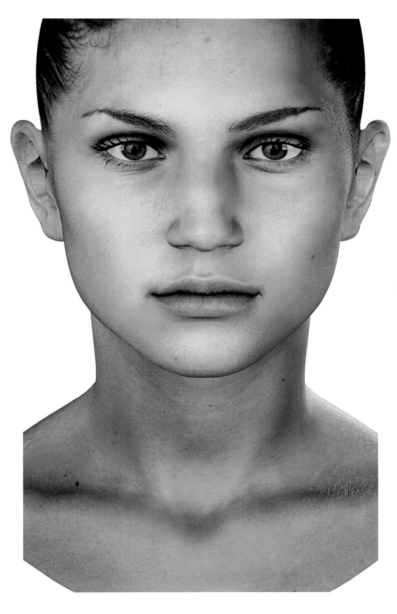

Step 15: Bump check

Weird things happen with the SSS. One phenomenon of SSS is that it seriously mutes your bump maps. This macro shot has a 15 setting. Bump strength is contingent on camera position. The closer the camera, the more you want to tone down bump settings. All you want to do with the bump is show a little bite. Monika's skin is very smooth, so when doing young skin don't overdo it on the bump.

Step 16: SSS check

Big pores always get better specularity. Notice the wonderful specular dings we are getting on the neck and collar bone. The neck usually has wonderful chicken skin. If you ever skinned a chicken, you know about the large skin dimples. Monika's healthy face has small tight pores. A lot of the neck and chest flesh has bigger pores so you would see naturally better specular highlights.

Step 17: Bump check

This was first pass at the shader. Believe it or not, I took the color map, just made it greyscale, added a touch of fog, and rendered. There are some shady spots. Parts in the upper lip and left eyebrow need some spot-fogging. I will go in with a 9% airbrush and spot-shade some grey into the bump.

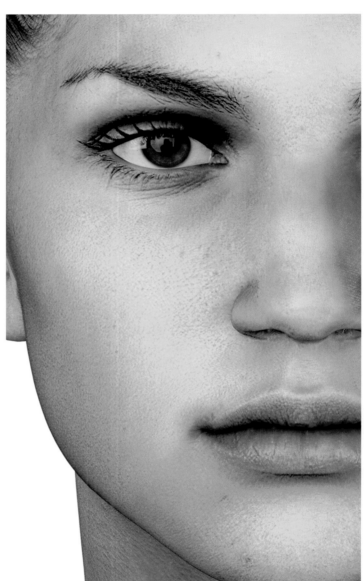

Step 18: Backface scattering test

The backface scattering neck trick is looking pretty good. When you think backface scattering, the most famous example is the shot in 'Lord of the Rings' where Gollum steps in front of a powerful light and you can see through his ears. Now you know the big trick. It's a piece of your greyscale color map. Keep in mind for this to work in real life, you need to stand in front of a powerful light or sunset. In other words, it's rarely seen.

Step 19: Test render

Keep in mind this is a quick render. I threw up a couple area lights at a 45 degree angle to pick up some specularity dings and some bump. This is a very neutral lighting set up. If I was shooting Monika in real life for a music video, I would use a KinoFlow light, or a ring light, or bounce something through some 10X silk. This is standard beauty lighting for makeup commercials. You want a flat even tone to the skin, especially with pain in the ass clients who want their female artists to be young and vibrant as possible. With male subjects you can take more risk with shadows and do more creative lighting. I actually turned off shadows for a quick cheat on rendering time. This is good enough to send off to the render person. The skin has life, but more importantly I know I've done everything I can to slam as much photographic detail as possible into those maps. I'm sure a good lighter can take it from here. Don't forget to save a look render. The lighting person should at least meet this level of quality, and it's good for his/her reference.

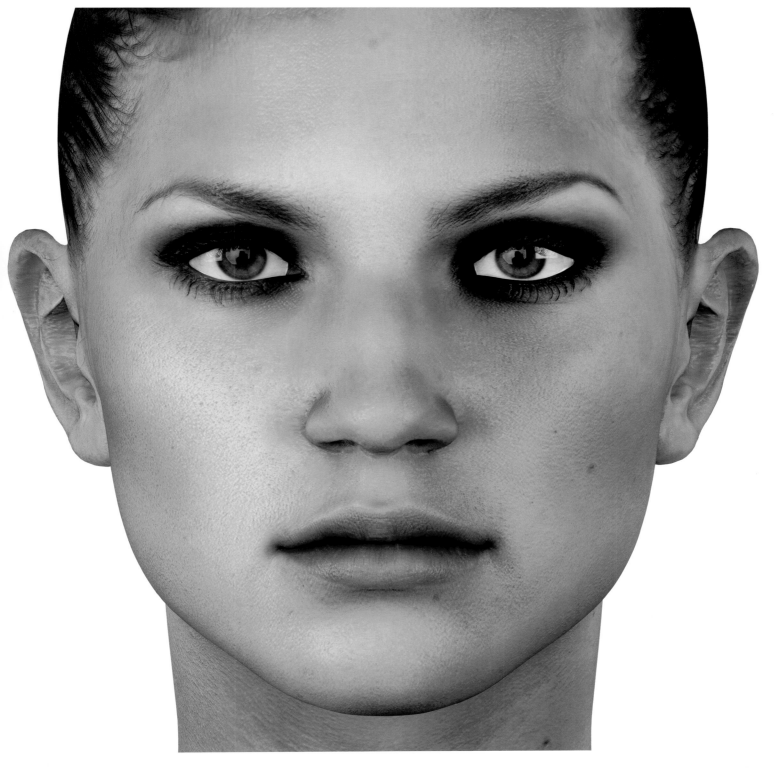

MATT HARTLE

LIGHTS, CAMERA, RENDER
LIGHTING AND RENDERING MONIKA

Lighting fit for a super model

The lighting direction for this project was pretty straightforward. Basically, we are creating a super model type of image, which means make her look hot! The best way to tackle any lighting project is to translate the stage direction, like "make her look like a super model" into something useful to you as a lighter. What makes a woman beautiful? Deep, liquid eyes, full lips, smooth clean skin, and a good form on the face. Luckily, the textures and model on this particular project are top notch, so the form and smooth skin are pretty much in place. Also, you need to understand the opposite of your objective. Male models are all about structure. Lighting should emphasize high cheekbones, strong jaw line, strong eyes, etc. So those are things we probably want to avoid with this lighting set-up.

To get underway, I first took a look at the model to see if there was anything we needed to be careful about when lighting and rendering. At this point, you need to make sure the geometry is in good shape and the UVs make sense. If you are planing to use something like displacement, it is paramount that the surface and UVs are super clean, or you are in for a lot of fix-it headaches. Like I said, the model is of very high quality, so we are covered there. The next thing is to look at the textures. These are also super nice. However, all the textures were provided at 4K. Excellent for image quality—possible headache in the pipeline. The demands for realism and image fidelity are always on the rise, so you have to find an economical way of dealing with the large file sizes.

This is where map textures with mental ray come in. They will save you—end of story. I have had multi-gigabyte textures burning over a hundred processor render farm with absolutely no problem or network bottle-necking due to MAP. They are magic, use them!

So now I am ready to start rendering. I came into this project late, and the timeline was crunched, so speed was a critical concern. I needed to get a photographic render, and couldn't afford to spend hours setting up lights. I needed a shortcut. Enter Image Based Lighting (IBL). IBL might be the greatest thing to ever happen to CG lighting! It doesn't do color bleed, or photon mapping. It does do amazing diffuse lighting and soft shadows. In short, it will get you to real faster than any other method. The downside: if you don't know what you're doing, it can be prohibitively expensive to render. As the name implies, IBL is all about the image you use, so you must choose wisely, selecting one that represents the illumination setup you are looking for. There's no better image type for IBL than HDRI. Now that we have our illumination model, it's time to look at the eyes. Eye's are about three things: reflection; refraction; and specular highlights. Reflection is obvious—you need the eyes to look shiny and bright against the soft skin of the face. They need to look liquid, which has a lot to do with using the cornea to refract the iris and attenuate the light traveling through it. Finally, you need a "figure" light to pop a hot spot in the eye. I used an area light that was just linked to the cornea geometry to achieve this.

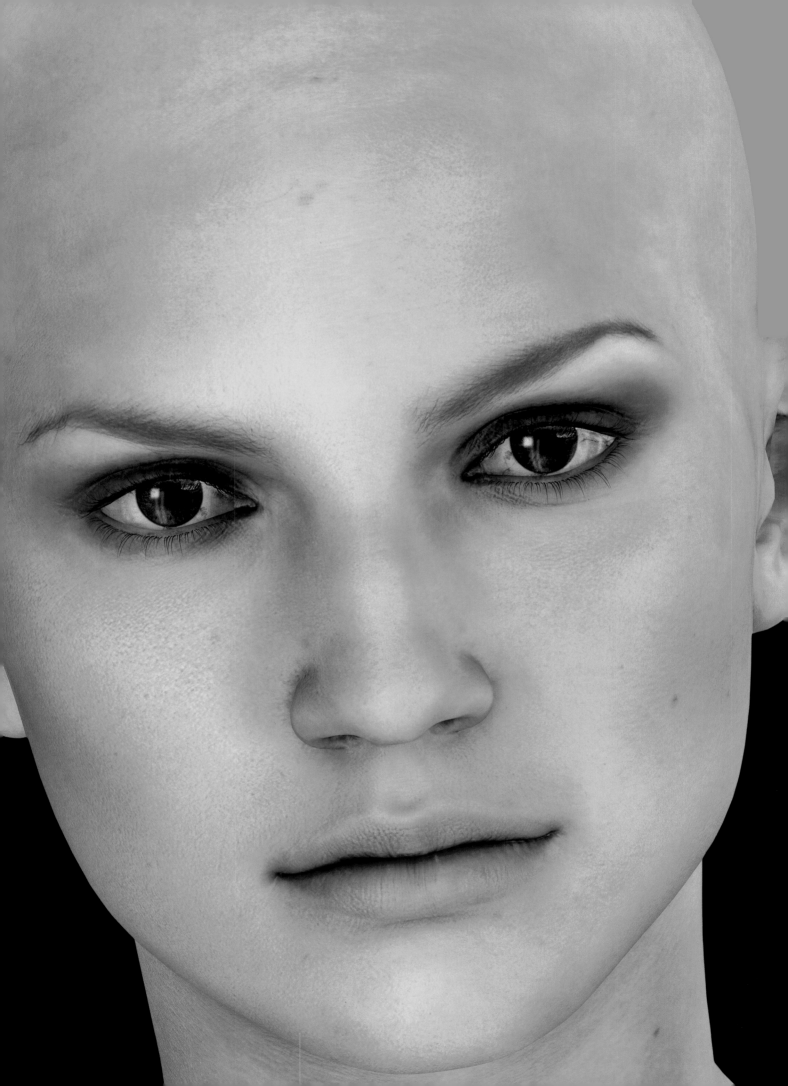

RENDERING
Lights, camera, render
Lighting and rendering Monika

Step 1: HDRI

A High Dynamic Range Image is a file that holds multiple exposure of the same image. By bracketing up and down when taking the images, a photographer is able to ensure he has information in the brightest and darkest parts of the image. These images are then combined into a single file, which can be used as light and reflection sources within 3D packages. HDRIs are especially good as a reflection sources because they provides for the full range of highlights and shadows on your ray traced objects.

Step 2: IBL nodes

Now that we have our illumination model, it's time to look at the eyes. Eye's are about three things, reflection, refraction, and specular highlights. Reflection is obvious—you need the eyes to look shiny and bright against the soft skin of the face. They need to look liquid, which has a lot to do with using the cornea to refract the iris and attenuate the light traveling through it. Finally, you need a "figure" light to pop a hot spot in the eye. I used an area light that was just linked to the cornea geometry to achieve this.

Step 3: Map conversion

When using hi-res textures, in our case 4K, you will want to use mental ray's proprietary format, MAP. The MAP format allows mental ray to load only the section and resolution it needs of the image file when rendering. To convert an image, use the following command from a shell or command prompt: imf_copy -r -p myImage.tif myImage.map I use New Technology Shell (available from www.highend3d.com). Any shell will work, including the command prompt built into Windows, or the terminal window in Mac OS X.

RENDERING
Lights, camera, render
Lighting and rendering Monika

Step 4: Map textures

The resulting file size will be larger than the original, but mental ray will only reference part of it. When saving the image out of Photoshop, use a format like TIFF with no layers (and with IBM PC byte order). The bit order of the file needs to be IBM PC for imf_copy to play nicely with it. You might need to convert your texture to a friendly format—I use SGI before converting to a MAP. You can use a built in Maya utility, imgcvt. So your workflow would go something like this: imgcvt mytexture.tif mytexture.sgi Now you have your texture converted to an SGI format, so you are ready to convert to a MAP: imf_copy -r -p mytexture.sgi mytexture.map

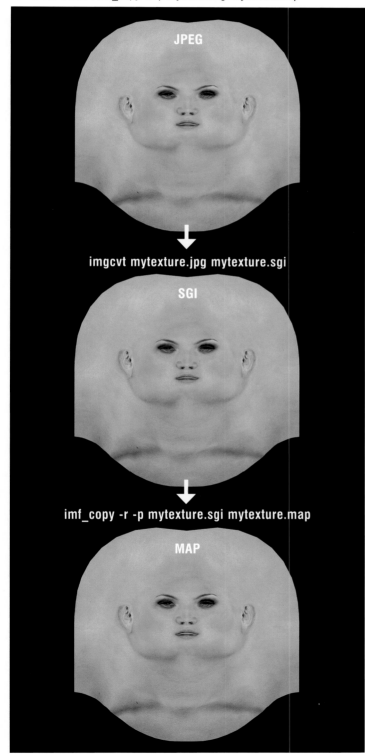

Step 5: Light maps

Light Maps are the key to getting the Sub-surface Scattering effect when using the simple skin shader from mental ray. Use the lowest resolution that produces acceptable results—using very high values in the File Size Width and File Size Height will be brutal on render times, especially if you are combining the SSS shader with an IBL lighting technique. Under Image Name, designate a file to be created. Using the MAP format will make your Light Map more efficient for mental ray. If you're rendering on a render farm, you'll need the map location local to each machine. Each machine will generate its own file—they don't share those. If you are on Windows, you might try something like: C:/mySSS.map

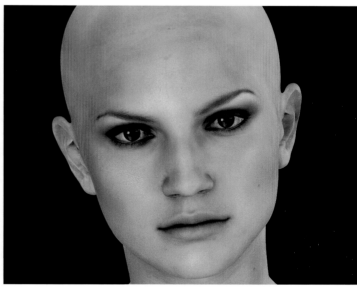

Step 6: Low-res light maps

Low-resolution light maps will exhibit the artifacts you see here. To fix this problem, simply add more resolution to the light map. Don't add more than you need. Add enough to get rid of the artifacts, but that's it. It's a good idea to keep these numbers in the powers of 8, eg 8, 16, 32, 64, 128, 256, 512, etc.

Step 7: Color alpha pass

Alpha channels are a very important part of any render as they allow you to isolate different areas of a render in the composite. A simple way to give yourself more alphas to play with is to do a pass assigning flat colors to objects or faces in your scene. When compositing, you key the color, or set your alpha to the specific color channel to extract the mattes.

Step 8: Bent normals pass

Bent normals is a method of associating a color to a direction, so green for Y, red for X, and blue for Z. Some compositing packages allow you to use this pass to adjust shading using light sources in the composite after you have already rendered. Another simpler way is to key into the color of the light direction you want to adjust and move levels or hue and saturation. It is also pretty common to use a bent normals shader in shader writing to fake Final Gather soft lighting.

Step 9: Ambient occlusion pass

Ambient occlusion is an extremely useful way to get realistic shading on your model without expensive Final Gather and Global Illumination calculations. Although ambient occlusion does not give you color bleed, combined with careful lighting it can produce wonderful results! Ambient occlusion is usually used in the composite, but applying the layer with a multiply function. Also of note, if you have a lot of specularity in your render, it's worth rendering out a separate specular pass, and compositing this over the ambient occlusion pass so you don't muddy up your highlights.

Step 10: Z-depth pass

This is a real workhorse render pass. A 16-bit Z-depth pass will allow you to simulate depth-of-field in your composite instead of at render time. Not only will this save you significant time—raytracers are horribly slow with depth of field—but it will give you a lot more control of the focus in the composite. You can also use Z-depth to add atmosphere, desaturate with distance, or any other number of effects that are simulated with depth. All these passes are powerful, but when combined, give you complete control over your composite! Try to get as close as you can in the render, but the real massaging will be done in the composite. It's often much more time efficient to make tweaks in the composite instead of having to go back to 3D rendering.

RENDERING
Lights, camera, render
Lighting and rendering Monika

Step 11: No SSS

The curse of "plastic looking skin" is most likely the result of not using SSS. Most respectable rendering packages have the ability to simulate SSS these days. Even though it can be more expensive to render with it than without it, you will have a very hard time getting similar results without extensive trickery. My recommendation is this: unless you are on a larger scale production where your skinned character will be seen in many dozens of shots, it is probably better to let the computers spend their time rendering, and for you to spend your time massaging the comp!

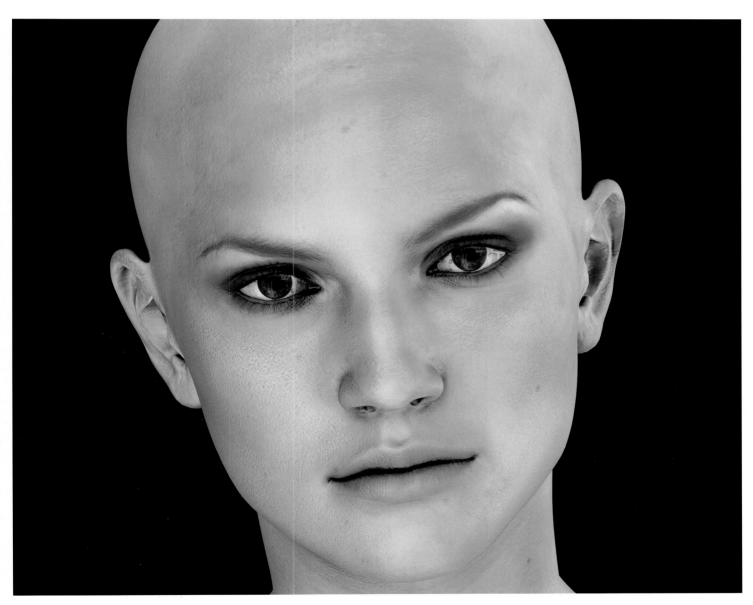

⬇ Step 12: SSS

Sub-surface scattering is a technique that simulates the bouncing of light through translucent objects, such as skin. By combining a variety of texture maps to address the specular, bump, and color of the various dermal layers, you can get pretty good looking skin. For this project, we are using mental ray's SSS Fast Skin method, meaning we are not scattering photons below the skin surface—we are just simulating the effect. Remember the light map—that's where the scatter light is stored.

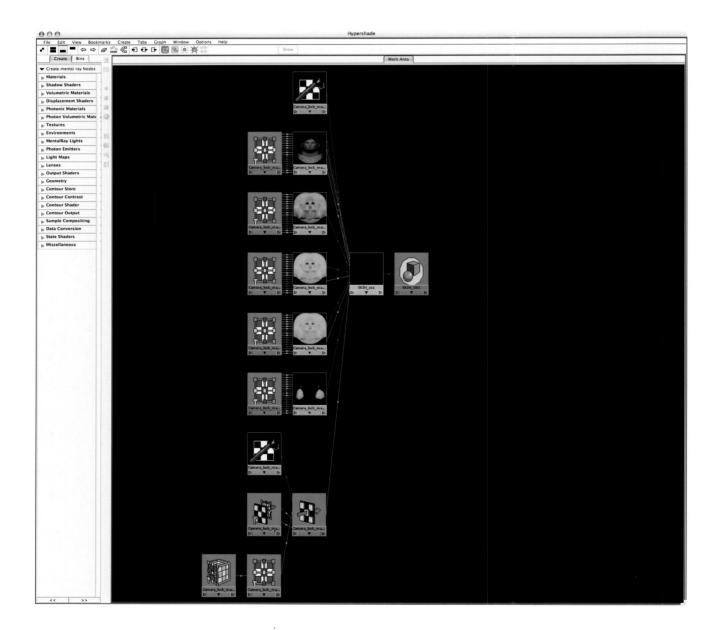

RENDERING
Lights, camera, render
Lighting and rendering Monika

Step 13: Final SSS render

Sub-surface scattering brings life to many types of surfaces, including skin, by simulating the diffusion of light through a volume. The shader in this project approximates this phenomena by "faking" the effects of light transmitting through the various layers of skin. When combined with specular, bump and shadows, it yields very acceptable results without the expensive overhead of tracing actual photons. Faking is a good thing when it provides desirable results, and tends to be the selected path of most productions. In production, we labor to make things look amazing, not look scientifically accurate!

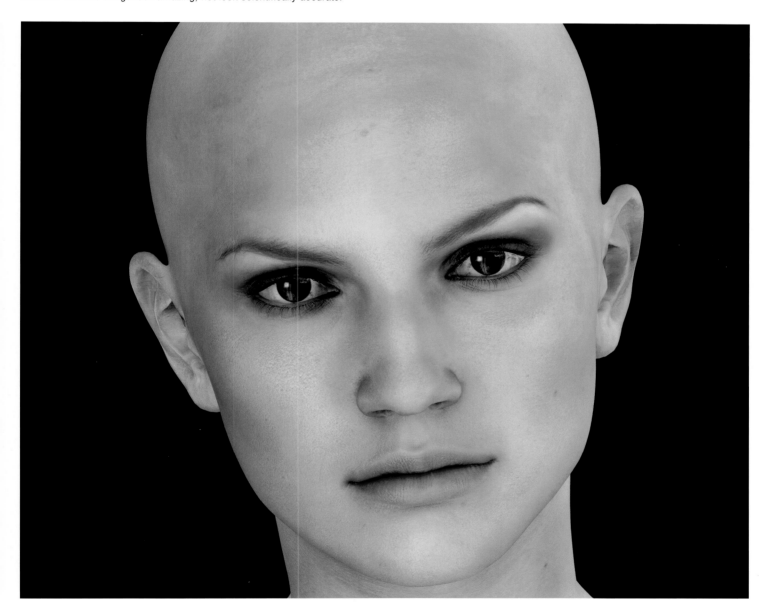

PAUL FEDOR

COSMETICS IN PIXELS
SIMULATING MAKEUP

Makeup isn't just for girls

If you want photo-real use a photograph. You can have your best illustrator sweat over painting makeup, but for time, money, and quality, please use photographs.

With a high-resolution photographic pipeline, you can settle the argument on makeup. You can't compare a 16-megapixel photo, taken by a decent photographer, with professional stylist to hand-painting. Makeup isn't just for the girls.

Often with video games we get a large quantity of soldiers with camouflage face paint. We go out and get real army surplus military-grade face paint and shoot it. You can try lame color corrections or various airbrush tricks, but nothing beats a great photograph. It's standard protocol to shoot with and without makeup. Whether it's lipstick red or 'Apocalypse Now' green, if you want photo-real use a photograph. You might even get L'Oréal as a client too.

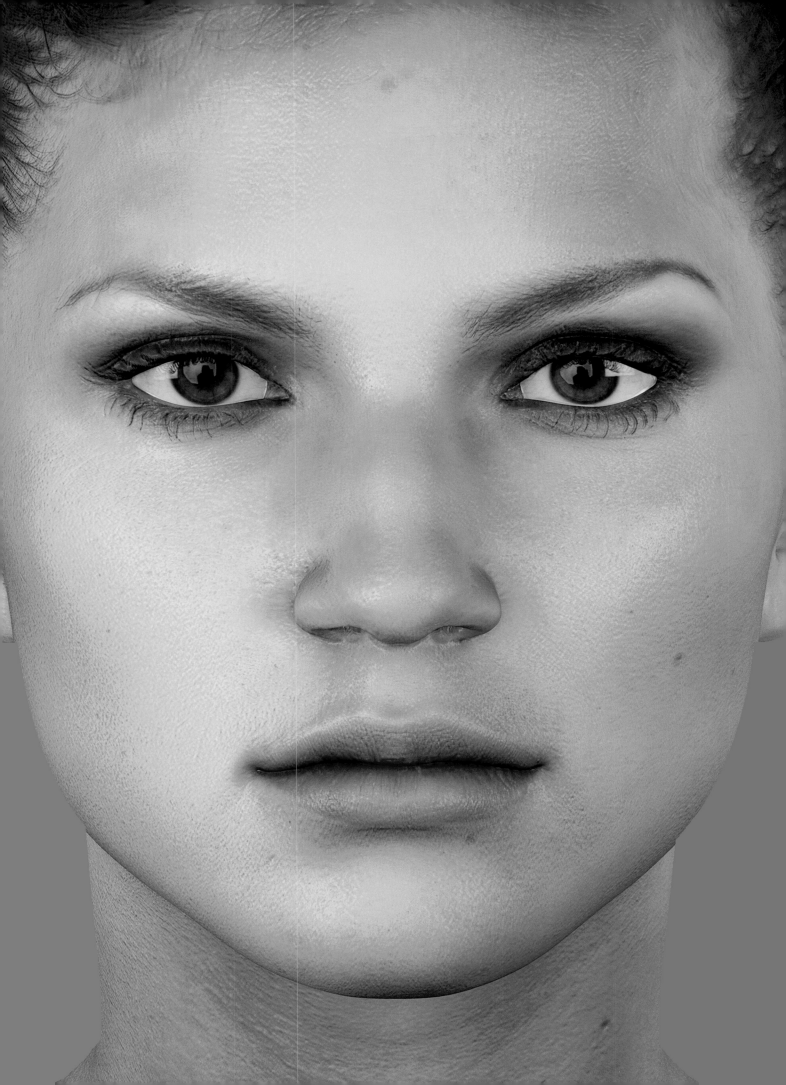

Step 1: Start with the eye

We will start with the upper eye lid. The makeup artist has lengthened the eyelashes and deepened the eye sockets with color. We'll slice off pieces of photos until I get an underpainting.

Step 3: Front projection

We can use Monika with no makeup as a true starter map. The makeup design is known in the business as "Heroin chic"—heavy on the eyes and minimal makeup everywhere else. I will replace the forehead, nose, cheeks, and lips. This will be a piece of cake—especially knowing I don't have to do Monika's ears and hairline again.

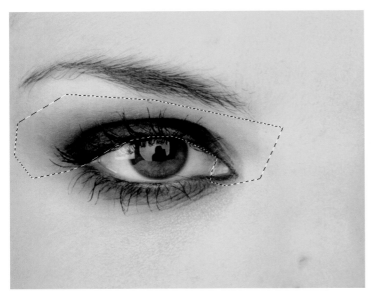

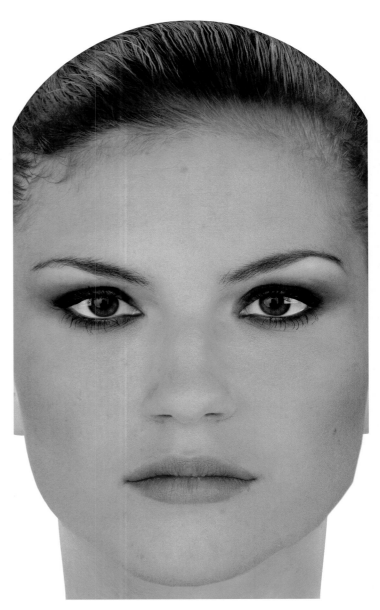

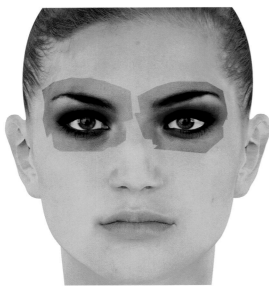

Step 2: Building the eyes

I'll keep creating patches of photos in a circular pattern. First with the lids, then the corners, to the lower lip. I usually do the corners of the eyes several times. I want to start extending makeup skin into the cheek and into the lower forehead.

⬇ Step 4: Baking heroin chic

Have you ever noticed a white turkey neck on a TV anchorman? It's because of the massive amount of makeup that needs to be applied when harsh TV lights bleach out the skin. TV makeup usually takes the skin down an exposure stop, otherwise, subjects would look pale. You can always tell by a pink neck. Monika's bake will give us trouble when blending it with her paler non-makeup skin.

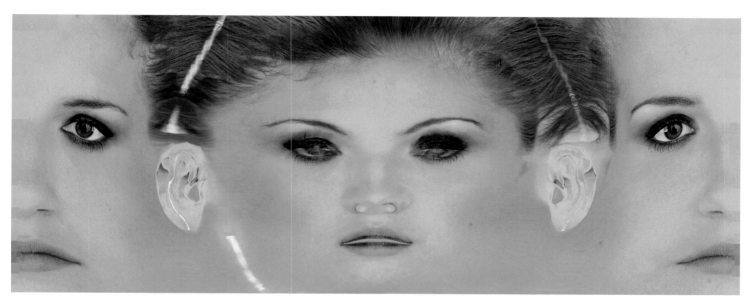

⬆ Step 5: Side blush

I am first going to find the edge of the makeup and the non-makeup skin, and work my way back. I'll then fix the streaking eyebrow and rebuild the temple. All the overlays show how much makeup is truly covering the face.

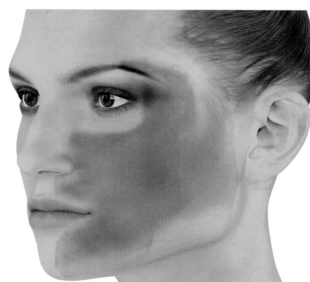

⬆ Step 6: 3/4 blush

I am going to have to pull a 3/4 projection to safely blend Monika's blush. There are also weird spots I'm getting in the side chin and upper lip. The non-makeup skin will show up as a white patch.

Step 7: Lashes, tears and brows

I will repeat profile and 3/4 projections for the left side. All the areas overlaid in red are reconstructed both in the profile view and 3/4 view. Don't be afraid to build up your projections. It only makes for a more believable map.

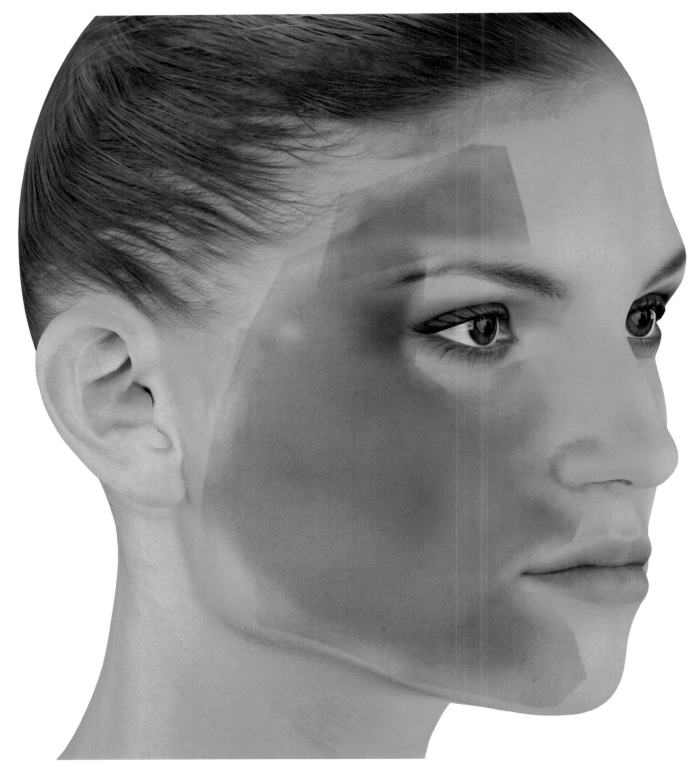

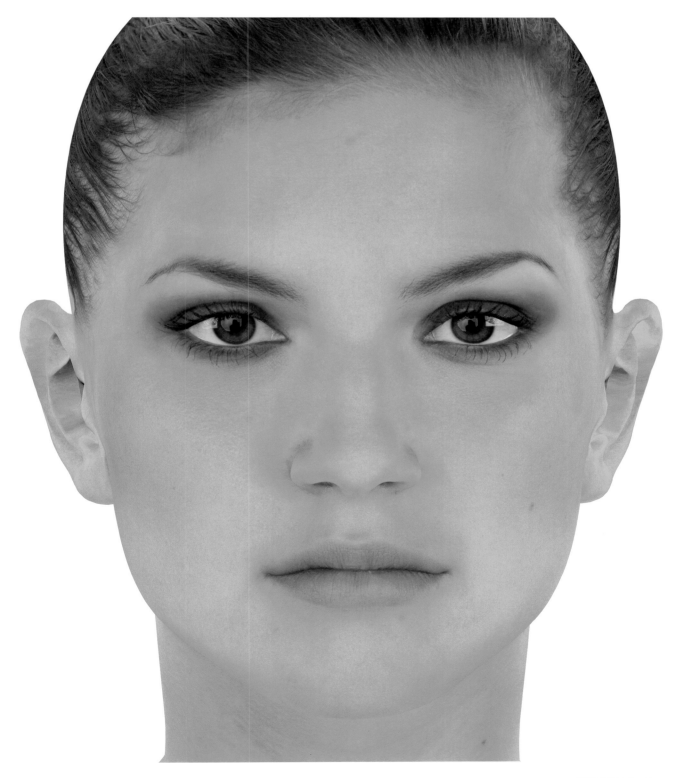

Step 8: Once more

I will have to do a second frontal projection to finally blend the blush, which is becoming troublesome. The surface shader really leaves you with no room to hide. The whole point to makeup is that it blends your skin for the appearance of being healthy. If you have to, pull more projections than normal. Look on the bright side—at least you're not doing ears.

Step 9: Bump

The power of the photos will show in the bump. If you hand-paint makeup, you will lose the pores underneath the makeup.

Step 10: Color map

Once you have your makeup face plate, you may have to do an overall color correct. A simple Levels and Color Balance change will finalize the map. Definitely check for any tonal inconsistencies.

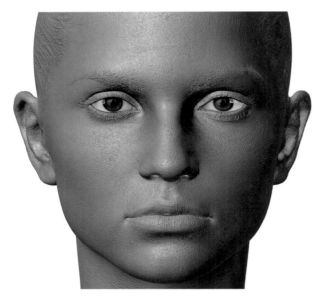

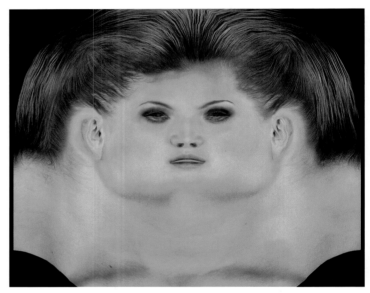

Step 11: Backface

Because we have all the bump data, it's very easy to generate the specular bake.

Step 12: Weight map

We can recycle the backface scattering over and over. Because the UV template never changes, and the typology never changes, you can use this map on every ethnicity, old, male, and female characters.

⏷ Step 13: Weight map

The one area that causes fluctuation in the SSS is epidermal color. Usually, I desaturate the color map, but that's usually for my Caucasian characters. Sometimes you need a little more power out of your epidermal color with ethnicities and doing makeup. If Monika wasn't wearing makeup I would desaturate epidermal color more. I am going to plug it in with a slight desaturation and see how it works.

⏷ Step 14: Subdermal color

The evenness of the photos will pay off later when I throw a shader on it. If it looks this good now, imagine when you add your bump, spec and shading.

⏶ Step 15: Weight map

The weight map can be a source of constant sorrow. The job of the weight map is to stop the scattering. The proper procedure is to increase the contrast—by making it more white, we get more scattering. Now with makeup, we have a natural source opacity. So for makeup or face camouflage you actually want the weight darker.

Step 16: Final SSS

I'll now do a simple light test on Monika. If I were shooting her in real life for a skin commercial I would probably use a ring light, a bay of KinoFlows, or maybe shoot some light through silk. It should be even—not harsh shadows. Often, as a director I was criticized for dark film. Commercials and most TV that you see have a lot of light—it's even, and it's boring. The SSS is good enough to turn over to the lighting team. "The Poor Man's SSS" is pretty reliable and there are no complicated settings. These are straight renders with just maps driving it.

Step 17: Under the shader

This is what "The Poor Man's SSS" looks like. Only six maps: Epidermal Color; Subdermal Color; Subdermal Weight; Bump; Specular (used twice); and backface scattering. I actually don't plug anything into the diffuse at all.

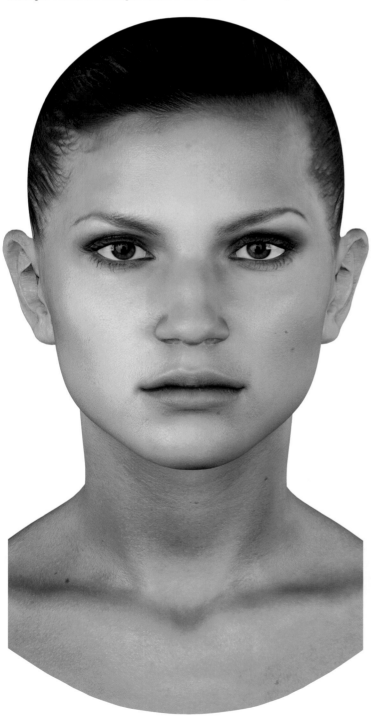

Step 18: Macro test

You might want to try a macro test. See how close you can go with 4K. Remember, adjust the bump down the closer you go. The eyebrows are getting a little sketchy. If I were doing this for film, we would have fur eyebrows.

Step 19: Different angles

Try testing "The Poor Man's SSS" with different angles and various light settings.

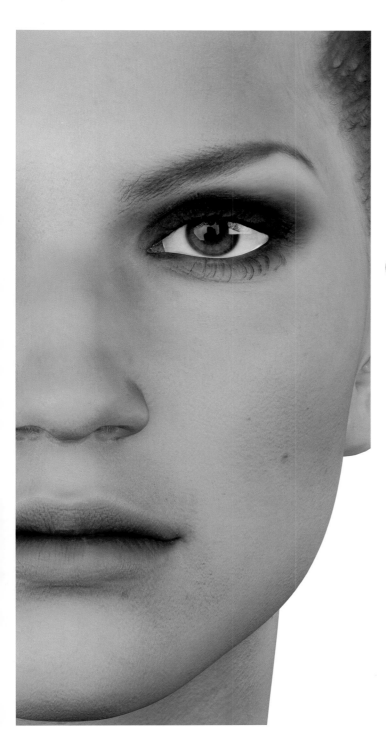

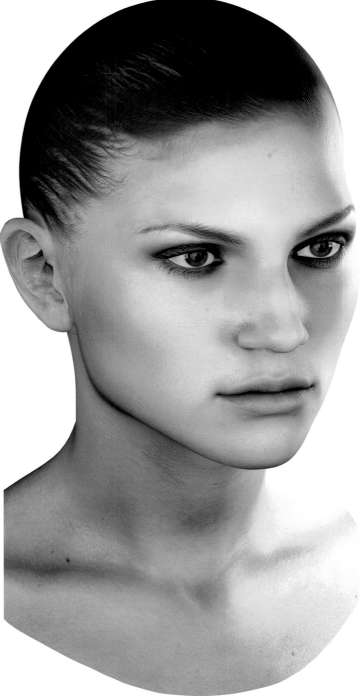

PAUL FEDOR

BRUISING & SCARRING
SIMULATING TISSUE DAMAGE

The dark side

Mughahhahaha! Welcome to my dark side. If you want to do creature textures, you might want to pay attention to this now.

Protecting photographs is nice, but when a scar job comes along, it's a chance to prove your chops as a texture artist. With a photographic pipeline, it's not a question of a scar, but what kind of scar? Do you want an acid scar, burn scar, battle scar, bruise, cut, laceration, or just a plain birth defect.

One of the most important and valuable things I did for Sony was to create a massive hi-resolution texture library. We shot planes, tanks, weapons, half-tracks, and missiles. Any type of metal for a vehicle or ship that a texture artist could ever want, we have archived. We shot rare lizards and bats from 'The Museum of Natural History' for all types of creatures, bats, dragons, or monsters. We shot the armor collection at 'Metropolitan Museum of Art' for every type of armor you could want. Just when I thought I had one of the craziest collections of hi-res photography, I came across 3D.SK's collection of dead cow pictures.

Part of the texture or matte painter's job is to have a crazy archive of photos. When I saw Peter's collection of photos from the slaughter house, I knew all my needs for scar photography were satisfied. If you don't have a weak stomach, then this tutorial is for you.

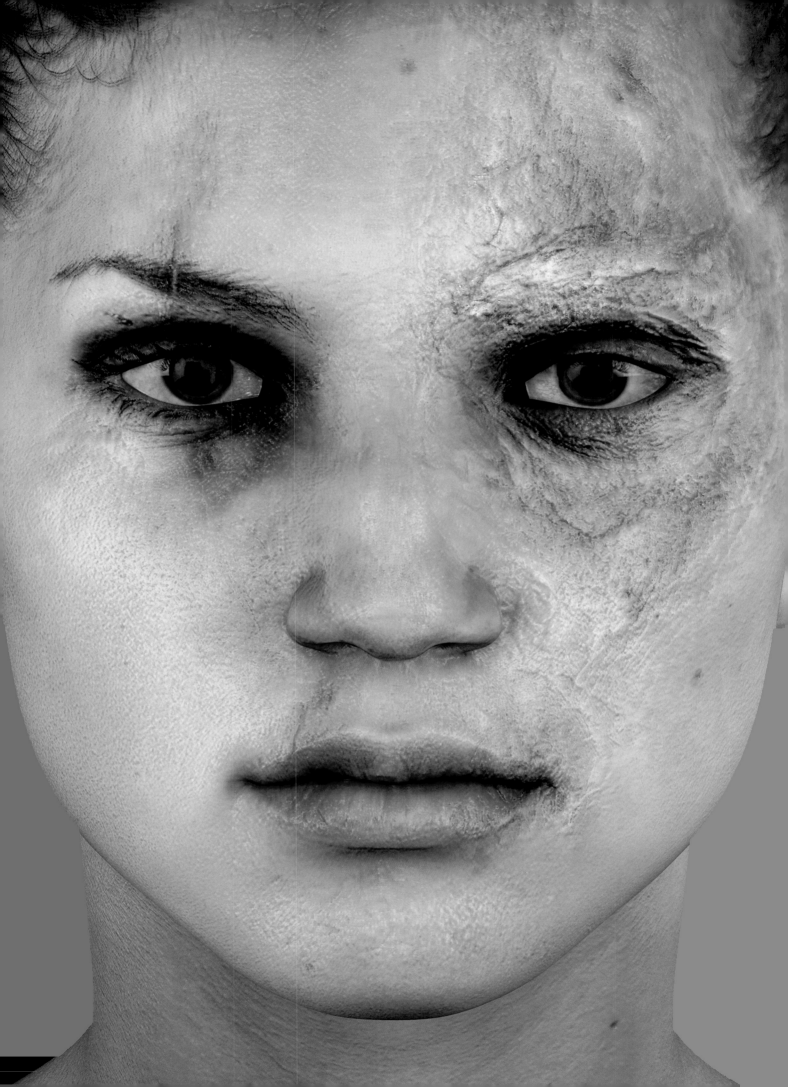

⬇ Step 1: Haemorrhage

I am going to start with a little eye haemorrhage. I'll also pepper the eyes with some broken blood vessels, and dilate the pupils. Next I'll add some dark circles and get to work on a black eye.

⬇ Step 2: Black eye

Like I said, texture artists work with some of the craziest concoctions of pictures. Surprisingly, nebulae photos from the Hubble telescope make for great bruises. The Overlay, Multiply, and Hard Light blend modes make for the best tricks in Photoshop.

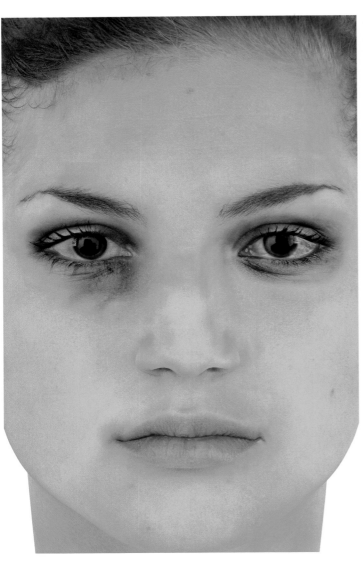

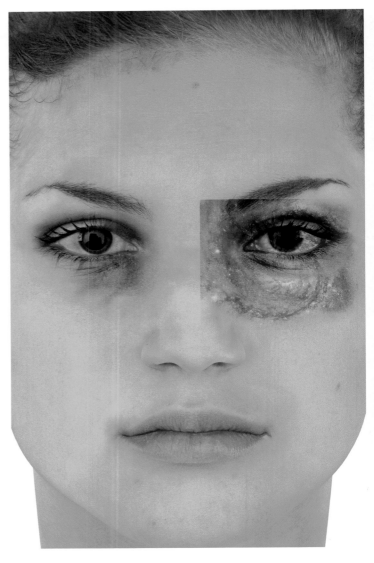

© NASA, ESA, Hubble Heritage Team.

Step 3: The color of a bruise

The universe is a strange thing—especially if it's a painful bruise. I am starting to bring out purples and dark reds for the underlying damage. Did you know depending on what part of your body it's in your blood has different colors. In fact, a blow to the head produces dark purplish blood as opposed to a finger prick. Take a look next time you have some head trauma.

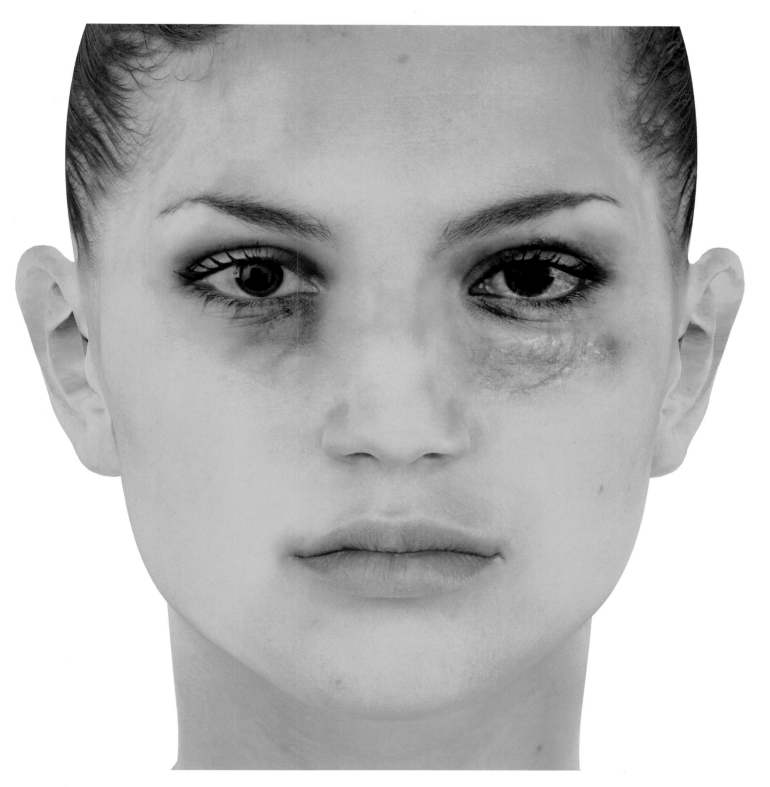

Step 4: Facial discoloration

I am slowly going to bring up the facial discoloration. I erase 80% of the galaxy, but the part that is left looks good. I will do a number of things to an overlay, including all types of Levels changes. Then I start to spot erase with a 9% brush.

Step 5: Side blush

I am going to start affecting the overall face. I'm going to make Monika paler, and then start to make her eyes really dark with a runny red nose. Next time you see someone with the flu, notice the strange pale color and severe red around nostrils and lips.

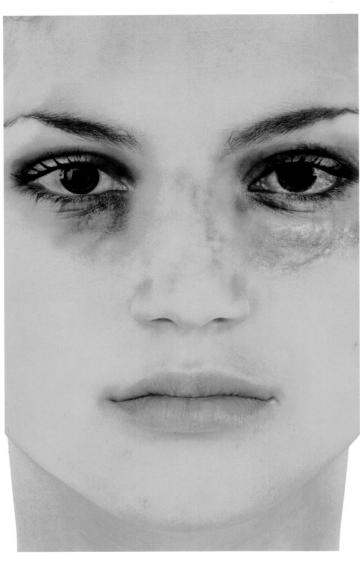

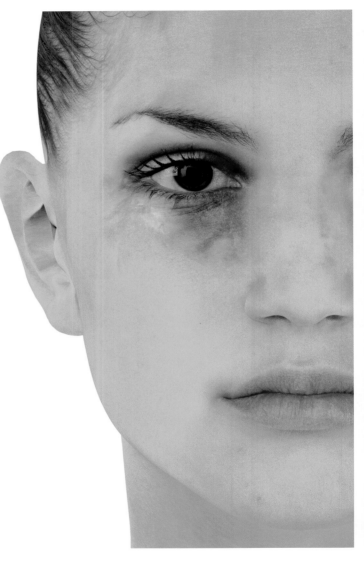

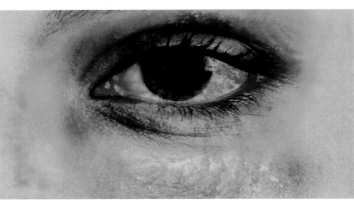

© NASA, ESA, Hubble Heritage Team.

Step 6: Knowing where to find reference

I start bringing out the scars. Do some Google searches on "Medical photography"—especially dermatology websites. Google gives the most results for exact word matches, so though it is deeply disturbing you'll find many graphic examples of domestic abuse using a term like "wife beating". You can try all types of word associations for types of accidents to get the imagery you need out of Google. A good texture artist knows where to find what they need on the net.

Step 7: Dead cow

I am going to start to bring out the dead cow from 3D.SK. The meat section on Peter's website will get you all the scar tissue you need.

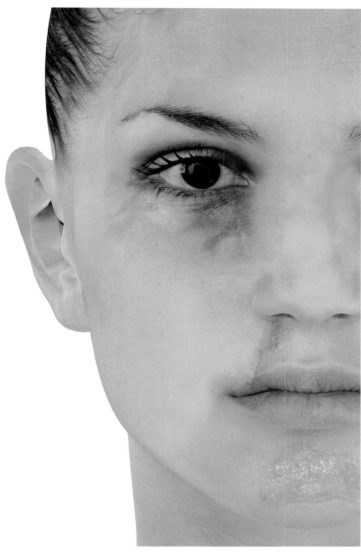

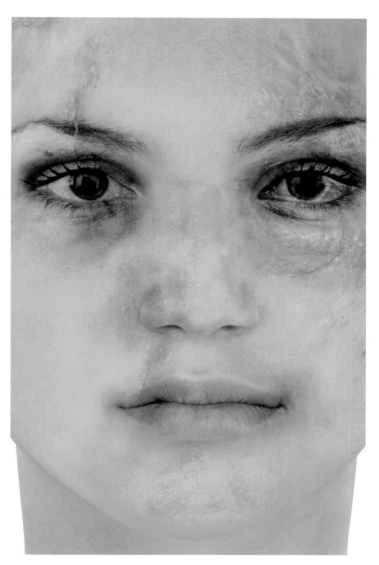

Step 8: Weight map

For the weight map I would usually use Levels and lift up the midtones and wherever there is white I would get scattering. Since scar tissue is rather opaque, I'm simply going to plug in a greyscale color map.

Step 9: Subdermal color

I am going to cover the color map when I split it into the subdermal color. I'll leak in some blue and magentas into the shadows to bring out the bruises.

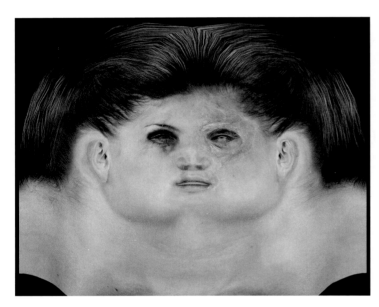

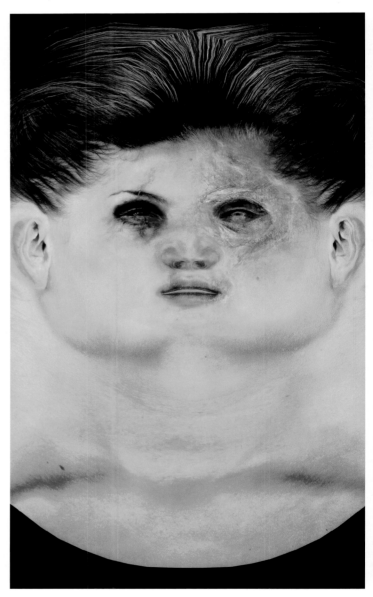

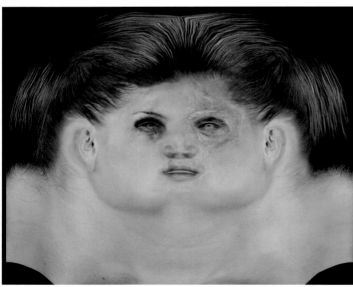

Step 10: Epidermal color

Another variation due to the scar circumstance is the epidermal color map. Usually, I desaturate the epidermal color map. With the power of the weight map cut back, I'm going to use the color map as the epidermal color without any desaturation.

Step 11: Permanent scar

The SSS really makes this scar take off. With scattering you get to explore the true depth of skin—especially in scar tissue. I did not change any setting or make any post tweaks in Photoshop. This render was done with two area lights, and just the current map plugged in.

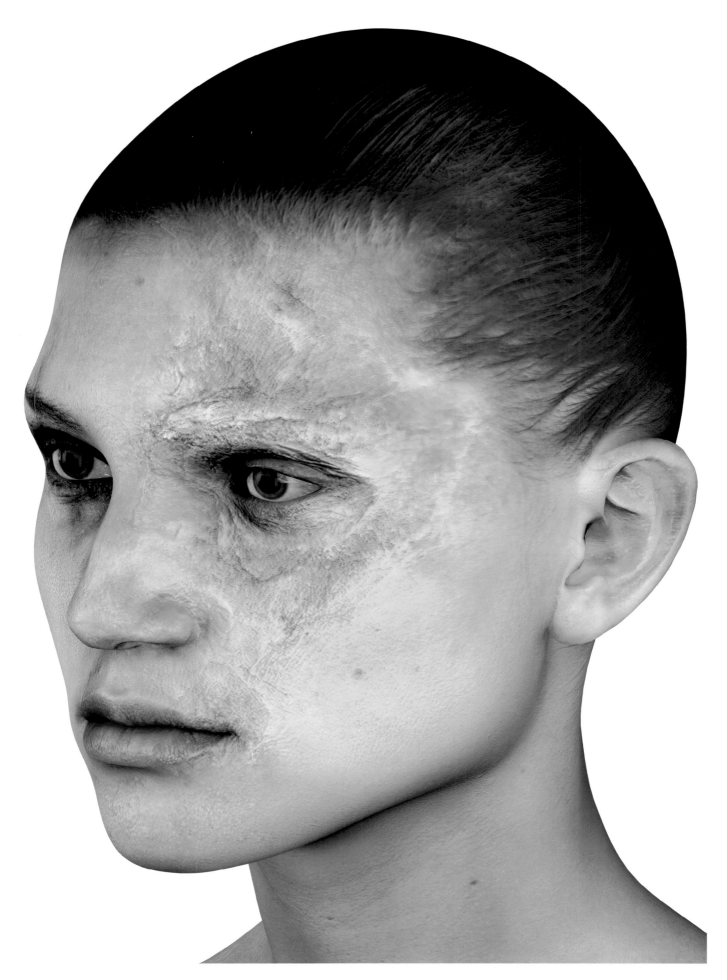

Step 12: Seeing other people

With scars and aging you really get to explore the strange mixtures of people's faces. I head over to 3D.SK and find a gentleman with a cleft palate.

Step 14: Fresh scars and older scars

I'm starting to dial in the scar. I've decided to make the left half of Monika's face beaten and bruised. The right side is going to be a burn scar. I also want to make the scar appear older, as if it has healed over. One thing that's bothering me is her right side eyebrow. If she were burned it would be melted off along with her eyelashes. So I'm going to go back to my meat textures and melt off the rest of the brow.

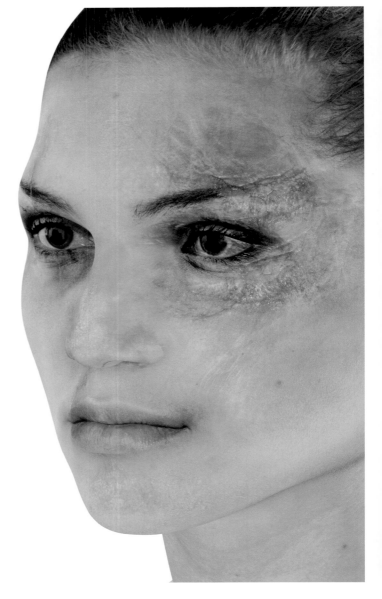

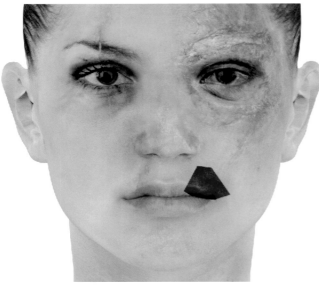

Step 13: Cleft palate

Cuts and cleft palates are really easy. Try the Overlay blend mode, desaturate, or play with Levels. Usually, if you have a decent photograph of a cut, it drops right in.

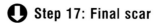

⬇ Step 15: Final color map

This is the final color map. From this one map, you can extrapolate all the information you need.

⬇ Step 17: Final scar

Pretty gruesome. The left side has been beaten and bruised. I added a nice little scar across her eye. Notice I painted out where the hair would be missing in the eyebrow. A couple of cleft palates later I finalized the right side burn. I melted off her eyebrow and started to bring out a skullish eye socket. I also tried to hint at some melted face muscle, and added a fade to the burn. It's pretty gruesome, but I am a fan of horror movie prosthetics.

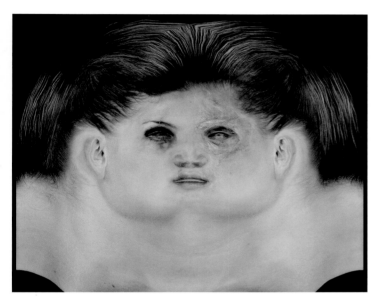

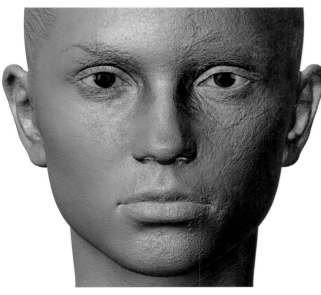

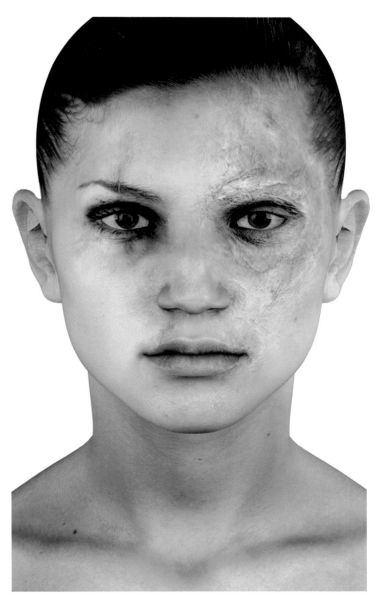

⬆ Step 16: Bump

At least the cow didn't give its life in vain. Look at all the dead cow in the bump! This is the most you will get out of the bump before you have to seek the help of ZBrush. You can take this and inflate it in ZBrush just from the map. With ZBrush you can easily paint a greater height into the deeper scar with brushes.

PAUL
FEDOR

AGING MONIKA
PAINTING IN THE YEARS

Skin-deep beauty

Aging is one of the fun tasks of a texture artist. The true power of beauty is in the texture artist's hands. With a hi-res photography pipeline aging becomes very specific. A vague question like "how old is old?" becomes "do you want Monika age 50? or age 75? or Monika the mummy?"

In fact, it is very hard to create a young beautiful face from a CG point of view. Young people have really tight pores, which make for really weak bump maps on smooth skin. Villains and older people have really large pores which really make for great specular and bump maps. So older is often easier.

Strange things happen to the skin when it ages. Skin actually gets thinner with time, so whatever is in the subdermal layer really starts to peak through. If I skinned Monika alive, her epidermis would have virtually no color in it.

The seven layers of epidermis (commonly thought of as your skin) are a semi-translucent layer kind of like a latex glove. This layer has no blood in it. In essence, the human body is a bag of water, bones and blood. The subdermis is where all the action is, with fat, blood, bruises, pigmentation, nerves, red, blue, and yellow veins.

As the body gets older, anomalies happen in the skin—especially in the subdermis. Skin sags and wrinkles. Blood circulation slows down, because your heart is weakening. This means less oxygen in the blood and blueish skin. A lot more blue veins occur. Weird fatty deposits pop up leaving blemishes. Dirt, crap, melanoma, and the tough road of life itself get embedded in your skin as you age. Your pores get bigger, and dirt gets in them. Zits become blackheads. Stress and income all play into the aging of your skin. It's a very interesting concept to argue that it's age, beauty and life that makes the skin.

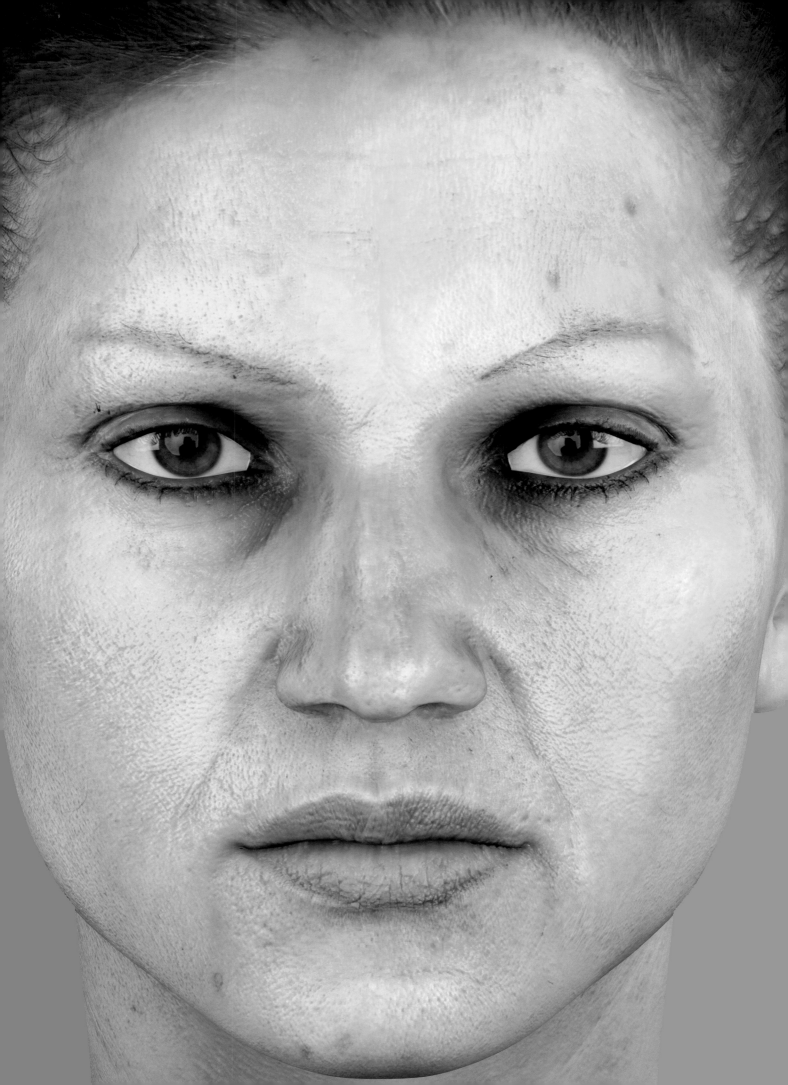

⬇ Step 1: The forehead

I am going to start with the forehead. The aging process will be a fairly easy one. The younger Monika's face map will serve nicely as a starter map. I won't have to do behind the ears again. Since we didn't cast a specific old woman for the shoot, I go to 3D.SK for help. I pull various pictures of grannies for wrinkles, bags, and weathered skin. I don't have a specific woman in mind so it will be from ages 50-80. What will work? I don't know. This is where photo-manipulation becomes painting.

⬇ Step 2: Nose and bags under eyes

I am getting a feel for my old age selects. You have to try different patches and match them with Monika's original complexion which I have desaturated and added some blue coldness. I'll mix and match eyebrows, bags, and nose. I still don't have a feel for the new older Monika just yet.

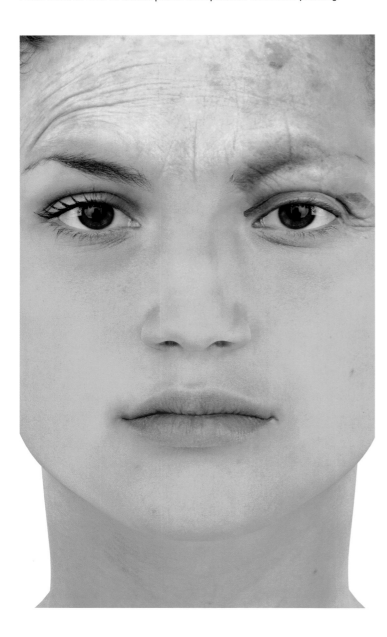

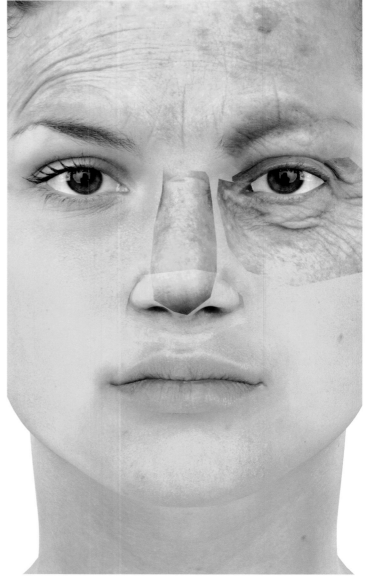

Step 3: Underpainting

I am moving quickly to get a first underpainting in. I pick photos for complexion only at this point, and have fun while Monika changes before my eyes. Right away I see the current age is 80. I don't think that geometry can support such an advanced age, so I may have to bring her age in at around 55. The photos of her cheeks are too bulbous. The eyebrows really don't feel like an evolution of Monika's originals, and the eye wrinkles don't seem to fit with no geometry to support a big eye bag. I think I'll wrangle Monika's age in a bit.

Step 4: Finding an age

I like Monika at 50. She's had a rough life by this time. She's drank and smoked her way to an appearance of age 60. I found a woman with plucked eyebrows. They don't exactly match Monika's younger eyebrows, but it's close enough. I like the fact they are plucked. It's good to know Monika still cares about her looks at this age. I am weathering the skin and being careful not to put in too much sagging skin. We don't have enough time to remodel her at this point.

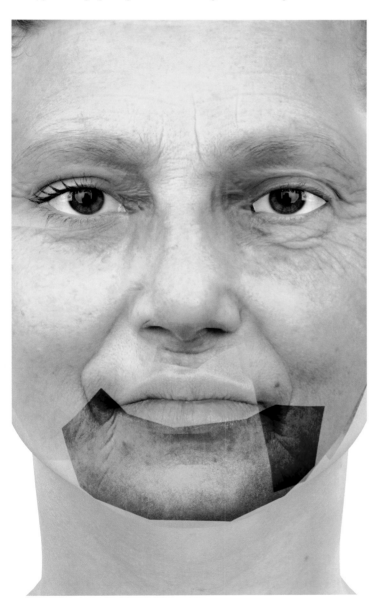

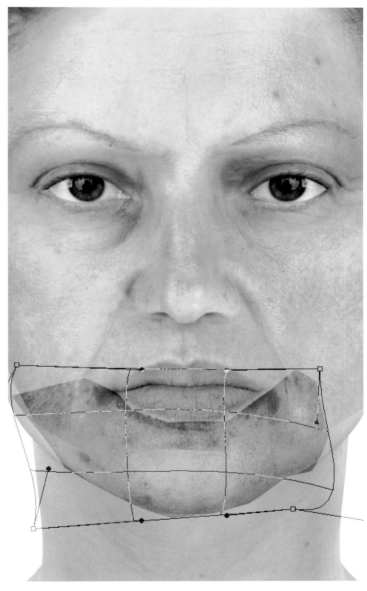

Step 5: Granny Monika

Older Monika is starting to shape up. Now that I know I am doing an age of around 50 I can dial it in. I add creases in the corner of her mouth. I do a complete reconstruction on her eye socket and loosen the skin on the lids, corners, and upper eye. Older people tend to lose their eyelashes. I remove the upper eyelashes and leave this tacky mascara under the lower lid. Granny Monika is really starting have a story behind her.

Step 6: Patchy complexion

The side projection becomes a little more menacing. I am starting to see a patchy complexion, but older people do have patchy skin. Nothing that an overall color correct won't fix, and it will even out once it gets buried in the shader. Sprinkle on some liver spots and Monika is really aging nicely. As usual, the corner of the eyebrow is a problem. A quick patch and some larger skin pores and she is looking done.

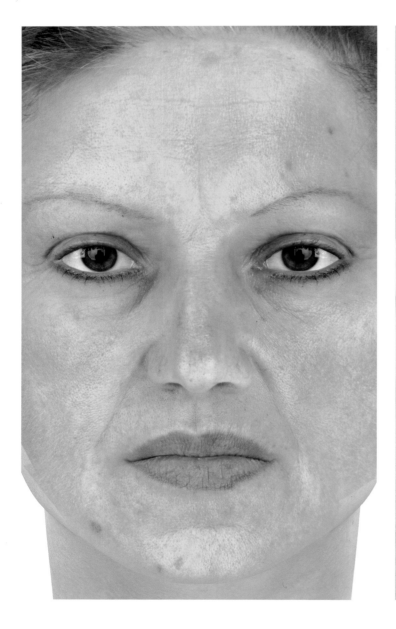

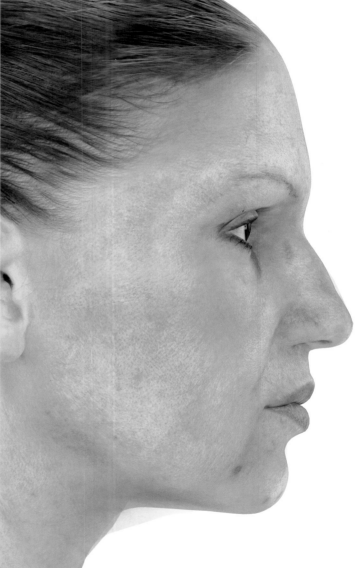

Step 7: Bump

What did I tell you about older skin? Makes for sweet bump maps. The bump will make a great displacement map as well. I am going to touch-up some nasty spots that seem to be buzzing. I take a 9% airbrush, sample a grey from bump, and spot-fog areas around the nose and lips that are a little funky. The bump shouldn't take longer than five minutes with all the effort that's been put into the color map.

Step 8: Subsurface shading

Sub-surface really kicks in with old people. There is so much going on under their skin. The initial SSS seems to be really working. The bump has a true bite to it, and the specularity has that unnatural grease that old people have. The aged lips and big pores really stand out. Play around with different color corrects in your subdermal color map. Sneak in blues and sickly magentas with spots of desaturation. Right now, I want to keep Monika older yet slightly beautiful. I have given her tissue damage already so I want to keep Monika the granny subtle. She's still sexy at age 55.

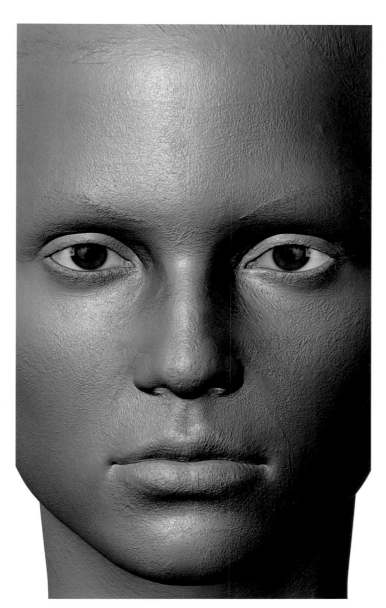

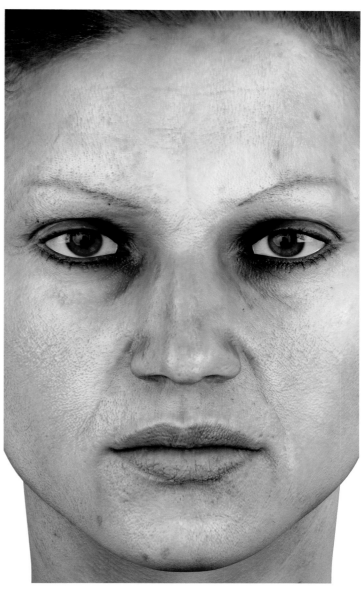

Step 9: Vein map

After revisiting the tissue damage tutorial, I think I have abused Monika enough. But for demonstration purposes, I wanted to include an example of the true power of SSS. Old people have a lot going on in their subdermis: spider veins; varicose veins; and broken blood vessels. In this case, I will add some alcoholic veins just to see how they react in the subdermal color map.

Step 10: Vein SSS

As you can see poor Monika has a slight drinking problem at age 50. I want granny Monika to be a slight healthy and still attractive age 50, so I am going to go light on the melanoma. For the final render I will dial back the veins, I've done too much to her already. This shows the true power of sub-surface shading. When you get good at old people or your next villain, give him some cancer clusters in the old subdermal and some drunken veins.

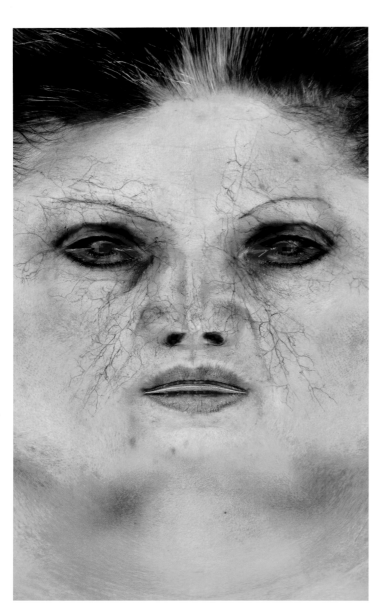

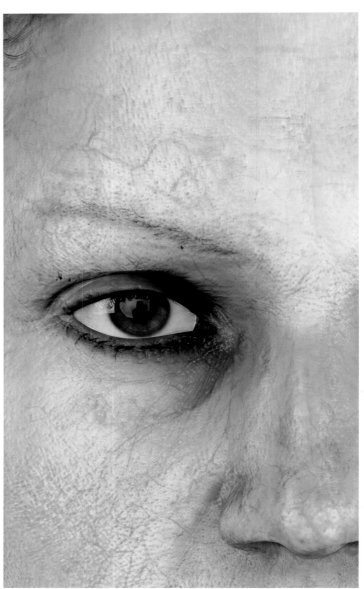

Step 11: Monika at 50

Monika at 50 has a thinner, bleaker complexion. Age lines develop all over. Mouth creases start to dig in as the skin gets bigger and bloated with fat deposits. Pores widen, and veins pop. Folds become wrinkled. Blotches sprout, and hair falls out. I could have done worse to Monika. I picked an age of 50 to show the range that a texture artist should be able to pull off. Using a Monika age 50 map, you can overlay it on Monika age 20 and spot-erase. Within 30 minutes, you can take this face render and turn it into age 40 or age 30 by simply ghosting the maps on top of each other.

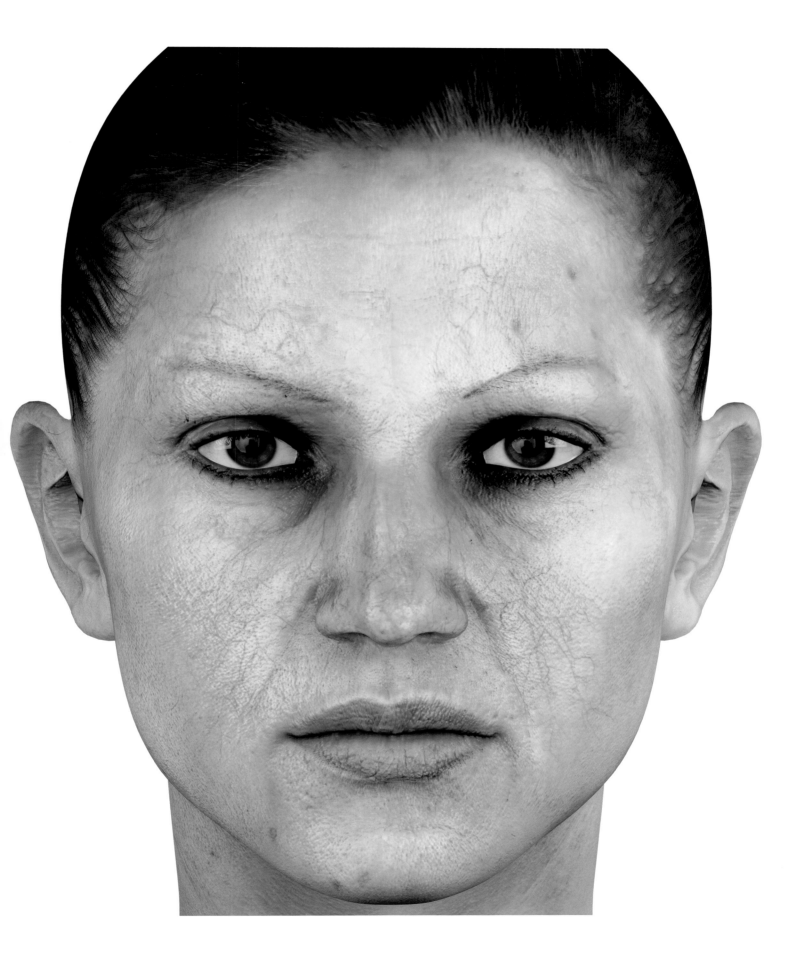

/ BALLISTIC /